OKANAGAN UNIV/COLLEGE LIBRARY

02301661

V

FOR REFERENCE

NOT TO BE TAKEN FROM THE ROOM

N 7825 .S68 1994
The Dent dictionary of
Speake, Jennifer

230166

D0769088

THE DENT DICTIONARY OF
SYMBOLS IN CHRISTIAN ART

OKANAGAN UNIVERSITY COLLEGE
LIBRARY
BRITISH COLUMBIA

THE DENT DICTIONARY OF SYMBOLS IN CHRISTIAN ART

JENNIFER SPEAKE

J M Dent
London

© 1994 by Jennifer Speake

First published 1994
Reprinted 1994

The right of Jennifer Speake to be identified as the author of this work has been asserted by her in accordance with the Copyright, Designs and Patents Act 1988.

All rights reserved

No part of this publication may be reproduced, stored in a retrieval system, or transmitted, in any form or by any means, electronic, mechanical, photocopying, recording or otherwise, without the prior permission of J. M. Dent Ltd.

Typeset by Deltatype Ltd, Ellesmere Port, Cheshire
Printed in Great Britain by Butler & Tanner Ltd, Frome and London
for
J. M. Dent Ltd
Orion Publishing Group
Orion House
5 Upper St Martin's Lane
London WC2H 9EA

British Library Cataloguing-in-Publication Data

A catalogue record for this book is available from the British Library

ISBN 0 460 86138 7

CONTENTS

For Graham

PREFACE

*Three-quarters of the spectators, who are otherwise fully
capable of doing justice to the work of art, are not
sufficiently instructed to know the subject of the picture. For
them it is a beautiful person who pleases but who speaks a
language that cannot be understood; they are soon bored
with looking at it because, where the understanding plays
no part, the duration of pleasure is very short.*

(translated from J.-B. Dubos *Refléxions critiques sur la
poésie et la peinture*, 1732)

The ancient international language of Christian symbolism was for many centuries common currency all over Europe. Its vocabulary is still encountered everywhere that medieval and Renaissance works of art are on view, but to many 20th-century spectators it no longer speaks as plainly as it once did. It has become to some degree both alien and alienating, setting up a barrier of incomprehension where the artist's original expectation was to make the work of art speak directly of its identity and intent.

This dictionary is intended as a key to that symbolism. Reading the clues in the symbols, the spectator can see that a detail that is apparently irrelevant, quirky or even trivial in a work of art may be highly significant. The figures and objects on the altarpiece and in the stained-glass windows of a medieval church may touch our hearts by their beauty, amuse by their quaintness or stir admiration by their colour or form, but this is only part of their purpose as conceived by those – whether great artists or obscure craftsmen – who have created nearly two millennia of Christian art.

The author of the 15th-century English poem *Piers Plowman* observed of church art that 'these paintings and images are poor men's books'. A basic grasp of the visual vocabulary of these 'books' can greatly increase both understanding and pleasure, whether or not the contemporary viewer has any Christian commitment.

This book aims to answer some very simple questions that almost every visitor to a church or art gallery has needed to ask at some time: 'Who is that?' 'What is she or he holding?' 'Why is she or he dressed like that?' 'What is that mouse/pig/snake doing in the picture?' Once alerted to the existence of this symbolism we became aware of how pervasive it is, not only in the great works of painting and sculpture but also in the lesser arts of stained glass, ecclesiastical embroidery, metalwork and manuscript illumination. If the reader who consults this book goes back to the works of art with sharper eyes and enhanced understanding, it will have fulfilled its purpose.

The entries in the dictionary are arranged in a single A–Z sequence to make it as simple as possible to find the answers to the two main categories of question that are

likely to be asked of it. First, there will be the questions that arise when enquirers know the name of the saint they are interested in but not why he or she is depicted in a particular way and with a particular object. The second category of query will originate with those who have identified a detail, symbol or object that is clearly significant in a work of art but do not know the name of the person(s) depicted or the significance that the artist attached to a particular item or, indeed, what exactly is going on.

Entries therefore fall into two main groups: biographies of saints and descriptions of objects and symbols. A system of cross-references (indicated by asterisks) operates between the two, directing the enquirer to additional information or suggesting further avenues to explore. Entries for objects will therefore normally contain one or more cross-references to entries for the relevant saints, where information as to why that object is related to that particular saint can be sought.

This book is not meant to be a comprehensive biographical dictionary of saints, but rather a guide to those saints that are most likely to be encountered in art. In this respect sober biographical facts – where any have been established – are generally of less importance than the often highly coloured 'legends'. Saints' lives, represented *par excellence* in the 13th-century compilation by Jacobus a Voragine known as *The Golden Legend* (Latin: *Legenda Aurea*), incorporated elements of the marvellous that would not have been out of place in a secular romance. In the case of New Testament characters the four canonical gospels were augmented by a number of apocryphal writings that furnished the Middle Ages with significant amounts of additional biographical detail; of these writings the *Gospel of James*, known also as the *Protevangelium*, is perhaps the most important as it provides a biography for the Virgin Mary that considerably expands on the New Testament material.

Medieval commentators and iconographers drew freely on these extra-biblical sources, but in recent centuries they have been relegated to almost complete neglect or, at best, the obscurity of academic editions in university libraries. Awareness of these sources can account for details that may at first sight seem arbitrary to the 20th-century observer. For instance, the *Protevangelium* account of the Virgin Mary's upbringing in the Temple in Jerusalem describes how she was given the task of spinning a purple (or scarlet) thread for temple vestments; hence the most commonly used Byzantine formula for Annunciation scenes has the Virgin busy with distaff and thread as the angel approaches her.

In this dictionary, therefore, the biographies of saints and biblical characters usually include only a very brief outline of the subject's life, sufficient to indicate the likely content of narrative scenes or pictorial cycles in which he or she features. Attention is primarily focused upon his or her individual iconographical character. Some indication is generally given of the popularity of a saint's cult and its geographical extent. Both these factors may be helpful clues to the likelihood of a particular identification; for instance, a stag with a crucifix between its horns in a painting from northern France or the Netherlands is very probably an illustration of the legend of St Hubert, while a similar picture from southern Europe is much more likely to be of St Eustace.

For objects whose identity may be in doubt, a visual index has been provided. Thus the reader who is not sure of the identity of the cylindrical object held by a female saint could consult the visual index, see that it might represent the ointment jar associated with St Mary Magdalene and be directed by the key word to the relevant entry in the text.

In addition to the biographical and object entries a third group of entries describes narrative scenes commonly found in Christian art. These entries identify the characters involved and highlight the different ways in which the same scene has been depicted at different times and at different places. As a rule of thumb, the frequency with which any single scene may be found is related to the importance of its role in the Church calendar and the significance of the symbolic burden that it carries. Besides the individual entries, there are entries for the most frequently encountered sets of people and things, such as the Twelve Apostles or the Instruments of the Passion.

The core area covered is that of Western European art. However, opportunities for travel in Eastern Europe and expanded contact with the art of the Orthodox Churches mean that more and more Westerners are being brought into contact with an artistic tradition that is both alien and yet profoundly related to the Western one. Basic information has therefore been provided in the text and in the artwork section to help the Western visitor to 'read' the decorative programme of an Orthodox church and to recognize the most important figures on the iconostasis (the screen that separates the sanctuary from the main body of the church). Where relevant, attention is drawn to significant differences in the way that the two traditions depict major events and figures, for instance the central event of the Resurrection.

The iconographic traditions of Eastern Christendom, anchored in the liturgy and the Church calendar, have remained extraordinarily stable over time; the late 16th-/ early 17th-century Russian pattern-book connected with the icon painters of the Stroganov tradition and the early 18th-century *Painter's Manual* by the monk Dionysius of Fourna embody formulae that can be traced back to the late Byzantine era. Some traditions – though few icons – even survive from the period before the great upheaval and destruction of the Iconoclast controversy, which covered the period from the mid-8th century until 843.

In the West too the artistic pursuit of startling originality and individuality is a Romantic or post-Romantic development; prior to this, artists painted – and patrons expected – images that were recognizably within tried and tested parameters. In the case of the facial features of some of the best-known participants in the Christian story, this meant a tradition that reaches back to the earliest period: a portrait of St Peter on a 4th-century Roman sarcophagus does not differ substantially from the way he is depicted throughout the whole span of Christian art, whether in the Orthodox, Coptic or Roman Catholic traditions.

THE DICTIONARY

A

Aaron The elder brother and spokesman of *Moses. During the events that led up to the Israelites' Exodus from Egypt (Exodus chs 7–12), Aaron and Moses together confronted Pharaoh and the Egyptian magicians, using Aaron's rod to perform wonders and bring down plagues upon the Egyptians.

Because he was the high priest of the Israelites during their subsequent wanderings in the desert, medieval and Renaissance artists often depicted Aaron in the vestments of a contemporary priest (or, even more incongruously, the tiara of a pope) and holding a *censer. He appears in this guise in the dramatic scene in which he defeats the challenge mounted against him by Korah, Dathan and Abiram (Numbers 16). When they attempted to usurp his position the earth opened and swallowed them up, and a plague struck down their adherents.

The immediate sequel to this episode was the settling of the question as to which of the twelve tribes of Israel should have precedence in religious matters. God told Moses to get the leader of each tribe to bring a rod to the altar, with his name written upon it; 'And it shall come to pass, that the man's rod, whom I shall choose, shall blossom' (Numbers 17:5). Next day the rod of Aaron, representing the tribe of Levi, was found to have budded and produced both blossom and almonds. The apocryphal gospel story of the selection of *Joseph as the husband of the Virgin Mary is based on this account of Aaron's rod. Both Joseph and Aaron therefore often appear holding a flowering staff. *See also* Golden Calf.

Abel *see* Cain and Abel.

Abraham Jewish patriarch, whose life is chronicled in Genesis (chs 12–25). In art Abraham is shown as an old man, as God did not command him to leave his home in Haran to seek the land of Canaan until he was seventy-five years old (Genesis 12:4). The incidents in his life that most attracted artists were his reception of the three angels (or men) in the plains of Mamre (*see* Philoxenia; Trinity) and his intended sacrifice of *Isaac.

Acacius, St (Acatius) An early martyr of unknown date, supposedly the leader of 10,000 Christians crucified by a pagan army on Mount Ararat in Armenia. His cult, apparently brought back from the Near East by returning crusaders, was particularly popular in Switzerland and Germany. He may wear a *crown of thorns. *See also under* Fourteen Holy Helpers.

Accidie (*or* Sloth) One of the *Seven Deadly Sins.

acheiropoietos (Greek, 'made without hands') In the Orthodox Churches, usually an icon of Christ showing the head, halo and part of the neck only. According to a Byzantine tradition dating back to the 6th century, the original of this icon type was the Mandylion, a piece of linen which Jesus pressed to his face, leaving his likeness on the cloth. The facial features and beard of this icon type were therefore considered authentic and became the basis of all medieval icons of Christ (*compare* Pantocrator).

Jesus gave the Mandylion to the envoy of King Abgar of Edessa, who had asked Jesus to come and cure the king of a serious illness. In 944 it was brought to Constantinople, and thereafter the icon type of the Saviour *acheiropoietos* became widespread, with some particularly famous 12th-century examples in Russia. The Edessa Mandylion itself may have been purchased by King Louis IX of France in 1247 and destroyed in the sack of the Ste Chapelle in the French Revolution. The earliest known surviving copy is a 10th-century icon at St Catherine's monastery, Sinai. In the West a comparable image was developed as the veronica (*see under* Veronica, St).

Another *acheiropoietos* mentioned in early writers is the impression of Jesus' body on the pillar or column to which he was tied to be scourged before the Crucifixion. *Acheiropoieta* of the Virgin Mary are also known to have existed.

Adam and Eve The first man and first woman, occupants of the Garden of *Eden until their fatal disobedience (*see* Fall of Man). There are two different accounts of the creation of Adam and Eve in the Bible (Genesis 1:26–8, 2:6–7, 21–3); artists and writers have drawn on elements from both, especially their innocent nakedness before the Fall (contrasted with their attempts afterwards to hide their nudity) and their dominion over the other creatures. The light work to which Adam was originally assigned by God – that of tending the Garden of Eden – contrasts with pictures of Adam laboriously digging and Eve spinning and child-minding after their expulsion from the garden, an allegory of the condition of fallen man.

Christ is often referred to in Christian writing as the second Adam since he came to save the world from the sin that was introduced into it as the consequence of the first Adam's fault. The Virgin Mary is likewise sometimes alluded to as the second Eve. This notion underlies the not uncommon placement of a scene of the Fall of Man next to one of the Annunciation or Nativity to convey the idea that the sin of the first Eve was cancelled out by the sinlessness of the second. *See also* Harrowing of Hell.

adder The adder sometimes symbolizes the hardened sinner who will not listen to the Word of God. The image comes from the Psalms: 'the deaf adder that stoppeth her ear; Which will not harken to the voice of charmers, charming never so wisely' (58:4–5).

The serpent in the Garden of Eden very often appears in an adder-like guise to express the treacherous malevolence of *Satan, and, more generally, the adder was seen as the symbol of evil. Hence the words of the psalm, 'Thou shalt tread upon the lion and the adder' (91:13), were interpreted as foretelling Christ's victory over the powers of death and hell. An early 6th-century mosaic in the archbishop's chapel at Ravenna shows Christ literally trampling the lion and adder underfoot. *See also under* snake.

Ad majorem dei gloriam (Latin, 'to the greater glory of God') When inscribed on a book held by a monk in a black habit, the identifying attribute of St *Ignatius of Loyola.

Adoration of the Lamb The glorification of Christ in heaven in the shape of a lamb (*see also* Lamb of God). This representation of the glorified and triumphant Lamb 'having seven horns and seven eyes' draws on the imagery of the book of Revelation (5:6–14). The Lamb, standing on the altar with a chalice and surrounded by adoring angels, is the central image in the lower central panel of the Ghent altarpiece, the polyptych painted by Jan and Hubert van Eyck for the cathedral of St Bavo, Ghent, in 1432.

Adoration of the Magi *see under* Three Magi.

Adoration of the Name of Jesus *see under* IHS.

Adoration of the Shepherds A sub-genre of *Nativity scene that became popular only in the later Middle Ages. Luke's gospel (2:8–20) is the only one that tells of how an angel (usually identified with *Gabriel) announced the birth of Christ to *shepherds in the fields and how they hastened to Bethlehem to see the new-born child. No mention is made of their number or of their bringing gifts, but three are often shown (thus balancing the *Three Magi) and a bound sheep or lamb (alluding to Christ's future sacrificial role) is generally prominent among their offerings, as in *Nativities* by the 17th-century Spanish painters Josef de Ribera (Spagnoletto) and Zurbarán.

The Annunciation to the Shepherds in the fields is sometimes shown in the background of these Adorations or more rarely as an independent scene. As a background to Nativities, the Annunciation to the Shepherds is a much older subject than the Adoration of the Shepherds, appearing for instance in this way in the Nativity mosaic of a Martorana at Palermo (mid-12th century).

Adoration of the Virgin A sub-genre of *Nativity scene, that concentrates on the Virgin kneeling in adoration beside the new-born Christ who lies in a radiant glow of light. The supernatural light surrounding the Child is mentioned in the 2nd-century apocryphal *Gospel of James (Protevangelium)*, but the kneeling Virgin derives from the account of a vision seen by St *Bridget of Sweden.

Adrian, St (died ?304) Martyr. There is some confusion in the details of his story, but Adrian was apparently a Roman officer at Nicomedia (modern Izmit) in Asia Minor, where there was a thriving Christian community. During a persecution there he was so inspired by the courage of some Christians in the face of torture and imminent death that he professed their belief. He was himself imprisoned, beaten and sentenced to death. His wife, Natalia, was a Christian. She visited him in prison disguised as a boy, arranged for his secret instruction in the Christian faith and witnessed his execution. His hands and feet were cut off on an anvil and his body was burned, but Natalia retrieved his ashes and one of his hands, which became revered relics.

Adrian is shown in art as a Roman soldier, sometimes together with Natalia. He is particularly frequent in the art of northern France, Germany and Flanders, being honoured there as the patron saint of soldiers, rather as St *Sebastian is in the Mediterranean lands. His emblem is the anvil. Natalia, whose steadfastness earned her the title of martyr even though she herself did not suffer actual martyrdom, shares a feast day with Adrian (26 August) in the Orthodox Church.

Aegidius, St *see* Giles, St.

Agatha, St (?3rd century) Sicilian virgin martyr. The highly imaginative legend of her martyrdom tells how she suffered many torments, including having her *breasts cut off, for refusing to repudiate her faith. She eventually died as a result of her sufferings.

The cult of St Agatha was widespread in Italy and elsewhere, and she is a patron saint of Malta; however, only four ancient churches were dedicated to her in England. She was thought to be able to protect her devotees from earthquakes, volcanic eruptions and fire (*see under* veil), so is sometimes depicted holding a burning building.

Agnes, St (early 4th century) Roman virgin martyr. Although very young (about twelve or thirteen), she considered herself betrothed to Christ and so resisted all attempts to compel her to marry; she was eventually put to death by being stabbed through the throat.

Shortly after her execution a basilica (Sant'Agnese fuori le Mura) was erected in Rome over the catacombs where she was buried. St *Ambrose was one of several eminent Christian writers and near-contemporaries who spoke in praise of her dedication and steadfastness. From Rome, where she was honoured as a patron saint, her cult later spread all over Europe. She is the patron saint of virgins and the betrothed, and there was a popular superstition that a girl could see a vision of the man she was to marry if she carried out certain rituals before she retired to sleep on St Agnes' eve (20 January), as in Keats' poem *The Eve of St Agnes*.

From as early as the 6th century (in the mosaics of Sant'Apollinare Nuovo, Ravenna) Agnes' emblem has been a lamb. This is an allusion both to her youthful age when she was martyred and also, punningly, to the similarity of her name to the Latin word for lamb, *agnus*.

Agnus Dei *see* Lamb of God.

Agony in the Garden *see under* Gethsemane, Garden of.

alb A white ankle-length garment with close-fitting sleeves, worn by priests at the celebration of the Eucharist. The colour signifies the purity required of the celebrant.

Alban, St (died *c*. ?209) The first British martyr. He was executed at Verulamium (now St Albans, Hertfordshire). A Romano-British soldier who sheltered a Christian priest during a persecution and was converted by him, Alban exchanged clothes with the priest, enabling the fugitive to escape. He was subsequently arrested, tortured and condemned to death.

The Venerable Bede (who dated Alban's martydom to the early 4th century) gives a detailed account of the miraculous happenings that accompanied Alban's death, including the dropping out of the eyes of the man who delivered the fatal blow. Alban's shrine was visited (429) by St *Germanus of Auxerre, who took some dust from it as a relic; thus the cult of St Alban came to extend to certain areas of France, as well as all over England. In East Anglian churches Alban is sometimes depicted along with the other regional saint, *Edmund.

Aldhelm, St (639–709) English churchman and writer. He was abbot of Malmesbury from the mid-670s and founded a number of churches. He became the first bishop of Sherborne in 705. He was a prolific and admired writer in both Anglo-Saxon and Latin, though his poetry in the former language has not survived. One story associated with him is that his pastoral *staff burst into leaf one day when he was preaching. He was buried at Malmesbury where a 10th-century tomb depicts scenes from his life. He is sometimes confused with the better-known St *Alban.

Alexis, St (died *c*. 430) Roman patrician who became a beggar and was known as 'the man of God'. His legend, which was extremely popular all over Europe, including the Slav lands, in the Middle Ages, is probably an invention based on elements in the lives of other holy men, and it is doubtful whether a genuine Alexis ever existed. In outline, the story tells how he renounced his wife on their wedding day and all his worldly rank and wealth to become a poor pilgrim who returned to live incognito as a beggar in his father's house for seventeen years. After his death

his identity was revealed by a paper found in his hands.

Alexis is shown in art in the short and ragged robe of a beggar, with unkempt hair and beard. He is commemorated in ecclesiastical calendars of both East (17 March) and West (17 July), and a part of the staircase under which he lived in his father's house is preserved in the church of Sant'Alessio, Rome. Romanesque wall paintings (*c.* 1100) of his story survive in San Clemente, Rome.

All Hallows The older English form of *All Saints.

All Saints All the blessed in heaven; the 'great multitude, which no man could number, of all nations, and kindreds, and peoples, and tongues, [which] stood before the throne of the Lamb, clothed in white robes, and palms in their hands' (Revelation 7:9). Depictions of this throng, which include unknown as well as named and formally canonized saints, formed part of the great altarpiece subjects like the *Adoration of the Lamb and the *Last Judgement.

All Saints is the second most popular church dedication in England, with over twelve hundred and fifty pre-Reformation dedications. On 1 November 731 Pope Gregory III consecrated a chapel in Rome with this dedication, after which the commemoration of all Christian saints, named and anonymous, became associated with that date in the Western Church. In the Eastern Church the observance is kept on the first Sunday after Pentecost.

All Souls The festival of the Church celebrated since the 10th century on the day following *All Saints. Unlike All Saints, however, it was not a popular name for a church in England, only a tiny handful of pre-Reformation dedications being known. All Souls College in Oxford, founded in 1438, is so called because its founder, Archbishop Henry Chichele, wished its members to pray for the souls of all the faithful departed, but in particular those who had fought in the recent French wars of Henry V.

Alpha and Omega The first and last letters of the Greek alphabet (A;Ω or ω), symbolizing the eternity of God: 'I am Alpha and Omega, the beginning and the ending, saith the Lord, which is, and which was, and which is to come' (Revelation 1:8). The phrase is also used with reference to Christ (Revelation 1:11). Alpha and omega may be painted behind the head or in the halo of God the Father or God the Son or on the book that they hold. The letters are frequently seen on Byzantine icons and mosaics of the *Pantocrator.

Alphege, St (954–1012) English bishop and martyr. He became archbishop of Canterbury (1005) but was captured by the Danes, who at that time had overrun much of England. They held him to ransom, but when Alphege forbade any money to be paid, his frustrated captors battered him to death with ox bones after a drunken feast.

Ambrose, St (339–97) Bishop of Milan from 374. He is one of the *Four Latin Doctors of the Church. Ambrose had a legal training and enjoyed a distinguished secular career before the people of Milan chose him by popular acclaim as their bishop, even though he had not yet even been baptized. He soon became immensely respected in his new role both as spiritual leader (he was an inspiration to St *Augustine at the turning point of Augustine's life) and political adviser. In art he appears in the regalia of a bishop, sometimes carrying an open *book, occasionally with a *scourge.

ampulla (Latin) A small vessel of baked clay, glass or metal, used to contain and transport liquids. Although emblematic of

pilgrimage in general, ampullae were particularly associated in England with the pilgrimage to Canterbury. Within a very short time after the murder of *Thomas Becket in the cathedral there (1170), pilgrims were using little metal containers, often stamped with a scene of Thomas's martyrdom, to bring home the shrine's miracle-working water, which, it was believed, had been tinged with the martyr's blood.

Anargyroi (Greek, literally 'the silverless ones') The title under which the physicians SS *Cosmas, Damian and *Panteleimon are often known in the Eastern Church, because they refused to accept money for their cures.

Anastasis see under Harrowing of Hell.

anchor The emblem of Hope and of several saints with seafaring connections. Hope, one of the *Three Theological Virtues, is shown as a woman leaning on an anchor, or with the anchor at her feet.

An anchor is also the frequent emblem of St *Nicholas of Myra, in his role as patron saint of sailors, and of St *Clement of Rome, who was drowned by being thrown into the sea with an anchor round his neck.

Andrew, St (died *c.* 60) Apostle and martyr. In the gospels he is named as the brother of Simon Peter, and, according to John's account (1:35–42), it was he who first recognized Jesus as the Messiah and brought Peter to him. An apocryphal gospel (3rd century), lost in its full form but known from summaries, gave an account of his missionary journeys, ending in his crucifixion at Patras in the Peloponnese (southwestern Greece). His weird and wonderful adventures at Wrondon, the City of Dogs, as narrated by a yarn-spinner called Charinus (recorded in glass at Greystoke, Cumbria), doubtless helped to keep his name in the medieval public eye, although he also had more solid claims to attention as the first-called of the disciples and Peter's brother.

As a fisherman, Andrew is sometimes shown in art holding a *fishing net but a more familiar symbol is the saltire (X-shaped) *cross. Early depictions of him show him with a Latin cross (for example, in the mid-12th-century mosaics at Cefalù, Sicily), the saltire cross only becoming commonly associated with his legend in the 14th century. A tradition dating from at least as early as the 6th century makes him grey-haired like Peter, but with bushier, more unruly locks, as in the mosaic portrait of him in the archiepiscopal chapel of San Andreas at Ravenna. Although Peter's opposite number in group portraits of the apostles is usually but unhistorically St *Paul, Andrew occasionally appears in that role, for instance, in the Pentecost mosaic at Monreale, Sicily.

The cult of St Andrew spread rapidly in the early Middle Ages. The modern church dedicated to him in Patras is supposedly on the site of his crucifixion and houses a gold reliquary containing the apostle's skull; this reliquary was removed to St Peter's, Rome, in 1460, when the Turks overran the Peloponnese, and was returned only in 1964.

A very old tradition concerns the supposed translation of some of his relics from Greece to Scotland by a bishop of Patras called Regulus (or Rule) in the 4th century. This bishop was instructed by an angel to take the relics and travel northwest until the angel told him to stop. His journey took him to a place in Scotland, later the town of St Andrews, in Fife. Andrew was subsequently adopted as the patron saint of Scotland; hence the saltire cross on the Scottish national flag.

Over six hundred and thirty ancient churches were dedicated to Andrew in England, putting him at number five in the

frequency list of dedicatees. His popularity in Britain originated partly in the historical accident of St Augustine of Canterbury having been prior of St Andrew's monastery in Rome before he was sent to evangelize the English and the consequent dedication to St Andrew of two important early churches (Rochester Cathedral and Hexham Abbey). In addition to his association with Greece, Andrew is also one of the patrons of Russia. His feast day in both East and West is 30 November.

angels In Jewish and Christian tradition, spiritual beings whose role is to serve and worship God. They are usually depicted in human form and winged.

The artists of the catacombs visualized angels as young men with neither wings nor haloes, but these two elements gradually became standard in the course of the 5th century. The angels flanking Christ in the 6th-century apse mosaic of San Vitale, Ravenna, are an early example of the accepted modern iconography: wings, haloes, white robes, a thin band worn round the head and wavy hair. Angels' wings, one or more pairs of which may be present, are usually bird-like and feathered. Some medieval artists also showed angels' bodies as being completely covered with feathers.

The word 'angel' derives from the Greek word for 'messenger', and their particular function was to act as intermediaries between God and mankind. Some Christian authorities also fostered the belief that guardian angels were assigned to every individual at birth and were responsible for protecting their charges against physical and spiritual harm and for presenting their prayers before the throne of God. (This belief had Jewish origins: in the apocryphal Book of Tobit the archangel Raphael was appointed the special guardian of the young Tobias.)

The term 'angel' is also used more specifically to denote the lowest rank in the traditional division of heavenly creatures into nine 'choirs' or orders (*seraphim, *cherubim, *thrones, *virtues, *dominations, *powers, *principalities, * archangels, angels). This classification was principally the work of the 6th-century philosopher known as (Pseudo-) Dionysius the Areopagite, and it was very widely known and followed in the Middle Ages.

The nine angelic orders occur in a number of places in medieval stained glass, mostly as small, subordinate figures; more unusual are the large figures in the main lights of some of the 15th-century windows at Malvern. As might be expected, incomplete sets are more common than complete ones. In some of the original sets, however, the nine orders were made up to ten, with one duplicated, if the requirements of architectural symmetry necessitated an even number. In the course of time some conventions about their depiction grew up, but these were not rigidly applied and a certain amount of scope was left for the imagination of individual artists. In these sets, angels are sometimes differentiated from the other orders by the wearing of a *coif.

Angels in art may fulfil a purely subsidiary role as 'extras', the embodiments of the joys and beauty of heaven. One angelic speciality is music-making and angel musicians often accompany joyful scenes such as the Annunciation or Nativity. Attendant angels swinging censers also frequent such compositions.

In other cases the biblical narrative provides the rationale for their presence, as in Jacob's dream: 'behold a ladder set up on the earth, and the top of it reached to heaven: and behold the angels of God ascending and descending on it' (Genesis 28:12). Jacob wrestling with a man (Genesis 32:24) by night was also interpreted as an angelic visitation, and so too were the three men who visited Abraham in the plains of Mamre (Genesis 18:1–22) (*but see under* Philoxenia; Trinity). Individual

angels are depicted executing God's commands in such scenes as the Sacrifice of Isaac, when an angel intervenes to prevent Abraham killing his son (Genesis 22:11); or they may act as God's spokesmen, as when an angel saves Hagar from despair in the desert (21:14–19).

Angels also occur in the New Testament narrative, ministering to Christ during his earthly life, notably after his baptism and the *Temptation in the Wilderness (Matthew 4:11). Many medieval treatments of the *Crucifixion include angels holding chalices to catch the blood gushing from the wounds of the dying Saviour. An angel may be present to receive the soul of the repentant thief (*see also under* souls).

In the context of the *Four Evangelists and their symbols, a winged *man (thus indistinguishable from an angel) represents St *Matthew. *John the Baptist may also be shown winged like an angel.

Anger One of the *Seven Deadly Sins.

animals Prominent in the legends of many hermits (*see for example* St Giles), whose saintliness is validated by the absence of either fear or ferocity in the wild animals with which they came in contact. Beasts accompanying St *Blaise recall the fact that his feats of healing extended beyond human patients.

Animals are particularly conspicuous in the medieval legends of Celtic saints. Thus, for example, Gobnet (Irish, 5th century) was an accomplished bee-keeper; Cieran of Clonmacnoise and *Bridget (Irish, early 6th century) kept cows; wild animals helped Ciaran of Saighir (Irish, 5th or 6th century) and his monks to build huts; Ronan (Scottish, 7th century) was transported to the island of North Rona by a whale; Gwinear (Cornish, date unknown) struck springs of water from the ground for himself, his horse and his hound; Corentin (Cornish, later a bishop in Brittany, date unknown) was nourished

by a *fish; the blind abbot Hervé (Breton, 6th century) was assisted by a wolf.

In biblical scenes animals feature prominently in the Garden of Eden; God creating the animals (Genesis 1:24–5) and Adam naming them (Genesis 2:19) are both standard ingredients of medieval picture cycles of the Creation and Fall of Man. The harmony between the different species, predator and prey, illustrates the paradisal state of Eden before the Fall. The entry of the animals into Noah's *ark was another popular subject with medieval artists. *See also* deer; sheep; stag; *etc.*

Anne, St (Anna) (1st century) Mother of the Virgin Mary. All the accounts of Anne and her husband Joachim – even their names – derive from the 2nd-century apocryphal *Gospel of James* (*Protevangelium*).

Anne's cult expanded from the 12th century onwards, in the wake of the increasing veneration of the Virgin Mary; France (especially Brittany), England and Ireland became the particular centres of her cult, followed later by Canada. In England over forty ancient churches were dedicated to her; she was patroness of religious guilds and there exist several Middle English versions of her life. Anne and Joachim take their place alongside the authentic gospel characters in one of the most moving episodes in the Coventry cycle of mystery plays, which depicts the despair and humiliation of the childless couple and their joy at the miraculous birth of a daughter. (The story of the Virgin Mary's birth and infancy has strong similarities with the Old Testament story of Samuel, who was also born to an aged mother and dedicated to the service of the Temple in Jerusalem.)

In art Anne is a matronly figure, often wearing a mantle of green (the colour of immortality). One scene that was popular with medieval artists was her meeting with Joachim before the Golden Gate of Jeru-

salem after the angelic vision announcing the birth of the Virgin. The subject is movingly treated by Giotto in his frescoes in the Arena Chapel, Padua; at the other end of the scale of artistic sophistication is its appearance in one of the carved stone roundels in the tympanum of the west door of the church at Higham Ferrers, Northamptonshire. Numerous examples also exist in stained glass. Its prominence may perhaps be explained by the idea – frowned upon by some sober theologians – that this meeting represented the moment of conception of the Virgin (the *Immaculate Conception). Eastern artists represent the conception of the Virgin as the separate appearances of the angel to Anne in a garden and to Joachim on a mountainside. Both Eastern and Western treatments can point to the *Protevangelium* as authority.

A popular subject, particularly in England, but found also in France, was St Anne teaching the Virgin to read. It is depicted, for instance, in stained glass (*c.* 1330–40) in the church of St Nicholas at Stanford, Northamptonshire, and in a wall-painting in the church at Croughton in the same country. A sculpture group showing the three generations – St Anne, Virgin Mary and Christ Child – was also widespread in the later Middle Ages, particularly in the Netherlands and Germany; painted treatments of the theme include a highly formal one by Masaccio (Uffizi, Florence) and an informal one by Leonardo da Vinci (Louvre, Paris). *See also* Holy Family.

Annunciation The announcement made by the archangel *Gabriel to the Virgin Mary that she was to become the mother of Jesus (Luke 1:26–38). It is one of the twelve great feasts of the Orthodox Church, celebrated in both East and West on 25 March. One of the most popular subjects for artists, it appears in many media, from a simple roundel in stained glass to elaborate compositions by the Renaissance masters. It was frequently adopted as an altarpiece, since in that position it reminded the congregation of the mystery of the Incarnation (God becoming man) which paralleled the mystery of Transubstantiation (the transformation of the bread and wine into Christ's body and blood) taking place on the altar below.

The basic elements of the scene are the angel (shown as a winged youth, often holding a white lily) and the Virgin herself, who may be praying or reading indoors or seated in an enclosed *garden. A variant favoured in Byzantine art is to show the Virgin busy with a spindle and distaff; this follows the story in the apocryphal *Gospel of James* (*Protevangelium*), which describes how she was one of the maidens selected to spin thread for temple vestments. Occasionally, also following the *Protevangelium*, the Annunciation is shown taking place beside a *well, to which the Virgin has come to draw water, as in the late 12th-century fresco in the church of the Anargyroi, Kastoria (northern Greece).

Artists sometimes introduced elements of church architecture (altar canopy, Gothic arches) or non-domestic furniture (laver, prie-dieu) to make clear the sanctity of the scene. The angel Gabriel may be dressed in the ecclesiastical robes appropriate to a *deacon at the celebration of the Mass.

Flowers associated with the Virgin are often present (*see* iris; violet). The white lily, if not held by the angel, stands in a prominently placed vase. A late medieval variant has a small figure of the crucified Christ set in among the lilies, thus linking the beginning and the end of his earthly life; this motif, called the Lily Crucifixion, was apparently unique to English artists. Less often, as in Simone Martini's *Annunciation* (painted for Siena Cathedral in 1333), the angel holds an *olive branch.

In the more elaborate compositions, the Holy Spirit in the form of a *dove descends

towards the Virgin or hovers over her head, and God the Father may be shown looking down from heaven. Other embellishments, found especially in northern European art, may be scrolls with Latin inscriptions based on Luke's gospel narrative: Gabriel's reads AVE GRATIA PLENA DOMINUS TECUM (Hail, thou that art highly favoured, the Lord is with thee) or simply AVE MARIA (Hail Mary); Mary's ECCE ANCILLA DOMINI (Behold the handmaid of the Lord). If the Virgin is reading, the words in the book may also be visible; they are commonly Isaiah's prophecy (7:14): VIRGO CONCIPIET . . . (a virgin shall conceive . . .).

Annunciation to the Shepherds *see under* Adoration of the Shepherds.

Ansanus, St (died 303?) Martyr; patron saint of Siena. He was born into a noble Roman family and secretly baptized by his nurse, Maxima. When he openly proclaimed his faith he was scourged on the orders of the emperor Diocletian and sent to Siena. There he made many converts, and eventually suffered martyrdom by beheading. His emblems are a *banner with a red cross and a cup or a fountain as a token of the baptisms that resulted from his missionary activities. He appears with other Sienese saints in Simone Martini's *Maestà* (1315) in the Palazzo Pubblico (town hall) of Siena.

Antony of Egypt, St (died 356) One of the founders of Christian monasticism. Much of St Antony's life was lived in solitude in the desert, where he underwent fantastic visions and temptations by devils, a subject that evoked bizarre flights of imagination from artists such as Teniers, Grünewald and Bosch. On account of his solitary life, he is sometimes referred to as St Antony the Hermit; he contests the honour of being the first Christian hermit with St *Paul the Hermit. His alternative

name of St Antony Abbot alludes to his role in the establishment of a monastic community. He is almost invariably depicted in Orthodox, Coptic and Western Christian art as an elderly monk with a long white beard, wearing a black habit with the hood drawn over his head. The monastery of St Antony in the Eastern Desert, in the area where he spent the last years of his life, was founded within a decade of his death.

Antony's emblems in Western art are a *pig and a *bell. In the art of both East and West he very often carries a crutch or staff in the shape of an elongated letter T. The Order of the Hospitallers of St Antony was founded at the beginning of the 12th century and spread over much of Western Europe. Its members wore black robes with a blue tau *cross and rang hand-bells in the street to attract charity. Their work was particularly connected with sufferers from ergotism (a painful condition of the skin which may lead to convulsions or gangrene and which is caused by eating cereals contaminated with the ergot fungus). Ergotism is therefore often known as St Antony's Fire. The Order's pigs were allowed to roam at large, hence St Antony's medieval role as the patron of swineherds.

Antony of Padua, St (1195–1231) Portuguese-born Franciscan friar, honoured particularly for his great powers as a preacher. He is even said to have preached to *fish. In art he is depicted wearing the Franciscan habit, carrying the *Christ Child and a *book or a book and *lily. Scenes from his life popular with artists were his distribution of food to the poor (much later institutionalized in the charitable fund known as St Antony's Bread) and his vision of the Holy Family. His assistance is sought to find things that have been lost, and his shrine at Padua became famous for the saint's wonder-working powers.

anvil As part of the equipment of a black-smith's shop, it is associated with an incident in the legend of St *Eloi (*see under* horseshoe), of whom it is sometimes the attribute. The anvil of St *Adrian was a famous relic at the convent of St Adrian at Grammont, Flanders.

Apollonia, St (died 249) Deaconess and martyr. She was attacked during an anti-Christian riot in Alexandria in Egypt by a mob who knocked out all her teeth and then threatened to burn her alive. Apollonia forestalled them by walking voluntarily into the flames. Her attribute is a pair of pincers or tongs gripping a tooth, and her aid is invoked against toothache.

apostles *see* Twelve Apostles.

apple By ancient Christian tradition, the fruit of the tree of the knowledge of good and evil, eaten by Adam and Eve at the Fall (Genesis 3). When it appears in pictures of the Virgin and Child, often held in the infant's hand, it is a reminder of the purpose of Christ's Incarnation: to redeem the Fall. The words of a well-known medieval English carol explicitly link the two events: 'Ne hadde the appel také been / . . ./ Ne haddé never our Lady / A been hevene-queen.'

aquilegia *see* columbine.

archangels Spiritual beings ranking immediately above the *angels in the heavenly hierarchy. The angels named in the Bible (*Gabriel, *Michael, *Raphael) are given the status of archangels in Christian tradition. Gabriel is the angel of the *Annunciation, who also foretold the birth of St *John the Baptist (Luke 1:5–38). Michael is the captain of the hosts of heaven (Revelation 12:7). Raphael plays a prominent part in the apocryphal Book of Tobit. A fourth archangel, Uriel, appears in Jewish apocryphal writings. All four are

shown in the dome mosaic (mid-12th century) of La Martorana, Palermo, prostrating themselves in reverence around the seated figure of the *Pantocrator.

A picture by Botticini, painted about 1467, shows the three biblical archangels as three young men accompanying the boy Tobias on his journey: Michael in full armour with his sword drawn, Raphael leading Tobias by the hand and Gabriel holding the lily of the Annunciation. In the Eastern Church the archangels are referred to as 'taxiarchs', that is, 'leaders of the host (of heaven)'. In this role they are shown in armour and holding a *globe surmounted by a cross.

Ark of the Covenant The wooden chest, overlaid with gold, in which the stone tablets of the Ten Commandments, brought down by *Moses from Mount Sinai, were kept. It was the most precious religious object of the Jews from the time of the Exodus, travelling with them on their journey to the Promised Land. David, after he became king, installed it at Jerusalem (2 Samuel 6). It was eventually permanently housed in Solomon's temple at Jerusalem, in the Holy of Holies or the innermost sanctum, where it represented God, concealed from but present with his people.

Medieval Christian authorities, basing themselves on the description of the Ark given in Hebrews 9:1–5, interpreted it as representing Christ; St Thomas Aquinas, for instance, saw the gold overlay as symbolizing Christ's wisdom and charity. Other commentators saw the Ark of the Covenant as a symbol for the Virgin Mary, who contained within herself Christ, the New Law, as the Jewish Ark had contained the Old Law. The 9th-century mosaic of the Ark of the Covenant created by artists from the Ravenna school of mosaicists in the eastern apse of the church at Germigny-des-Prés, near Orléans, France, should be read as a symbolic

representation of the Virgin, as this is the position that a depiction of the Virgin would normally occupy in a church of this era.

Ark, Noah's The vessel built by Noah on God's command to save his family and representatives of all living creatures from the Flood (Genesis 6: 14–22). The Church Fathers (St Augustine of Hippo, Tertullian) saw Noah's Ark as an allegory of salvation, and identified it with the Church, the sole means by which all mankind is saved. This interpretation partly explains why Noah's Ark, or at least its superstructure, often appears in medieval Christian art to look more like a building than a seaworthy ship.

armour The equipment of the archangel Gabriel and numerous *soldier saints. It is also emblematic of warfaring Christians in general, the true soldiers of the Church Militant, whom St Paul exhorted: 'Put on the whole armour of God, that ye may be able to stand against the wiles of the devil' (Ephesians 6:11).

The type of armour depicted is usually that familiar to the artist from contemporary military practice, with little or no thought for historical accuracy. Thus the supposedly Roman soldiers in early 15th-century English alabaster panels of the *Resurrection are dressed in typical medieval armour. (In such cases the minutiae of the equipment may be of assistance in dating a sculpture.) The armour of the Roman or Byzantine soldier is frequently seen in icons of warrior saints in the Eastern Orthodox Church and also sometimes in the West (associated particularly with 3rd- and 4th-century martyrs such as SS *George, *Demetrius of Thessaloniki, *Maurice and *Victor). The plate armour of the *knight as equipment for these saints is a late medieval innovation, predominantly in the West. St George often appears in Roman armour in Eastern Orthodox icons and in the plate armour in Western medieval and Renaissance art.

arrow The emblem of SS *Christina, *Edmund, *Giles, *Sebastian, and *Theresa of Avila. Christina, Sebastian and Edmund were all shot to death with arrows. Christina was a virgin martyr of uncertain date and provenance, whose cult centred on Bolsena in Italy. The historical core of St Sebastian's legend is as shadowy as that of St Christina's, but his martyrdom was a popular subject with 15th-century Renaissance painters in that it offered them the opportunity to portray a male nude in an acceptable religious context. Edmund was a genuine historical personage, a 9th-century English king who was defeated in battle by marauding Danes and subsequently shot with arrows when he refused to renounce his faith or accept Danish overlordship. In art he usually appears crowned and holding an arrow, as for instance in the Wilton Diptych, in which he is shown as one of the patron saints of Richard II, presenting the young king to the Virgin and Child.

In the case of St Giles, the arrow is a reminder of the story involving the saint's pet deer, which one day became the quarry of the Visigothic king, Wamba, who was hunting in the forest near Giles' retreat. The king shot an arrow into the undergrowth through which the deer had fled and on riding up to his prey was astonished to discover Giles himself wounded with the arrow, the deer protected in his arms from the pursuing hounds.

An arrow, sometimes shown as trailing fire, is also the emblem of St Theresa of Avila. This arrow of divine love is depicted in the hand of the angel who stands over the swooning saint in the famous sculpture group made by Bernini in the 1640s for Sta Maria della Vittoria, Rome. The imagery of the arrow or lance was suggested by the highly emotive terms in which Theresa herself described her mystical experiences.

Ascension The taking up of Christ into heaven forty days after the *Resurrection. The event took place on the Mount of Olives and was witnessed by the apostles and, according to an ancient tradition, the Virgin Mary. Artistic treatment of the Ascension focuses on two details in Acts 1:9–10: 'a cloud received him out of their sight . . . while they looked steadfastly toward heaven as he went up.' In many medieval representations Christ is indicated simply by a pair of feet disappearing skywards into a cloud. The presence of the Virgin Mary and the attention of the apostles focused on the ascending Lord differentiate Ascension scenes from the superficially similar mountain-top event of the *Transfiguration.

The Ascension is one of the twelve great feasts of the Orthodox Church. As a scene it lends itself particularly well to being placed in the dome of a church, with Christ in glory in the centre and the apostles around the drum of the dome, gazing upwards, with the Virgin Mary and angels. The words of the angels to the apostles appear as the inscription on the 9th-century mosaic in the dome of Hagia Sophia, Thessaloniki: 'Ye men of Galilee, why stand ye gazing up into heaven? this same Jesus, which is taken up from you into heaven, shall so come in like manner as ye have seen him go into heaven' (Acts 1:11). A very similar composition is found in the late 12th-century mosaic in the central dome of St Mark's Cathedral, Venice.

aspergillum A brush used for sprinkling holy water, particularly for exorcizing evil spirits. *See also* aspersorium.

aspersorium A vessel used for sprinkling holy water. It is one of the liturgical objects seen in the hands of attendant angels, and it, or an *aspergillum, occasionally appears as an attribute of certain saints such as *Martha in their role as vanquishers of evil spirits.

ass A symbol of humility and patience. Christ rode on an ass when he entered Jerusalem for the last time before his Passion (Luke 19:28–40; John 12:12–16), in fulfilment of the Messianic prophecy in Zechariah 9:9: 'Rejoice greatly, O daughter of Zion . . . behold, thy King cometh unto thee: he is just, and having salvation; lowly, and riding upon an ass, and upon a colt the foal of an ass.'

In the episode of Balaam's ass (Numbers 22:22–35), the animal, unjustly beaten by Balaam for trying to avoid an angel invisible to its rider, is granted the power of speech by God and rebukes Balaam for his harshness.

An ass is also the emblem of St *Germanus of Auxerre. A story told in the 13th-century compilation of saints' lives, *The Golden Legend*, relates how Germanus, Bishop of Auxerre, then part of the Roman province of Gaul, went to Ravenna to plead the cause of his fellow countrymen before the Roman emperor. While he was there the emperor's wife Placidia invited him to dine with her. Germanus rode from his lodgings to the palace upon an ass, but while he was at dinner the ass died. The empress, learning of this, gave the bishop a fine horse, but Germanus declined the gift, saying he would return to his inn by the same means as he had come. When he came out of the palace the dead ass jumped to its feet and carried the holy man home as if nothing had happened. *See also* ox and ass.

Assumption The bodily taking up into heaven of the Virgin Mary (*see also* Dormition). The usual way of showing this was to have the Virgin carried upwards by angels, while the apostles, gathered to mourn her, gaze after her in amazement or stare at her empty tomb. Roses or lilies, flowers particularly associated with the Virgin, sometimes fill the sarcophagus in which she had been lying. Some late medieval versions of the Assumption, such

as that by the 15th-century Sienese painter Matteo di Giovanni (National Gallery, London), show the Virgin letting fall her *girdle, which is to be caught by doubting *Thomas.

The Coronation of the Virgin as Queen of Heaven, following her Assumption, is often depicted or implicit in the Assumption itself; thus in Titian's altarpiece for Sta Maria de' Frari, Venice, an angel is shown ready with the crown as the Virgin is borne upwards by putti. The simplest version of this subject, common in the 14th century, has just two figures: Christ and the Virgin. In this version she is seated before or beside him, head inclined to receive the crown that he places upon it and hands together in prayer. A more elaborate composition involves the Virgin in an attitude of prayer before a *Trinity consisting of the Father and the Son with the Holy Spirit in the form of a dove between them. The dove holds the apex of the Virgin's crown in its beak and the Father and Son simultaneously place it upon her head and bless her.

The Assumption and Coronation, whether as separate scenes or aspects of the same scene, are not part of the traditional iconography of the Virgin in the Orthodox tradition.

Athanasius, St (295–373) Bishop of Alexandria from 328 and one of the *Four Greek Doctors of the Church. The Athanasian Creed, a profession of faith formerly much used in the Western Church, was erroneously attributed to him. He is honoured in the Eastern Church as a vigorous and effective opponent of the heresy of Arianism.

Among the Four Greek Doctors Athanasius is conventionally shown as white-haired and balding, with a rather squared-off beard. Elsewhere he sometimes appears with St Cyril of Alexandria (378–444), who has a dark, pointed beard and wears the peaked bonnet associated with the patriarchate of Alexandria. (Athanasius of Alexandria should not be confused with St Athanasius of Athos (c. 930–c. 1001), who is shown dressed as a monk and with a double-pointed white beard.)

Audrey, St see Etheldreda, St.

Augustine of Canterbury, St (died c. 604) Italian-born missionary bishop who came to Britain in 597 to evangelize the Anglo-Saxons. He established his see at Canterbury, where the monastery of SS Peter and Paul was later renamed St Augustine's. See under building.

Augustine of Hippo, St (354–430) Bishop and theologian; one of the *Four Latin Doctors of the Church. He was born at Thagaste in the area of North Africa that is now Algeria. His mother, St Monica, instructed him in the Christian faith but it was not until he came under the influence of St *Ambrose while visiting Milan that he finally dedicated himself to the service of God. His *Confessions* tell the story of the events, inward and outward, that brought about this profound conversion. From 396 he was bishop of Hippo (modern Bône).

St Augustine wrote numerous books and treatises, including, right at the end of his life, *The City of God*; his writings, known and translated all over Europe, exerted an immense effect upon subsequent Christian thought. He frequently appears in art with the other Latin Doctors or in the guise of a *bishop, holding a pastoral *staff. Alternatively, he may be dressed in the habit of a monk. Some artists give him the attribute of a *heart of fire.

aureole see under halo.

Auxiliary Saints see Fourteen Holy Helpers.

Avarice One of the *Seven Deadly Sins.

axe The emblem of the apostle *Matthias. The man chosen by lot to take the place of the traitor Judas Iscariot (Acts 1:15–26), Matthias is sometimes confused in the early apocryphal writings and in art with St *Matthew, whose emblem is usually a *halberd. In northern Italy a saint who may appear with an axe in hand is St Proculus, who is particularly honoured at Bologna; unusually for the early martyrs, who generally died unresistingly, he killed a persecuting Roman official with an axe. *See also* battleaxe.

The detail of an axe lying underneath a tree, often to be seen in Orthodox icons of *John the Baptist, alludes to the Baptist's words to the Pharisees and Sadducees: 'And now also the axe is laid unto the root of the trees: therefore every tree which bringeth not forth good fruit is hewn down, and cast into the fire' (Matthew 3:10).

B

Babel, Tower of *see* Tower of Babel.

babies Associated with Charity (*see* Three Theological Virtues), who is often personified as a woman with one infant at her breast and others clinging to her.

balance *see* scales.

baldness *see under* hair.

ball A ball or globe of fire reportedly hovered over the head of St *Martin of Tours when he was saying Mass, and so sometimes appears as his emblem.

The pawnbroker's sign of three gold balls is the emblem of St *Nicholas of Myra. The association originated in the story that, under cover of darkness, he once threw three bags of gold into the window of a house as a dowry for the three daughters of a poor nobleman who lived there, thus enabling them to avoid prostitution and to make honourable marriages. The three round bags of gold became confused with three balls. *See also* globe.

bandage *see under* corpse.

banderol(e) *see* scroll.

banner A symbol of victory, associated with several of the martyrs. The best known of them is St *George, who is often shown with his banner of a red cross on a white ground; SS *Ansanus and *Ursula may display a banner of similar design.

In many depictions of the *Resurrection the Risen Christ steps from the tomb holding a banner with the cross or *chi-rho

on it, a token of his triumph over death. A banner with a cross is often held by the *Lamb of God.

Baptism of Christ The event described in the first three gospels (and implied in John 1:29–34) when Jesus went to the River Jordan to be baptized by *John the Baptist. At this moment 'the heaven was opened, And the Holy Ghost descended in a bodily shape like a dove upon him, and a voice came from heaven, which said, Thou art my beloved Son; in thee I am well pleased' (Luke 3:21–2). In the Eastern Church the Baptism of Christ is commemorated at *Epiphany and has more importance than it does in the West.

Besides the essential figures of Jesus and John, the *dove is usually shown and angel attendants hold Jesus' garments, while other candidates for baptism look on from the river bank. As well as naturalistic fish in the water, there are also sometimes tiny figures of a man and of a woman riding upon a fish, who both turn away from the divine spectacle. They are, respectively, personifications of the River Jordan and of the sea, embodying the statement from the Psalms: 'The sea saw it, and fled: Jordan was driven back' (Psalm 114:3). Early treatments of the scene show the Jordan as a pagan river god, with reeds around his head, a retinue of fishes about him and at his side an overturned water jar from which the stream is flowing.

Barbara, St A virgin martyr of unknown date and nationality. Her legend, written not less than three hundred years after her supposed death, nonetheless won her great

popularity in many countries. She may carry a *peacock feather but her usual emblem is the *tower in which she was shut up by her tyrannical pagan father. Enraged at her conversion to Christianity, he had her tortured and condemned to death. He was himself then struck dead by lightning. St Barbara is therefore invoked against lightning strikes and is the patroness of those whose work puts them in danger of sudden death through explosions, such as gunners, miners or firework-makers. She was also one of the *Fourteen Holy Helpers.

Barnabas, St (died ?61) Apostle and martyr. A Cypriot Jew, he accompanied *Paul on his first missionary journey. An unreliable account states that he was martyred at Salamis on Cyprus.

Bartholomew, St (1st century) Apostle and martyr. He is usually identified with the disciple called Nathanael in John 1:45–51. Nothing is known for certain of his missionary journeys nor of the date of his death, but there is a tradition – a favourite with artists – that he was flayed alive before being beheaded at Derbend by the Caspian Sea. The flaying *knife is his emblem and sometimes he also appears carrying his skin, as in Michelangelo's fresco of the Last Judgement in the Sistine Chapel. The cult of St Bartholomew was widespread, with numerous church dedications.

Basil (the Great), St (c. 330–79) Bishop and scholar; one of the *Three Holy Hierarchs and *Four Greek Doctors of the Church. He was born at Caesarea in Cappadocia (Asia Minor), and became bishop there in 370. His influence, both by his writings and his practical example, was very great and he laid down the principles of communal monastic life that still guide and inspire the monks and nuns of the Eastern Orthodox Churches. St *Benedict, founder of Western monasticism,

considered himself to be Basil's disciple, which helps to explain the esteem in which Basil continued to be held in the West, even after the split with Constantinople in 1054.

In Orthodox art Basil is shown as a bishop, distinguishable from the other Doctors by his long, dark, pointed beard.

basket If containing fruit and flowers, the emblem of St *Dorothy; if containing bread rolls, of St *Nicholas of Tolentino. The legend of St Dorothy describes her as one of the victims of the persecutions instigated by the Roman emperor Diocletian in the early 4th century, condemned to death for refusing to marry or to sacrifice to the pagan gods. As she was taken to the place of execution, a young lawyer called Theophilus jeeringly asked her to send him some fruit from the garden of paradise. Immediately before she was beheaded she prayed that the lawyer's request should be fulfilled and an angel appeared with a basket of apples and roses. Theophilus was converted and he too later died a martyr.

The Augustinian friar St Nicholas of Tolentino founded the charity known as 'St Nicholas' Bread', which was given to the sick and to women in labour. Paintings show him with the basket, from which he dispenses bread.

bath The subject of two stories popular with Renaissance artists: *David and Bathsheba and the apocryphal History of Susanna, who was spied upon by two elders as she bathed in her husband's garden.

Bathhild, St (died 680) Anglo-Saxon slave girl who married (649) the Frankish king Clovis II. She was regent for her young sons after the death of Clovis, but lost power in 665 and became a nun in the monastery of Chelles, which she had founded. Her cult was centred in northern

France, where she is shown in art as a nun wearing a crown and sometimes carrying her punning emblem of a ladder (French: *échelle*/Chelles).

battleaxe The emblem of St *Olaf of Norway. He was a renowned warrior in the best Viking traditions of pillage and piracy, but when he directed his zeal towards imposing Christianity by force upon his pagan subjects he lost his kingdom and eventually died in the battle to regain it.

bear The emblem of St *Vedast.

beard The style of a beard can in many cases be a clue to the identity of the wearer. There is a strong and very ancient tradition of depicting St *Peter with a short, wavy and rounded beard, grey or greying, with similar short-cropped hair. St *Paul is generally visualized as having a balding head and a rather more pointed beard. In Byzantine depictions of the *Twelve Apostles, *Philip and *Thomas are often identifiable by their beardlessness, while among the *Three Holy Hierarchs, St Basil the Great is particularly remarkable for his luxuriant dark beard. The immensely long white hair and beard of St *Onuphrius provided the saint's only clothing. The fictitious virgin martyr St *Wilgefortis miraculously grew a heavy beard to deter an unwanted suitor.

Christ is always shown bearded in medieval and later art on the authority of the *acheiropoietos* likeness. However, in the early Christian era, up until the 6th century, he was more often beardless, a concept based on the idealized representations of the young male in pagan antiquity.

Becket, St Thomas *see* Thomas Becket, St.

beehive *and/or* **bees** The emblem of SS *Ambrose and *Bernard of Clairvaux. St Ambrose, one of the *Four Latin Doctors of the Church, was characterized as 'doctor mellifluus' (the honeyed teacher) on account of the sweetness and persuasiveness of his prose style. In token of this future eloquence, it is said that a swarm of bees settled on him when he was an infant.

bell The attribute of SS *Antony of Egypt, Kevin and Winwaloe. A bell and *pig are attributes of St *Antony of Egypt; a small bell and the smallest pig in a litter were formerly known as a 'tantony bell' and a 'tantony pig' from a corrupted abbreviation of the saint's name. A pig with a bell round its neck accompanies St Antony in a Passion altarpiece painted for a fraternity (guild) in Tallinn, Estonia, by an anonymous Netherlandish artist in the early 16th century. More usually, the saint holds a small handbell.

Kevin (or Coemgen; d. 608) was founder and abbot of the monastery of Glendalough in Co. Wicklow, a centre for pilgrims from all over Ireland. He visited St Cieran of Clonmacnoise when Cieran was dying and was given the older saint's bell. St Winwaloe (*or* Winnol; French: Guénolé) was a 6th-century Breton abbot whose cult was known in southern England on account of both his monastery's connection with Cornish foundations and the translation of his relics to various English centres. At the sound of his bell fish would flock together to follow him.

Benedict, St (*c.* 480–*c.* 547) Italian monk whose *Rule* is the basis for monasticism in the Western Church. He founded the monastery of Monte Cassino (*c.* 529) and gained an immense reputation as a holy man and miracle-worker. Many legends have attached themselves to his name, including one in which the Devil appeared to him in the form of a raven and another in which he broke a cup containing poison by making the sign of the cross over it. In art he appears in a monk's habit with pastoral staff and book in reference to his role as

founder of the Benedictine Order and a great spiritual instructor.

Bernard of Clairvaux, St (*c.* 1090–1153) Cistercian monk responsible for the reform, prestige and expansion of the Cistercian Order in the 12th century. Born near Dijon in Burgundy, he became a monk (1113) at Cîteaux before being promoted to the abbacy of the new monastery at Clairvaux. Under his regime, Clairvaux founded many daughter houses in France, England and elsewhere. The *beehive, which he shares as an emblem with St *Ambrose, signifies his eloquence.

Bernardino of Siena, St (1380–1444) Franciscan friar renowned as a preacher. *See under* IHS.

birds The audience in the ever popular scene of St Francis of Assisi preaching to the birds. An early example (1297–1300) is in the fresco cycle by Giotto in the upper church of the basilica of St Francis at Assisi. In general, birds may sometimes be symbolic of souls, which inhabit both the physical and the spiritual world as birds inhabit both earth and air, but individual species may also have their own particular symbolism. *See also* blackbird; dove; eagle; goldfinch; owl; peacock; raven.

bishop Many male saints are depicted in their role as bishop, wearing the episcopal ring, mitre and other vestments. First and foremost among them is St Peter, leader of the apostles and by tradition first bishop of Rome, who is usually further distinguished by his *keys. St *Ambrose of Milan is another early bishop who is always shown in his robes of office. Bishops of the Eastern Churches are also shown in their episcopal vestments, the most characteristic garment being the *omophorion, with the tunic called a sakkos as the equivalent of the Western *dalmatic.

The 11th-century missionary bishop St Sigfrid, sent from England to evangelize the Swedes, is sometimes shown carrying the heads of his three nephews. They were his assistants until they were killed during one of his absences in the mission field. Other bishops, including St Augustine of Hippo and St Wilfrid, carry the *crozier, symbolic of their role as *shepherd of their flocks. St *Patrick is sometimes shown in full episcopal dress trampling upon a *snake.

bit and bridle A symbol of temperance, one of the *Four Cardinal Virtues. Temperance is personified as a woman holding a horse's bit and bridle to symbolize restraint.

blackbird An attribute of the 6th-century Irish abbot St Kevin into whose hand, outstretched in prayer, a blackbird is supposed to have laid her egg. The saint remained in the same position until the egg hatched.

In other contexts the blackbird can have malign associations, being mentioned as a manifestation of the Devil in the 13th-century *Golden Legend* account of St *Benedict.

Blaise, St Bishop and martyr of unknown date and locality, though possibly to be identified with a martyred bishop of Sebaste (Armenia) in the early 4th century. According to his legend (written long after his supposed dates and lacking in historical credibility), Blaise worked miracles of healing for both people and animals, and hence was enrolled as one of the *Fourteen Holy Helpers. His cult was widespread in Western Europe (feast day 3 February; 11 February in the East); as Sv Vlaho he is patron saint of Dubrovnik. There were only five ancient church dedications to him in England, the most important of which was the shared dedication of the priory at Boxgrove in Kent. One of Blaise's miracles involved healing a boy with a fishbone

lodged in his gullet, and on this account his blessing is invoked against diseases of the throat.

As a single figure Blaise is shown in bishop's regalia, often with his hand to his throat. In the Byzantine tradition he is thought of as an old man with wavy hair and a pointed beard. His emblems are a *candle or candles and a *comb. There is a cycle of scenes from his legend in the early 12th-century frescoes at Berzé-le-Ville, near Cluny, in eastern France. He was the patron saint of wool combers.

blessing *see under* gesture.

blindfold A symbol of the impartiality of Justice. Justice is usually personified as a blindfolded woman holding a pair of scales and a sword (*see also* Four Cardinal Virtues).

In medieval and Renaissance church art the blindfolded may also be symbolic of the Jews' rejection of the New Testament. In this case the blindfolded woman represents the Synagogue and is usually shown as looking dejected and clutching the tablets of the Jewish law and a broken staff. She is very often one of a pair with the personified Church, as in the late 15th-century carving by Gil de Siloe in Burgos Cathedral which has the two figures on either side of the enthroned Virgin.

boar With a naked child riding upon it, the emblem of St *Cyricus. *See also* pig.

boat The attribute of the apostle *Simon and some other widely travelled saints. Alternatively, a boat may indicate a saint's patronage of sailors and all those who face the perils of the sea. An ancient tradition relates that SS Simon and *Jude travelled together to Persia, where they were martyred; they share a feast day (28 October) in the Western Church and often appear next to each other in representations of the apostles. Confusingly, Jude too can sometimes be seen holding a boat.

Among the apostles, Peter, Andrew, James and John worked as fishermen before they were called to be Jesus' disciples, so a boat can also be associated with episodes in which they feature. For instance, fishing boats often form the backdrop to Jesus' summoning of the four who became his first followers (Matthew 4:18–22). The scene known in Italian as the 'Navicella' [little boat] shows Jesus walking on the waves towards the disciples' storm-tossed boat (Matthew 14:22–33).

A boat is also the attribute of the 7th-century missionary monk Bertin, who founded a monastery, later called after him, at modern Saint-Omer in northern France. The site of the original foundation was surrounded by marshland and accessible only by boat. A young woman holding a model ship or boat is likely to be St *Ursula. A bishop with a boat is probably St *Erasmus in his character as a protector against storms at sea, but a boat is also the occasionally seen attribute of St Anselm (*c.* 1033–1109), theologian, abbot of Bec (Normandy) and archbishop of Canterbury. Boats also occur in several episodes in the legend of St *Nicholas of Myra. One may also be seen in the background of depictions of St *Julian the Hospitalier, alluding to his role as ferry-man. *See also* Ark, Noah's.

Bona, St (*c.* 1156–1207) A native of Pisa who went on pilgrimage at an early age, journeying first to the Holy Land and later to the shrine of St James at Compostela in Spain. She became a guide on the arduous route, and this has caused her to be instated in recent years as a patron saint of travellers, along with St Christopher. Bona is shown in art in the dress of a *pilgrim.

Bonaventura, St (1221–74) Italian bishop and theologian, who spent many years

studying and teaching in Paris. He was made head of the Franciscan Order in 1257, and among his many writings is a biography of St Francis. His emblem is a cardinal's *hat.

bonds Satan is often represented as a bound or chained figure in fulfilment of the words of Revelation 20:1–2: 'And I saw an angel come down from heaven, having the key of the bottomless pit and a great chain in his hand. And he laid hold on the dragon, that old serpent, which is the devil and Satan, and bound him a thousand years.' The chained figure of the defeated Devil, trampled underfoot by the victorious Christ, appears in many versions of the *Harrowing of Hell (Anastasis), for instance in a mosaic dating from the late 1000s in the church at Daphni, near Athens. *See also* chains.

bones The means of the bizarre death of St *Alphege.

The valley of dry bones in the vision of Ezekiel (37:1–14) is sometimes interpreted as an allegory of the general resurrection of the dead. For bones in *Crucifixion scenes *see under* skull.

Boniface, St (died 755) English monk, missionary and martyr. After many years as a teacher and scholar in monasteries at Exeter and Nursling (near Southampton), Boniface went in 718 to evangelize among the pagan tribes of Germany. He enjoyed considerable success and his bishopric at Mainz became a centre for missionary activity, staffed largely by men and women brought over from England. At an advanced age he turned his attention to the heathens in Frisia (Holland) and died a martyr when a band of them attacked him in his tent. His body was taken for burial to the monastery at Fulda, which he had founded and which is still the centre of his cult.

In art Boniface is shown as a bishop, with mitre and staff and possibly a *book pierced by a sword. His success in overthrowing paganism is represented in the scene in which he has felled the oak sacred to the Germanic god Thor and is baptizing converts by the fallen tree.

book The attribute of the *Four Evangelists. Pre-13th-century depictions of the *Twelve Apostles also usually had them holding books or scrolls to denote their status as instructors in the Christian faith. In some cases where evangelists and apostles occur together, the evangelists are differentiated by having books, as opposed to the scrolls that are held by the apostles who were not evangelists (for example, the mid-12th-century mosaic figures at Cefalù in Sicily). Later sets of apostles may continue to keep their books alongside more individual identifying attributes. St *Paul habitually appears with both book and sword.

Many other saints are shown clasping a book as a symbol of devout and studious lives. Bishops such as St *Ambrose, who were also writers, very often hold books. In northern Europe a bishop with a book run through by a sword is probably St *Boniface, the book standing for his missionary teaching, the sword for his death. A large gospel book is the special attribute of saints who were also deacons (*Laurence, *Vincent of Saragossa), reflecting their role in presenting the Scriptures to the priest for reading during the liturgy. The Franciscan friar St Antony of Padua has as his emblem a book and *lily, or alternatively an open book with the Christ Child seated upon it (or on his opposite arm). A monk holding a book may be St Benedict, the book in his case being the *Rule* which he wrote for the monastic community that he founded at Monte Cassino (*c.* 529) and which became the basis of monastic orders in the Western Church. St *Ignatius Loyola, too, often holds the rule book of his order.

Among female saints, St *Zita holds a book as well as the objects appropriate to her role of housekeeper, and the mystic St Catherine of Siena is depicted with a book and *heart. A group comprising a woman teaching a young girl to read is probably St *Anne instructing the Virgin Mary.

Byzantine representations of Christ as *Pantocrator show him holding a book in his left hand. For the book with seven seals (Revelation 5:1) *see under* Last Judgement.

Bosom of Abraham Trinity *see under* Trinity.

bottle *see under* flask.

bower A garden shelter overgrown with vines or flowers, popular in medieval gardens. A *rose bower was sometimes used by artists as a setting for the Virgin Mary, for instance in two famous 15th-century works by the Rhenish artists Stefan Lochner (painting in Wallraf-Richartz Museum, Cologne) and Martin Schongauer (painting in the church of St Martin, Colmar). *See also under* garden.

box The ointment pot or jar of *Mary Magdalene is sometimes shown as a box. A small box for medical requisites can be held by one or both of the physician saints *Cosmas and Damian.

boy There are a number of boy saints. One who had an extensive cult in Western Europe was St *Cyricus. William of Norwich (died 1144) enjoyed a strong local cult in East Anglia in the 12th and 13th centuries. He was twelve years old when he was killed by some unknown hand, and the discovery of his mutilated corpse led to accusations of ritual murder against the Norwich Jews. It was believed locally that he was tortured and crucified in a parody of the Crucifixion of Christ, and he is shown in East Anglian churches carrying three *nails. A similar antisemitic story is

told of 'Little' St *Hugh of Lincoln (so called to distinguish him from the Bishop of Lincoln also called Hugh).

Slightly older is St Pancras of Rome (early 4th century), who was around fourteen years old at the time of his martyrdom. In England a crowned youth may be either St *Edward the Martyr or St *Kenelm.

bread *see* loaves.

breasts The emblem of St *Agatha, who is traditionally shown in art displaying her amputated breasts on a tray or dish. Their resemblance to bells led to her being accounted the patron saint of bell-founders. A further confusion led to the breasts being understood as round loaves, and in some places on her feast day (5 February) bread is blessed in church.

A saint with strong folklore associations is Gwen Teirbron (St Blanche) of Brittany, mother of the triplets SS Winwaloe, Jacut and Vennec. Breton artists show her with three breasts, one for each child.

Bridget of Ireland, St (Brigid, Bride) (*c.* 450–*c.* 523) Irish abbess, known as 'the Mary of the Gael', who founded a religious community for women at Kildare. Many stories associated with her have folkloric elements, but among Irish saints her cult ranks second only to that of St *Patrick and it has spread throughout the Celtic lands and beyond. The Welsh place name Llansantffraid means 'St Bride's church', and around nineteen pre-Reformation churches have this dedication. Her usual emblem of a cow (less commonly a cheese) recalls her fabled skill at dairying, which made the animals under her care produce miraculous quantities of milk.

Bridget of Sweden, St (Birgitta) (*c.* 1303–73) Swedish noblewoman, visionary and founder of the Brigittine Order; patron saint of Sweden. In art she appears as a

black-habited nun with a white veil and wimple; she may hold a crozier to signify her status as leader of her order or a candle in recollection of the story that she deliberately allowed hot wax to burn her hand to remind her of Christ's wounds. A crown at her feet refers to her repudiation of worldly rank. She contributed most significantly to Western Christian art with her account of her vision of the Virgin and newborn baby (*see* Adoration of the Virgin).

As a lady-in-waiting at the royal court, Bridget attempted to counteract the prevailing frivolity, and after her husband's death (1344) devoted herself to the establishment of her religious order, with its mother house at Vadstena. In 1349 she left Sweden for good and, apart from undertaking several pilgrimages, settled in Rome where she sought papal approval for the Brigittines and combined an active role as adviser to popes and kings with an austere life and numerous works of charity.

bridle *see* bit and bridle.

broom An attribute of St *Martha as a token of her domestic preoccupations.

bucket An attribute of St *Florian.

building Models of buildings are commonly carried by saints or donors responsible for particular church or monastic foundations. These very often have a purely local significance, reflecting the dedication of one particular church.

In addition to his more usual attribute of *keys, St Peter sometimes holds a tiny church building to represent his unique position as the foundation of the Church itself, according to Christ's words reported in Matthew 16:18 – 'thou art Peter, and upon this rock I will build my church.' He

is shown in this way, for instance, in an alabaster statue from Flawford, near Nottingham, carved about 1380. On account of his similar position vis-à-vis the Church in England, St *Augustine of Canterbury features in some English churches with a building in his hands.

bull St Sylvester is sometimes depicted with a bull in chains. The allusion is to a story in the 13th-century compilation of saints' lives, *The Golden Legend*, of a contest between the saint and twelve Jewish wise men who had ridiculed the Christian faith. One of the Jews made a ferocious wild bull drop dead by the power of his incantations, but Sylvester restored it to life in Christ's name. All the scoffers and many onlookers were converted. *See also* Golden Calf.

bush, burning The sign seen by Moses when God appeared to him in the desert and appointed him leader to rescue the Israelites from slavery in Egypt (Exodus 3). The bush that 'burned with fire, and . . . was not consumed' (Exodus 3:2) was interpreted allegorically from an early date as being like the body of the Virgin Mary, which contained the Son of God. The burning bush is sometimes set side by side with the scene in the *Garden of Eden showing the serpent lurking in the tree of the knowledge of good and evil in order to tempt Eve; as that tree brought about the *Fall of Man, so the Virgin Mary, foreshadowed in the burning bush, made salvation possible. An example of such an arrangement occurs in the late 15th-century windows in the church of St Mary, Fairford, Gloucestershire.

butterfly A symbol of transformation and resurrection, often present in pictures of the Christ Child.

C

Cain and Abel The two eldest sons of Adam and Eve. Cain tilled the ground and Abel kept sheep; when they both made offerings of their produce to God, the *sacrifice of Abel was accepted, while that of Cain was rejected. In jealous anger, Cain murdered his brother (Genesis 4:1–8).

Christian tradition held Abel to be the archetype of the innocent victim and therefore a forerunner of Christ. The point is sometimes made in art by placing the scene of the killing of Abel next to that of the Crucifixion.

calf Two calves accompany St *Walstan, an Anglo-Saxon agricultural saint who had a strong local cult centred around his shrine at Bawburgh in Norfolk. Walstan was given an in-calf cow by a grateful employer, and the two calves to which she gave birth ultimately conveyed the saint's body to its burial place at Bawburgh. Among the miraculous incidents along the way, the track of their passage was left visible on the waters of the River Wensum.

The calf, mentioned as such in Revelation 4:7 but more usually referred to as an ox, is the traditional symbol of St *Luke (*see* Four Evangelical Beasts). *See also* Golden Calf.

camel The emblem of St *Menas of Egypt, patron saint of merchants and of all those who traverse the desert by camel.

John the Baptist's 'raiment of camel's hair' (Matthew 3:4) is sometimes taken very literally by artists as a camelskin and he is shown with the beast's identifiable head and limbs dangling about his person.

candle A symbol of Christ as 'the light of the world' (John 8:12). The light of a candle is a tiny visible reminder of the invisible uncreated light of divine glory, and is an important symbol in Christian ritual, although traditions differ in the different Churches. A particularly dramatic instance is the use of candles at the celebration of the Easter liturgy in an Orthodox church; in a totally darkened church, the priest lights a single candle in the sanctuary, which he carries to the sanctuary doors, where he gives the Easter greeting to the congregation: 'Christ is risen!' The attendant clergy then light their own candles from the flame at the sanctuary door and from them the light is passed throughout the church to the candles held by the congregation.

A lighted candle is the emblem of SS *Bridget of Sweden and *Geneviève of Paris. The latter used to take a candle with her when she went by night to pray in the church, defying the attempts of the Devil to disrupt her devotions by blowing out the flame. (A similar story is told of the patron saint of Brussels, St Gudule (died early 8th century).) A young woman holding a candle in late medieval art may be the personification of Charity (*see under* Three Theological Virtues).

Two crossed candles denote St *Blaise, whose remedy against throat complaints involved the holding of two candles to the afflicted area. Candles set round the rim of a wheel are the emblem of St *Donatin.

candlestick Sometimes seen in paintings of the *Last Judgement. The vision of St John in Revelation begins with seeing

Christ in the midst of seven golden candlesticks, which were interpreted as the seven churches of Asia (Revelation 1:12–13, 20). *See also* menorah.

capstan *see* windlass.

cardinal A member of the second highest rank (next to that of pope) in the Roman Catholic Church hierarchy. Their vivid red robes and distinctive *hat make them easily distinguishable from other ecclesiastics in art. Among the *Four Latin Doctors of the Church, St Jerome is often differentiated from the other three by being dressed (anachronistically) as a cardinal.

Cardinal Virtues *see* Four Cardinal Virtues.

Catherine of Alexandria, St (?4th century) Virgin martyr. Her legend, which may well be no more than an attractive fabrication, was very popular and widely known. She was one of the *Fourteen Holy Helpers and the patron saint of girls and of those whose trades involved wheels, such as wheelwrights and millers. The spinning firework known as the Catherine wheel is named after her. The fact that church bells are mounted on wheels helps to account for the inscription of her name on many English medieval bells; she was also the patron saint of the London guild of bell-founders.

According to her legend, the Roman emperor Maxentius wished to marry her, but Catherine indignantly rejected him, saying that she was already the bride of Christ. In response to her protests against the persecution of the Christians, fifty eminent philosophers were summoned to dispute with her and overthrow her belief. Such was Catherine's eloquence that it was the philosophers who were converted. (Hence her patronage of students of philosophy and theology in the medieval universities.) All fifty were burnt to death by the enraged emperor, and Catherine was imprisoned. In her cell she was strengthened in her resolve by a vision of Christ, and a dove came to bring her food. The emperor then decreed that she should be tortured on a spiked wheel, but the contraption disintegrated, killing some of the bystanders. She was then beheaded, and from her body there spurted milk instead of blood.

Catherine's body was carried by angels to Mount Sinai, where it was discovered in the 9th century. The great desert monastery there, founded by the Byzantine emperor Justinian in 527, adopted her name and became the centre from which her cult was dispersed throughout the Byzantine lands and eventually to Western Europe.

Catherine is one of the most popular female saints, and her eventful legend furnished subjects for artists in many media. Her emblem is the spiked wheel, either intact or broken in pieces; she also often appears with the crown, sword and palm of martyrdom. She may also be shown trampling on the tiny figure of her persecutor. There is a fine stained-glass window of her, crowned, with wheel and sword in Ludlow church.

Many Renaissance artists painted 'The Mystic Marriage of St Catherine', an interpretation of the vision she is said to have had while in prison. She had been given a devotional image of the Virgin and Child, which she kept in her cell, and in her vision she received a ring from the Infant Jesus in acknowledgement of her desire to be considered 'the bride of Christ'. The large number of surviving Italian paintings on the subject reflects its suitability as a wedding gift or for the commemoration of a marriage. Other saints are often present as witnesses, making these pictures similar to the *sacra conversazione*. (Italian pictures that show a nun, rather than a girl with a wheel, as the recipient of the ring, are of St *Catherine of Siena.)

Catherine of Genoa, St (1447–1510) Italian noblewoman and mystic. Born Catherine Fieschi, she converted her dissolute husband and from 1473 they devoted themselves to caring for the sick.

Catherine of Siena, St (1347–80) Italian mystic and spiritual leader. Born Catherine Benincasa, she became a member of the Dominican Third Order and gained a following (the Caterinati) through the manifest holiness of her life. Her writings helped to spread her influence as far afield as England, where her *Dialogo* was translated in the 15th century as *The Orchard of Syon*. An English version of her life was published by Caxton in the early 1490s. In her later years Catherine worked tirelessly to heal the rift in the Church known as the Great Schism, concerning the election of rival popes in Rome and Avignon.

In art Catherine generally appears in Dominican dress, frequently holding a *lily. Like her namesake, St *Catherine of Alexandria she had a vision in which she received a ring from Christ to mark her as his 'bride'. Her vision seems to have been based on pictures, with which she would have been familiar, of 'The Mystic Marriage of St Catherine (of Alexandria)'. Some later artists, following a slightly different account of her vision, show her kneeling before the adult Christ, while the Virgin looks on.

cauldron A subsidiary emblem of St *John the Evangelist. According to an ancient tradition, the Roman emperor Domitian ordered John to be plunged into a cauldron of boiling oil at the gate of Rome that led south to Latium. The saint emerged unscathed. The former feast of St John at the Latin Gate (6 May), now dropped from the Church calendar, commemorated this apocryphal event.

St *Vitus too may be shown in a cauldron.

cave In Eastern Orthodox art the black mouth of a cave symbolizes the benighted state of unredeemed humanity. In icons of the Nativity, therefore, the new-born Christ lies in or in front of a cave to signify his descent into the human condition, and the black cave-like tomb from which *Lazarus is raised has a similar symbolic import.

Cecilia, St (?3rd century) Virgin martyr. Her legend, composed long after the time at which she is supposed to have been martyred, associates her with the apparently genuine historical figures of SS Valerian and Tiburtius, but Cecilia's own identity cannot be ascertained. Cecilia was married to a pagan called Valerian, but when she told him that she had dedicated her virginity to God, he agreed to respect the vow; he and his brother Tiburtius became Christian converts and eventually suffered martyrdom. Cecilia was condemned to be suffocated in the bathroom of her house, but when the heat failed to kill her it was decided that she should be beheaded. The soldier sent to behead her struck her three times without killing her, and she lingered for several days before succumbing to her wounds.

Cecilia's house was soon consecrated as a church and from the 6th century she was honoured as a saint. In the 9th century her remains were translated from the catacombs to the church of Sta Cecilia in Trastevere, Rome. Because her legend described how an angel brought to her and Valerian crowns made of lilies and roses, medieval artists showed her holding a wreath of flowers.

It was not until the 16th century that she was adopted as the patron saint of musicians, and from that period she is often shown holding a miniature organ, lute or other instrument. Raphael's picture of her (Pinacoteca, Bologna) shows her holding a portative organ with other musical instruments at her feet. The concept of her

patronage of musicians may have been prompted by the phrase from the account of her martyrdom that describes her as 'singing to God in her heart' during the music-making at her marriage feast.

censer A metal vessel, also known as a thurible, used for the ceremonial burning of incense. It is generally suspended from chains by which it is swung to spread the smell of the incense during a church service. As this is usually the task of one of the lesser clergy, a censer sometimes appears in art as the attribute of a *deacon (for example, St *Laurence in the 12th-century mosaics at Monreale, Sicily). Censers are also wielded by worshipping angels and may appear as the attributes of Old Testament figures such as *Aaron and *Melchizedek to denote their priestly status.

centurion Mentioned in the first three gospels, the officer in charge of the Roman soldiers attending the *Crucifixion. As the sky darkened and the earth shook at Jesus' death he exclaimed, 'Truly this was the Son of God' (Matthew 27:54). Commentators also identified him with the soldier who pierced the side of the dead Jesus with his lance (John 19:34), and he was given the name *Longinus.

In medieval representations of the Crucifixion, the centurion is often prominently placed among the figures at the foot of the Cross. Stylized versions of the scene from the early Middle Ages may show him in the act of running his lance into Jesus' side, forming a symmetrical composition with Stephaton, the man who offered Jesus vinegar to drink from a sponge on a reed (Matthew 27:48).

chains The emblem of St Leonard, patron saint of prisoners. No worthwhile historical evidence concerning his life survives, but the 11th-century biography, written some five hundred years after his presumed existence, says that Leonard was a hermit, who founded the abbey of Noblac, near Limoges. The 13th-century compilation of saints' lives, *The Golden Legend*, relates how the count of Limoges set up a chain of enormous weight on a lofty tower, from which condemned men were suspended. An innocent servant of Leonard's who suffered this treatment after being wrongly convicted prayed to his master in his extremity. Thereupon the saint appeared and released him and told him to take the chain into the nearby church, to the great discomfiture of the cruel count. In 1103 the crusader prince Behemond visited Noblac to give thanks for his release from a Muslim prison, and from then on the cult of St Leonard, promoted by returning crusaders, spread rapidly from France through Germany, Switzerland, Italy and England.

The chains of St Peter also featured in ecclesiastical calendars and art. The church of San Pietro in Vincoli (St Peter in Chains), Rome, houses the fetters allegedly found in the prison in which St Peter was confined before his martyrdom. Church dedications and the feast (1 August) of St Peter ad Vincula commemorated the deliverance of Peter from Herod's prison in Acts 12:7: 'And behold, the angel of the Lord came upon him, and a light shined in the prison: and he smote Peter on the side and raised him up, saying, Arise up quickly. And his chains fell off from his hands.' *See also* bonds.

chalice A cup on a stem in which the wine is contained at the Eucharist. When the Church is personified in art it is usually as a woman holding a chalice. In many representations of the Crucifixion angels are shown holding up chalices to catch the blood that falls from the wounds of the crucified Christ (*see also* Holy Grail). For the chalice as the emblem of particular saints, *see under* cup.

chariot Of fire, *see under* Elijah. The chariots and horsemen of Pharaoh, drowning in the Red Sea on their doomed pursuit of the Israelites (Exodus 14:23–8), made a dramatic subject interpreted by numerous painters.

Charity *see under* Three Theological Virtues.

cheese The emblem of St Juthwara and the occasional emblem of St *Bridget of Ireland. In the latter case it alludes to Bridget's prowess at dairying and housekeeping. The strange legend of Juthwara (Aude) tells how her wicked stepmother advised her to apply cheeses to her breasts to relieve the soreness brought about by her religious austerities. The stepmother then told her own son that Juthwara was pregnant, and he, finding Juthwara's bodice damp, cut off her head. A spring of water gushed out at the spot, and the dead saint carried her own head back to the church for burial.

cherry Sometimes called 'the fruit of paradise', it is one of the fruits seen with the Virgin and Child as a hint to viewers of the rewards of heaven.

cherubim The second-ranking order of *angels, after the *seraphim. The cherubim were winged spiritual beings, often, but by no means always, shown with two pairs of wings and feathered bodies. Exodus 25:20 describes how two golden cherubim were set on either side of the *Ark of the Covenant. The principal source of artists' visualization of the cherubim was the vision of Ezekiel (1:4–25; 10:1–22) when they appear as fiery supporters among the wheels of God's throne.

As the embodiment of divine wisdom, a cherub may hold a book, for instance in the tracery of the south window of the antechapel, New College, Oxford. In post-medieval art cherubim may appear simply as a head surrounded by wings. Their iconography is often fused with that of the seraphim; in a vault mosaic at Cefalù in Sicily, for instance, identical six-winged beings with eyes on their wings are designated both cherubim and seraphim. Elsewhere an attempt at differentiation may be made by depicting the cherubim as gold or blue, while the seraphim are a fiery red.

child Several child saints (*see also under* boy) enjoyed more than a purely local following. Notable among these is St *Cyricus, whose emblem in art is a naked child riding upon a boar. This alludes to a story that the emperor Charlemagne once dreamt that his life was imperilled during a hunt by a wild boar; a naked child appeared and promised to save him, if the emperor would provide him with clothes. The Bishop of Nevers, where the cathedral is dedicated to St Cyr(icus), interpreted the dream as meaning that the emperor should reroof the church.

In other cases a child appears alongside certain saints, such as St *Zenobius, recalling a particular episode in the saint's life. Christ in the form of a child sits on the shoulders of St *Christopher. St *Nicholas, as patron saint of children, sometimes has as his emblem a child or children in a tub, in allusion to the incident in which he brought back to life three boys who had been murdered by a butcher and thrown into a brine tub. A saint with numerous children (traditionally twenty-four) was the legendary Welsh king St Brychan.

The Virgin Mary and Christ Child are of course the principal mother-and-child image in Christian art, but a woman suckling a child can also be the personification of Charity; in this case, her sisters Faith and Hope may not be far away (*see* Three Theological Virtues). An episode in both art and literature in which young children appear was the Massacre of the *Holy Innocents.

By an ancient iconographical formula, found in both Eastern and Western art, *souls are depicted as miniaturized people and hence confusable with children. *See also orans.*

chi-rho The Christian monogram consisting of the intersecting Greek letters X and P, which are the first two letters of 'Christ' in Greek. The monogram was adopted by the Roman emperor Constantine the Great in 312 for his military banner (labarum) after he had seen a vision in which he was told, 'By this sign you will conquer.' From this period the chi-rho became ubiquitous in Christian art, in murals and mosaics, on sarcophagi, lamps, vestments and church vessels. After the 12th century, however, it was supplanted by the *IHS monogram.

Christ *see under the various New Testament events;* Crucifix; Pantocrator; Trinity. For symbolical representations of Christ *see under* cross; Lamb of God; throne.

Christ Child The narrative scenes in which the Christ Child (or Infant Jesus) most frequently appears are those of the *Nativity with the associated Adoration of the Magi and Adoration of the Shepherds, the *Presentation in the Temple, the *Circumcision, and the *Flight into Egypt. He is also the focal point of the non-narrative compositions of the *Maestá and the *sacra conversazione.*

Artists' visions of the Christ Child vary greatly. Italian Renaissance art generally favoured a naturalistic baby, often lacking even a halo, while Byzantine art showed a miniaturized adult. In both traditions he often raises his hands in a *gesture of blessing that is significant of his divinity. Symbolic significance frequently attaches to objects held by the Child or placed close to him, for instance a *goldfinch or an *apple. *See also under* Virgin Mary.

Christina, St (?4th century) Virgin martyr. The legend of St Christina contains very little in the way of ascertainable fact. Two different women are apparently involved, one who lived in Tyre (Lebanon) and the other in Bolsena (Italy), but who are venerated in the Eastern and Western churches on the same day (24 July). The most likely explanation is that the story of St Christina of Tyre was imported into Italy and was adapted and attached to an early Christian martyr in Tuscany who was killed after undergoing a series of torments for refusing to sacrifice to pagan gods. Her chief emblems are a millstone, which miraculously failed to sink when she was tied to it and thrown into Lake Bolsena, and/or an *arrow, with which she was finally shot to death; she also sometimes appears with a wheel (her legend has resemblances to that of St *Catherine of Alexandria) or pincers.

Christmas *see under* Nativity.

Christopher, St (?3rd century) Martyr; patron saint of travellers. The cult of St Christopher was thriving at least as early as the 5th century in Asia Minor, helped by Greek versions of his legend, but historical facts about him are lacking. By the 11th century pilgrim hospices on the route from northern Europe to Rome had been named after him at Pavia, Siena and Lucca.

In the West Christopher's story was well known in the version contained in the 13th-century compilation known as *The Golden Legend.* A 'Canaanite' giant, Christopher sought out the strongest prince in the world for his master, rejecting first a king (who disappointed him by being afraid of the Devil) and then the Devil himself (who was afraid of the Cross of Christ). Searching further, Christopher chanced upon a hermit living by a hazardous ford, who told him that he could serve Christ by assisting travellers to pass over it in safety.

One night Christ in the form of a child

came to the ford and asked the giant to carry him over. As Christopher waded through the water, the child grew heavier and heavier, until Christopher exclaimed, 'What art you and art so yonge, bar I never so hevy a thynge?' (scroll in 15th-century mural of St Christopher at Horley, Oxfordshire). The child then revealed himself as Christ, bearing the whole world upon his shoulders. Before vanishing, he told the saint that if he planted his staff in the ground it would burst into leaf by morning.

Christopher's subsequent career as missionary led to his being arrested and tortured by a pagan king. Scorning the temptations offered by two beautiful women, he was then made a target for the arrows of the king's retainers, but the arrows glanced harmlessly away from him, though one veered back and blinded the king in one eye. Christopher was then beheaded, but before he died he told the king how to restore his sight by anointing his eye with earth mixed with the martyr's blood. Thus instructed, the king duly regained his sight and was converted to Christianity.

The picturesque aspects of this story ensured Christopher's popularity, but it was also believed, on the authority of St Ambrose, that the saint had prayed just before his death that those who remembered him should be preserved from sickness and harm. Hence he was looked upon as one of the *Fourteen Holy Helpers; hence, too, the belief that if a person looked upon the likeness of St Christopher he would that day be safe from sudden death. This explains the conventional positioning of a painting of St Christopher on the north wall of a church immediately opposite the south door by which the congregation normally enters. In addition to nine ancient English churches, seven medieval bells are known to have borne his name and were thought to have the same protective powers as did the paintings of the saint.

Generally the paintings show only the giant with the child on his shoulder; the child often carries an orb to indicate his dominion over the world. However, from the end of the 14th century other elements of the story were also featured, such as the sprouting staff (mid-15th-century mural at Pickering, Yorkshire) and the arrow striking the eye of the wicked king (late 15th-century mural at Shorwell, Isle of Wight). The early 15th-century paintings at Slapton, Northamptonshire, and Breage, Cornwall, include mermaids with comb and mirror among the fishes at the saint's feet.

church As a model, carried by founding saints and donors, *see under* building.

Circumcision The operation prescribed by Jewish law for male infants, carried out on Jesus eight days after birth (Luke 2:21). It is commemorated on 1 January. In art the persons involved – Jesus, his parents and the officiating priest – are often augmented by others suggested by Luke's account of the *Presentation in the Temple, which immediately follows the Circumcision in his gospel; the subjects are often conflated. In both cases Mary usually holds the baby over an altar or has laid him down on one, making the symbolic equation of Jesus' body and the Eucharist.

Clare, St (1194–1253) Italian nun and contemplative; founder of the Order of Poor Clares (Minoresses). The austere rule of life for her nuns was drawn up by St *Francis of Assisi, and the Order spread, like the Franciscan friars, to Spain, France and even England, although Clare herself passed all her life at Assisi. When the town was in danger of being sacked by the army of Emperor Frederick II, Clare, who was ill, had herself carried to the walls and appeared there holding a *monstrance. The besiegers fled. Clare's emblem in art is therefore a monstrance or a *pyx.

Clement of Rome, St (died *c.* 100) Pope and martyr; traditionally the third pope after St Peter. According to the 4th-century account of his life, Clement was exiled to the Crimea because of the vigour and success of his evangelizing in Rome. There he was forced to work in the mines, but, undeterred, he continued with his missionary work and made many converts. Among his acts was his miraculous discovery of a spring of water. He appears in art with the papal insignia of three-armed *cross and tiara, but also with the *anchor relating to his martyrdom. Clement's fame derived not only from his missionary work but also from an important (because so early) pastoral letter to the Christians of Corinth.

The 9th-century missionaries to the Slav peoples, SS Cyril and Methodius, later claimed to have recovered Clement's body, plus anchor, and translated both to the basilica of San Clemente in Rome, where frescoes of a slightly later date depict the legendary acts of the saint. One of the scenes shows a miracle involving a child, found alive and well after a year, in a church dedicated to St Clement which had become submerged by the sea; the anchor is prominently displayed on the church's altar.

St Clement had a following in several parts of Europe, and in England forty-three churches bore dedications to him. He seems to have been particularly popular in East Anglia; the scenes of his finding the spring and being thrown into the sea appear, for instance, on roof bosses in the cloister of Norwich Cathedral (early 15th century). The church of St Clement Danes in London has an anchor as its parochial emblem.

cloak The best-known episode in the early life of St *Martin of Tours was his cutting his cloak in half in order to share it with a shivering beggar. He is usually shown as a soldier on horseback, in the act of dividing the cloak with his sword.

St *Alban too is sometimes shown holding a cloak or similar garment in remembrance of his exchange of clothes with a Christian priest during a persecution. The priest escaped, but Alban was caught and martyred.

The *Virgin Mary as the Madonna della Misericordia may extend her cloak to cover a group of her devotees, and St *Ursula is sometimes shown sheltering her followers in a similar way.

clock An occasional symbol of Temperance, signifying its orderly and measured nature. *See under* Four Cardinal Virtues.

cloth Imprinted with Christ's features, the emblem of St *Veronica. *See also* veil.

cloud An artistic convention, often highly stylized, indicating the unseen presence of God. Rays of light shining from the cloud or an eye or a hand appearing from the middle of it were standard conventions for indicating divine power or omniscience.

Feet disappearing into a cloud were a shorthand means of depicting the *Ascension in a confined space such as a roof boss or small panel. As Christ vanished into the clouds at his Ascension, so he will appear seated on a cloud at the *Last Judgement: 'behold a white cloud, and upon the cloud one sat like unto the Son of man' (Revelation 14:14).

clover The emblem of St *Patrick. Its three leaflets symbolize the Trinity, and St Patrick used it to explain the concept of the 'Three-in-one' when he taught the Christian faith to the Irish.

club The usual emblem of St *Jude and of St *James the Less. Jude, according to the apocryphal account of his martyrdom, was clubbed to death in Persia, where he had undertaken a mission with St *Simon.

A fuller's club (used for beating cloth) was the traditional instrument of death of St *James the Less, who was said to have been thrown down from the pinnacle of the Temple in Jerusalem and then beaten to death as he lay on the ground.

cock The emblem of St *Vitus and a symbol of vigilance. The triumph of vigilance over the wiles of the Devil is symbolically represented in the 12th-century pavement of the church at Murano in the Venetian lagoon by a mosaic of two cocks carrying between them a trussed fox.

A cock may accompany St *Peter as a reminder of his frailty in denying Christ, who, on the night of his betrayal, warned Peter, 'this night, before the cock crow, thou shalt deny me thrice' (Matthew 26:34).

cockle shell *see* shell.

coif A simple, close-fitting headcovering commonly worn by lay people in the 13th and 14th centuries. Clergy wore it only when on a journey, and this may be the reason why some medieval depictions of angels show them thus attired, since their role was to travel on God's business.

columbine When blue, one of the flowers associated with the Virgin Mary. When white, its form and name combine to suggest a *dove (Latin: *columba*) and so it can symbolize the Holy Spirit.

comb The emblem of St *Blaise. According to his legend he was tortured by being lacerated with wool combs before being beheaded.

Communion of the Apostles A subject closely related to the *Last Supper. It shows Christ actually instituting the sacrament of the Eucharist, giving bread and wine to the apostles who are lined up at a communion table to receive it. A peculiarity of the composition, seen especially in Byzantine art, is that Christ is often depicted twice, offering bread to one file of apostles and wine to the other.

corn A symbol of the sacramental bread of the Eucharist. A sheaf of grain lying in front of the manger – or even forming a pillow for the infant – in *Nativity scenes is an allusion to Christ as 'the living bread which came down from heaven' (John 6:51). When ears of wheat or corn appear together with *grapes, the latter represent the Eucharistic wine. In Botticelli's *Madonna of the Eucharist* (*c.* 1470; Isabella Stewart Gardner Museum, Boston), for instance, the angel holds out a handful of grapes intertwined with ears of corn for the Christ Child to bless.

The ears of corn associated with St *Walburga, patroness of crops, whose protection was invoked on her feast on 1 May, may have been transferred to her from a pagan fertility goddess. *See also under* Flight into Egypt.

Coronation of the Virgin *see under* Assumption.

Cosmas and Damian, SS (probably 3rd century) Eastern martyrs, possibly of Syrian origin; patron saints of doctors. Their legend describes them as twin brothers skilled in medicine who practised their art on both humans and animals. They were put to death together with their three younger brothers during a persecution of Christians, perhaps in 287 or 303. Fra Angelico painted scenes from their martyrdom on the subsidiary paintings of an altarpiece: after being thrown into the sea and into fire and being stoned and shot at with arrows, from all of which they emerged unscathed, they were eventually decapitated.

Their cult was established in the East from at least as early as the 5th century, where the numerous church dedications

and depictions of them refer to them under their joint title of *Anargyroi. They are depicted in mosaic in the 6th-century church dedicated to them in the Forum at Rome. As general medical practitioners, their patronage was invoked by medieval guilds of apothecaries, physicians and surgeons all over Europe. In Italy the Medici family of Florence adopted them as patrons (hence the frequency of the name Cosimo in Medici circles); an altarpiece by Botticelli of the two saints kneeling before the Virgin Mary shows them with the faces of Lorenzo and Giuliano de' Medici.

In France the major church dedicated to Cosmas and Damian is at Luzarches, near Ecouen, which housed the relics brought back from Jerusalem in 1170 by a returning crusader, Jean de Beaumont. The saints' most famous miracle – the posthumous miracle of the black leg – was a popular subject for artists in 15th-century Spain. Pedro Berruguete and Gallego were among those who gave lively interpretations of the legend of how the saints, after their death, came to the guardian of their church in Rome and amputated his cancerous leg, replacing it with a sound limb taken from the body of a black man who had recently died.

An intriguing feature of their cult is the similarity between the Christian twins Cosmas and Damian and their pagan counterparts Castor and Pollux, known as the Dioscuri, who were worshipped all over the Roman world. The practice known as incubation was part of the healing cult of Cosmas and Damian, as it had been in the great shrines of the pagan deities: the patient passed a night sleeping in the temple in the hope of experiencing healing through the visitation of the god in a dream.

As in church dedications, so in art Cosmas and Damian appear together. They are shown as young or middle-aged men holding implements of their profession such as a mortar and pestle, an apothecary's jar or box, a scalpel, a glass phial or a flask.

Covetousness One of the *Seven Deadly Sins.

cow The emblem of St *Bridget of Ireland. One of the stories concerning the cows at her nunnery describes how they provided a miraculous quantity of milk to slake the thirst of unexpected visitors.

crescent moon A symbol of the Virgin Mary as Queen of Heaven. She was identified with the 'woman clothed with the sun, and the moon under her feet' in Revelation 12:1. The *Assumption window (c. 1500) of the Lady Chapel in Fairford church, Gloucestershire, shows her precisely in this guise, standing on the moon, with rays of sunlight streaming from her.

For the symbolism of the moon in Crucifixion scenes, *see under* sun and moon.

Crispin and Crispinian, SS (?late 3rd century) Martyrs, perhaps of Roman origin. The centre of their cult was established at Soissons in France from at least as early as the 6th century. However, the legend that they were missionaries there, who earned their living by shoemaking so as not to be a burden upon the Christian community, is probably an invention to account for the presence of their relics, which may have been brought from Rome. They are the patron saints of shoemakers and all who work in leather, and their emblem is a *shoe or a shoemaker's last.

A further embellishment to the story of Crispin and Crispinian gives it an English angle, to the effect that they fled to Kent to avoid persecution; the supposed site of their workshop in Faversham was a place of pilgrimage on the Canterbury trail and an altar was dedicated to them in Faversham church. Even so, the names of these essentially French saints would be almost

forgotten in England if Shakespeare had not put them into the mouth of his King Henry V when exhorting his troops before the battle of Agincourt, fought on their feast day of 25 October.

crocodile *see under* Theodore, St.

crook The trademark of a shepherd and hence the emblem of popes, bishops, abbots and abbesses as shepherds of the Christian flock. In this role they follow the example of Christ whom biblical imagery portrays as the Good *Shepherd – 'the Shepherd and Bishop of your souls' (1 Peter 2:25). In the Western Church the crook became the liturgical *crozier.

cross The emblem of several early martyrs who suffered death by crucifixion, including the apostle St *Philip. In Orthodox art a small cross may be held by any martyr, not necessarily just those who were crucified.

The cross is not among the prominent symbols of the first centuries of Christian art as found in the catacombs; one of the earliest significant representations of it is in a mosaic at Ravenna (*c.* 440). The cross set on a starry background in the mosaics of Sant'Apollinare in Classe and the archbishop's chapel at Ravenna represent the glorified Christ himself to the congregation at the time when there was still debate as to the propriety of representing him in human form. (The question was settled at the Byzantine Council in Trullo (692), decree 82 of which states that it is preferable to use a figurative rather than symbolic representation of Christ. The same council also laid down that the representation of the cross should not be placed on the floor, as it is inappropriate for the symbol of Christian victory to be trampled underfoot.)

There are numerous different types of cross. Early writers differed over whether the Cross of Christ was a tau cross (*crux*

commissa) shaped like the letter T or whether the upright extended above the crossbar (*crux immissa* or Latin cross). Both kinds are seen in Crucifixion scenes; a cross with the arms forming a Y-shape is less common but can be seen in northern European Gothic art.

The tau cross (or a staff in this shape) is one of the attributes of St *Antony of Egypt. The cross of St *Andrew (X-shaped) is known as a saltire cross. The banner of St *George, sometimes helpful in distinguishing him from the archangel Michael and other warrior saints, has a red cross on a white ground. A tradition that also sometimes finds expression in art is that of St *Peter being crucified on a cross placed upside down. St *Clement and other papal saints are sometimes depicted with the three-armed cross of their office, while archbishops and patriarchs may carry a cross with two arms. A cross mounted on a long staff may signify a preacher or missionary, hence the long thin cross held by St *John the Baptist.

A female saint who appears with a cross is St *Helena, not in her case an instrument of martyrdom but in reference to her far-famed discovery of the True Cross in 326 at Jerusalem. *See also* crucifix.

crow Often confused with a *raven by both storytellers and artists, for instance in the legend of St *Vincent of Saragossa whose remains were guarded from scavenging beasts by a crow or raven.

crown With the *palm frond, a distinguishing mark of martyrs. The name of the first martyr, St *Stephen, means in Greek a 'crown'. In Byzantine art, either a martyr may wear the crown or the hand of God may appear holding the crown over the martyr's head.

Sometimes a crown may mean no more than that the wearer was of royal lineage, as in the case of SS *Etheldreda and *Walstan (*see also* sceptre). St *Edmund,

on the other hand, is doubly entitled to his crown, being both king and martyr, as is the martyred princess St *Ursula. (A crowned head guarded by a wolf is also emblematic of St Edmund.) Some very early depictions of St *Sebastian show him as an old man holding a crown of martyrdom, in contrast to the later and more familiar picture of the saint as a young man shot through with arrows. A crown lying at the feet of St *Josse and certain other saints signifies rejection of the royal honours to which they were born. Among the angelic orders, *dominations and *principalities are commonly invested with crowns as symbolic of their function. A line or grouping of twenty-four crowned figures in scenes of the Last Judgement are the *Four and Twenty Elders mentioned in Revelation 4:4

The triple crown or tiara, distinctive headgear of popes, attained its present main elements of three coronets of diminishing size in the early 14th century. However, no sense of anachronism was felt by artists in depicting much earlier pontiffs, such as Popes *Gregory the Great and *Sylvester, thus attired. God the Father is very often shown wearing a triple crown in late medieval and Renaissance art. A double crown is the emblem of St *Elizabeth of Hungary.

The list of crowns made of materials other than gold must start with Christ's crown of thorns. In the early Middle Ages Christ is shown bareheaded on the Cross, but during the 13th century it became usual for Western artists to show a fillet or narrow band around his head; after about 1300 this was generally replaced by the crown of thorns. The crown of thorns sometimes also forms the lowest tier of a triple crown worn by Christ in glory, as in a late 15th-century alabaster panel showing the Coronation of the Virgin (Castle Museum, Nottingham).

As a symbol of her intense spiritual identification with the sufferings of Christ, St *Catherine of Siena is sometimes shown wearing a crown of thorns or receiving it from Christ, as too is St *Acacius. The crown of thorns also appears in sets of *Instruments of the Passion.

Scenes of the Coronation of the Virgin as Queen of Heaven (*see under* Assumption) show her being crowned with a single, double or triple crown. But she is also identified with the 'woman clothed with the sun . . . and upon her head a crown of twelve stars' (Revelation 12:1), which provided biblical justification for artists to depict her wearing a starry circlet.

In Byzantine art, scenes of weddings show bride and groom wearing the marriage crowns traditional in Orthodox Church ritual since the 6th century. An example is the *Marriage at Cana fresco in the church of St Nicholas Orfanos, Thessaloniki (14th century). For crowns of flowers, *see under* wreath.

crozier The staff carried by bishops and others in authority in the Church. A crozier is therefore frequently seen in the hands of saints who occupied such positions. Abbesses such as SS *Etheldreda and *Gertrude of Nivelles also carry croziers as a mark of their office.

In the Western Church the shape of the crozier recalls the shepherd's crook, hence the alternative term for it 'pastoral staff'. The crozier first appeared as a liturgical object in the 7th century. In the later Middle Ages croziers evolved into immensely elaborate and precious works of art, such as the crozier (*c.* 1367) of Bishop William of Wykeham, preserved at New College, Oxford.

crucifix An image of Christ on the Cross used as an aid to devotion (*see also* Crucifixion). In the Eastern churches a crucifix generally takes the form of a painted icon, whereas in Western churches crucifixes in stone, wood or metal are the norm. In England it was usual to find a centrally

placed crucifix over the entrance to the chancel of a church; although the crucifixes themselves were removed and destroyed at the Reformation, the rood (i.e. cross) screens on which they were displayed still remain in many places. Small portable crucifixes in metal, wood or ivory and miniature jewelled crucifixes made to be worn as jewellery are among the masterpieces of medieval and Renaissance art.

A popular subject in Roman Catholic art around the time of the Reformation was the Mass of St *Gregory, the miraculous appearance of a crucifix over the altar at which Pope Gregory I was saying Mass. This comparatively late addition to the Gregory story led to the adoption of a crucifix as one of his emblems. A crucifix held between the horns of a stag is the emblem of SS *Eustace and *Hubert. A crucifix also appears in pictures of St *Francis of Assisi receiving the *stigmata. For the Lily Crucifixion *see under* Annunciation.

Crucifixion The death of Christ on the Cross, portrayed in every medium used in Church art (*see also* crucifix). The subject was not apparently shown before the 5th century, due in part to the doctrinally inspired reluctance on the part of artists to show Christ as having been dead; debate on the acceptability of such images apparently continued until well into the 11th century. One of the earliest surviving examples of a Crucifixion is the naive depiction of the three crosses carved on the wooden door of Sta Sabina, Rome (*c.* 420–30), with Christ open-eyed and head erect. Over the centuries there have been many changes in the artistic conventions that governed its presentation, as well as doctrinally based differences between the different Christian denominations.

Apart from the very earliest attempts at the subject (the Sta Sabina Christ wears a loincloth), Christ was always portrayed fully clothed up until the 11th century.

The concentration of some late medieval German artists upon the expression of extreme physical agony in a nearly naked body is a doctrinal world away from the austere figure of the crucified Christ in Byzantine art. The crown of thorns, almost invariably a prominent detail in Western crucifixes of the Middle Ages and later, is absent in Greek and Russian icons, which show Christ either bareheaded or with a thin band around his head. Likewise, Eastern artists usually show two nails fastening Christ's feet, which rest on a crossbar, compared with the usual single nail through the feet to the vertical of the Cross in Western art; the result is that the former show an altogether less contorted body than the latter.

As the focus of innumerable altarpieces in the Western Church, the scene can be treated with stark simplicity, involving very few figures, or with considerable elaboration. Artists drew on the four gospels' accounts of those present at the foot of the Cross: the Virgin Mary and a number of other women, among them *Mary Magdalene and Mary Cleophas; St John the Evangelist (traditionally equated with the disciple to whose care Jesus entrusted his mother (John 19:25–7); Roman soldiers under the command of a *centurion. Other followers of Jesus and mocking Jews are peripheral to these main actors. On either side of the main Cross are the crosses of the two thieves.

Traditional details with scriptural authority include the inscription over Jesus' head (*see* INRI), a skull on the ground (Golgotha is interpreted as 'a place of a skull' in Matthew 27:33) and a darkened sky (Matthew 27:45). Non-scriptural details are angels with chalices, catching the blood that flowed from Jesus' wounds, and a miniature *sun and moon over the Cross.

Apostles who reputedly suffered crucifixion were SS *Andrew, *Peter and *Philip. St *Acacius was the victim of a mass crucifixion.

cruets Small silver containers associated with St *Joseph of Arimathea, who was believed to have collected the blood of Christ in one cruet and his sweat in another, and to have brought these two precious relics with him to England. In a liturgical context they held the wine and water for the Eucharist.

cup The stemmed cup or *chalice is the emblem of several saints. Most commonly seen is the cup with a serpent writhing above it held by St *John the Evangelist. An apocryphal tradition relates that the apostle was challenged to drink a poisoned cup by the high priest of the temple of Diana at Ephesus; John's prayer over the cup drew out the poison in the form of a serpent or tiny, winged dragon, and he then drank the contents down unscathed.

Another poisoned cup legend involves St *Benedict, who sometimes appears with a broken cup in allusion to an incident in which poison was slipped into his drink by certain monks, who, having invited him to become their spiritual leader, had grown disgruntled because of the harshness of the regime that he imposed upon them. When Benedict blessed the cup before drinking from it the vessel shattered, betraying the presence of the poison.

Chalices are associated with several saintly bishops. A chalice lying on the ground at the feet of the English bishop St Richard of Chichester (1197–1253) alludes to the occasion when he was celebrating Mass and accidentally dropped the chalice, but it miraculously remained unspilt. St *Hugh of Lincoln holds a cup with the Christ Child seated upon it. The German bishop St *Norbert has a chalice with a spider emerging from it.

Cuthbert, St (*c*. 634–87) Anglo-Saxon monk; bishop of Lindisfarne (685–7). An active missionary and a man of outstanding personal holiness and abilities, Cuthbert was instrumental in persuading the people of the north of Britain to accept the customs of Rome in preference to those of the Celtic Church which they had hitherto followed. A few years after his death his body was found to be uncorrupted, and from that time his shrine at Lindisfarne was the centre of a strong cult. When the Danes sacked Lindisfarne in 875 surviving monks tried to find a permanent resting place for the body and relics of Cuthbert. After over a century of wandering they came to a final halt at Durham, where the great Norman cathedral was built over the shrine; Cuthbert's relics remained there from 1104 until the shrine was abolished at the Reformation.

From the 12th century Cuthbert was accounted one of the most popular English saints. Most of the one hundred and thirty-five churches dedicated to him are in the northern counties; there are also seventeen in Scotland. No particular emblem is associated with him, but scenes of his life, miracles and post-mortem travels appear in a number of places, perhaps most notably in a window at York Minster.

Cyricus, St (Cyriacus, Quiricus, Cyr) (died *c*. 304) Child martyr; patron saint of children. He is thought to have come from Iconium (modern Konya in Turkey). With his mother, St Julitta (or Juliette), Cyricus was caught up in a persecution of the Christians at Tarsus; although only three years old, he defied their tormentors and was eventually killed.

Cyricus' cult and legend, the latter known in several variants, have been in existence since as early as the 4th century, and his fame and relics spread to Western Europe. Churches dedicated to St Cyr(icus) are numerous in France. The cathedral at Nevers (a joint dedication with St Julitta) is connected with the story of the saint's appearance in a dream to the emperor Charlemagne; this story is the origin of the emblem of St Cyricus: a

naked *child riding on a wild boar. In Wales, by a confusion arising through the similarity of names, the legend of Cyricus merged with that of the shadowy Celtic saint Curig. His feast day in the East is 15 July; in the West 16 June.

D

dagger The weapon that killed the English king St *Edward the Martyr and the Italian Dominican preacher St *Peter Martyr. St Edward is generally shown crowned and holding a dagger in his hand. The usual distinguishing feature of St Peter Martyr in art is a gash in the head, but some artists, Fra Angelico among them, also show a dagger plunged in his shoulder. St *Justina of Padua may also appear with a dagger or sword embedded in her breast.

dalmatic A loose-fitting knee-length vestment with sleeves, worn as an over-tunic by a *deacon (and occasionally by a bishop). The equivalent garment in the Eastern Church is called a sakkos. It was originally white but since the 10th century has been usually of coloured silk.

As a form of dress appropriate to deacons on the feast days of the Church, the dalmatic can help to identify saints who held that ecclesiastical rank, such as *Laurence, *Stephen and *Vincent.

Damian, St *see under* Cosmas and Damian, SS.

Dance of Death A late medieval and Renaissance theme found particularly in French and German art. It is also commonly known under its German title of *Totentanz* or French *danse macabre*. Death in the form of a skeleton invites young and old, rich and poor, to dance with him. There is an imposing 15th-century painted Dance of Death in the church at La Chaise-Dieu in Haute Loire, central France, and the theme was also inter-preted in sequences of woodcuts, the most famous of which was that published by Hans Holbein the Younger (Lyons, 1538). It also appears in secular contexts, as in the 17th-century paintings in the roof of the Spreuer bridge at Lucerne.

Daniel (6th century BC) Old Testament prophet, renowned for his wisdom. Only twelve chapters make up the book of Daniel in the Hebrew Bible (and the Authorized Version) but there were well-known ancient additions, not now accepted as canonical, which include the story of Susanna and the elders.

Daniel was carried off as a child from Judea to Babylon by King Nebuchadnezzar. Among his companions were Hananiah, Mishael, and Azariah to whom were given the Babylonian names, respectively, of Shadrach, Meshach, and Abednego. All four gained high office, and Daniel won the king's confidence as an interpreter of dreams. However, the Jews' refusal to pollute themselves with pagan worship eventually brought the king's wrath down upon them. Shadrach, Meshach and Abednego were thrown into a fiery furnace; they were miraculously preserved by an angel, whom onlookers saw standing with them in the midst of the flames, and when the king called them they walked unharmed from the fire.

Daniel foretold the downfall of the Babylonian empire by interpreting the writing that appeared on the wall at a feast given by Nebuchadnezzar's successor Belshazzar. The Median king Darius, who then held sway in Babylon, set Daniel in a position of authority but Darius was

tricked by those who envied the Jew's influence into throwing him into a den of lions. Daniel survived this ordeal unscathed ('God hath sent his angel, and hath shut the lions' mouths' – Daniel 6:22); the king ordered that Daniel's accusers should be thrown to the lions instead, and they were duly devoured.

Both these scenes – Shadrach, Meshach and Abednego in the fiery furnace and Daniel in the lions' den – are frequent in Christian art from the 3rd century. On catacomb walls and sarcophagi they are usually reduced to their bare elements: the three youths standing praying (*see orans*) in the flames and Daniel standing between two lions. The dangers of being thrown to the wild beasts or burned alive were very real to the Christians in the era of the persecutions; Daniel and his companions, defiantly practising their religion in the midst of a pagan population and divinely protected from the harm intended to them, struck a particular chord with the embattled Christians of the Roman empire. Both scenes declined in importance in the artists' repertory later in the Middle Ages, although Daniel and the lions have retained a modest popularity.

Daughters of God *see* Four Daughters of God.

David (10th century BC) Second king of the Hebrews. The authorship of the Psalms was traditionally attributed to him. David was the son of a man of Bethlehem called Jesse. According to the genealogy given in Matthew 1, David was an ancestor of Jesus, who was greeted as 'Son of David' (Matthew 21:9) at his triumphal entry in Jerusalem before the Passion. David features regularly with his son Solomon in the medieval representation of Jesus' ancestry known as the *Tree of Jesse. The crowned figures of David and Solomon are frequently in the forefront of the spirits of the righteous dead in the *Harrowing of Hell. In most contexts David is normally identifiable by his crown and harp.

The earliest episode from David's life that attracted artists was his playing the harp to King Saul, who was troubled by an evil spirit (1 Samuel 16:14–23). Following this was his killing of the Philistine giant Goliath (1 Samuel 17:32–51). Paintings and sculptures of David as a youth show him with the head of his adversary at his feet or in his hands, or simply holding a sling or stone.

After Saul's death David became king of Judah and some years later managed to unite his kingdom with that of the Israelites, setting up his capital at Jerusalem. His long reign was eventful and glorious. The biblical narrative however also chronicles family quarrels and personal treachery, in particular his fatal breach with his son Absalom (2 Samuel 13:30–18:33) and his murder by proxy of Uriah the Hittite, whose wife Bathsheba he saw and coveted as she washed herself (2 Samuel 11:2–27); both these episodes appear in art.

David, St (Dewi) (6th century) Welsh bishop, abbot of St David's in Dyfed; patron saint of Wales. He was honoured in Ireland, Cornwall and Brittany, but the heartland of his influence was South Wales, where numerous ancient churches were dedicated to him. He is credited with the founding of ten monasteries, in which the monks followed his example of extreme austerity. His power as a preacher is alluded to in his emblem of a *dove. When shown preaching he often stands on a small hill, in reference to the story that the ground rose up beneath him at the synod of Brefi to enable him to be heard among the great multitude of the people; the hill and the church at Llanddewibrefi in Dyfed commemorate this event.

The origins of the custom of wearing a leek or daffodil on St David's Day (1 March) seem buried in folkloric obscurity.

deacon An ordained minister of the Church, ranking below a priest. The first deacons were the seven appointed by the apostles to serve (Greek: *diakonos*, servant) the fledgeling Christian community at Jerusalem (Acts 6:1–8). In art deacons often hold a gospel book – in reference to their holding it for reading during the liturgy – and wear the *dalmatic. Alternatively, the deacon taking part in a Mass may wear an *alb, with a *stole over the left shoulder. In addition to these features, the deacon saints *Stephen, *Laurence and *Vincent are also entitled to hold the *palm of martyrdom.

The angel *Gabriel in *Annunciation scenes is sometimes dressed in the sort of vestments worn by a deacon assisting at the celebration of the Mass, thus stressing the sacramental nature of the scene.

Death Personified in medieval and later art as a cadaver or skeleton. *See also* Dance of Death; Three Living and Three Dead.

Death of the Virgin *see* Dormition.

deer The emblem of St *Giles and the two female saints of Ely, *Etheldreda and Withburga (died *c.* 743). Two deer sometimes accompany St Etheldreda as a reminder of the occasion during a famine when two does are said to have kept the saint's community at Ely supplied with milk. Withburga, who lived as a solitary, was likewise said to have been supplied with milk by her pet doe.

The key incident in the legend of St Giles hinges on the attempted shooting of a deer in the course of a hunt; the arrow was miraculously deflected, wounding Giles himself. *See also* stag.

The motif of deer drinking at a stream, fountain or spring is not uncommon in Christian art, especially of the 4th and 5th centuries; examples occur in the mosaics of the mausoleum of Galla Placidia, Ravenna (5th century) and St John

Lateran, Rome (13th century, but following an antique model). The imagery is based on the opening verse of Psalm 42: 'As the hart panteth after the water brooks, so panteth my soul after thee, O God.' The deer thus represent the soul's intense thirst for the life-giving waters of the Christian faith. The motif was considered particularly appropriate to baptisteries as it was there that the newly converted were admitted into full membership of the Church through the immersion in the font.

Deisis (*or* Deesis) (Greek, 'entreaty') A group consisting of the Virgin Mary and John the Baptist in supplication on either side of Christ *Pantocrator. The Virgin stands on Christ's right, following the words of the psalm: 'upon thy right hand did stand the queen' (Psalm 45:9). The Deisis very often occupies the central position in the iconostasis that screens the sanctuary from the congregation in an Orthodox church.

Demetrius, St Warrior saint of unknown date and obscure background, greatly venerated in the Orthodox Church. He is the patron saint of Thessaloniki, where the main church is dedicated to him. The city claims to have been preserved from destruction on several occasions by the saint's fighting alongside the defenders on the walls. The version of his passion recounted at Thessaloniki identifies him as a Roman soldier beheaded in the 3rd century for proclaiming the gospel, but the name has also been associated with a deacon martyred in Serbia.

Demetrius' armour-clad figure, very often on horseback, is a familiar icon in Orthodox churches. Post-medieval icons of him may show him with a moustache. On an iconostasis screen Demetrius wears and tunic and a cloak, like St *George. Like St George too, he is honoured with the title of 'the Great Martyr', and the two

warrior saints may be represented as a pair, Demetrius on a dun, bay or reddish-coloured charger, George on a white or grey one. Demetrius' feast day in the East (26 October; 8 October in the West) marks the traditional time for flocks to return to their winter quarters; thus the festivals of these two Great Martyrs stood at either end of the Greek farming year. Until quite recently aspects of the cult of St Demetrius in some isolated areas of the Balkans suggested that the saint had usurped the responsibilities of the ancient grain goddess Demeter, whose major festival was likewise celebrated in October.

Demetrius may occasionally be shown trampling upon a gigantic scorpion, an allusion to an incident that befell him while in prison.

demons *see* devils.

Denys, St (Denis, Dionysius) (died *c.* 250) Bishop and martyr; one of the patron saints of France. According to a 6th-century account, Denys was sent as a missionary to Gaul, made many converts and became bishop of Paris, but was eventually imprisoned and beheaded. The abbey of St-Denis was built over his tomb. The missionary bishop later became confused with the 5th-century Neoplatonist philosopher, Dionysius the Areopagite, who in turn was merged with the Athenian Dionysius the Areopagite mentioned in Acts 17:35. This muddle was fostered by the canny abbots of St-Denis, who thus greatly enhanced their saint's credentials, as well as the prestige of the abbey so that it became the burial place of the French kings.

A miraculous embellishment to the story of the martyrdom of St Denys was the detail of his corpse carrying his severed *head to the site of the future abbey.

Deposition The removal of the dead body of Christ from the Cross. It was a subject that found much favour with painters and sculptors, and is included in the sequence of the *Sorrows of the Virgin.

In sequences of scenes of the Passion, it appears after the *Crucifixion and before the *Entombment. The personnel involved reflect the gospel accounts of the witnesses to the Crucifixion, with the Virgin Mary, supported by St John the Evangelist, at the foot of the Cross. *Joseph of Arimathea, who obtained permission from Pilate to bury the body of Christ, is prominent among those removing the nails or lifting down the body, often with the aid of a ladder.

Descent from the Cross *see* Deposition.

Descent into Hell *see* Harrowing of Hell.

desert The setting for scenes from the lives of many saints and penitents. In the Old Testament Moses sees the burning *bush in the desert, and the scenes from his life after the Exodus are set there. Ravens brought food in the desert to the Old Testament prophet *Elijah and to the desert hermits, notably St *Antony of Egypt. The scenes of St *John the Baptist preaching by the River Jordan and baptizing Christ are set in a desert landscape, as is Christ's *Temptation in the Wilderness. SS *John Chrysostom, *Mary of Egypt, *Onuphrius, and *Jerome are sometimes shown crawling naked on all fours across the desert in an extreme act of mortification and penance.

desert fathers The holy men who, from the 3rd century onwards, withdrew from the settled communities of Egypt to lead a life of asceticism and contemplation in the wilderness. Struggles against the demons that were thought to inhabit desolate places were a major feature of their spiritual life, most commonly represented in art in the temptations of St *Antony of Egypt. This movement, from which

sprang the Eastern monastic tradition, spread to Palestine and Syria; other notable figures in it were Arsenios the Great (354–445) and Makarios the Great (*c.* 300–*c.* 390).

Artists acknowledge the austerities that these monks and hermits underwent by depicting them as emaciated and unkempt, with luxuriant beards, sometimes wearing monastic robes but sometimes in rags or near nakedness.

Devil, the Another name for *Satan. *See also under* dragon.

devils Evil spirits in grotesque forms, often painted black and with bat-like wings (as opposed to the bird-like wings of *angels). They appear as tempters and tormentors in pictures of St *Antony of Egypt and other hermit saints. In depictions of the Last Judgement they carry off the souls of the damned to hell and in Crucifixions they hover around the cross of the wicked thief.

A robust reversal of the theme is a devil gripped by the nose with a pair of *tongs, a feat associated with the two metalworking saints *Dunstan and *Eloi. A tiny devil may be shown hovering around the *candle of St Geneviève, endeavouring to blow out the flame.

Dionysius, St *see* Denys, St.

dish The most notorious is the 'charger' on which the *head of St John the Baptist was placed (Mark 6:28). Other saints use a dish to display the particular attributes associated with them: breasts (St *Agatha), eyes (St *Lucy) etc.

doctors The physician's patrons *Cosmas and Damian sometimes appear capped and gowned as medieval doctors, holding the instruments of their profession.

Doctors of the Church The title given

since the Middle Ages to theologians of outstanding influence as teachers in the Church and as examples of Christian life. Although the numbers have expanded (and even, since 1970, include a woman, St *Theresa of Avila), Western medieval religious art generally acknowledges just four (*see* Four Latin Doctors). A different set of four is honoured by the Orthodox Church (*see* Four Greek Doctors).

doe *see under* deer.

dog The emblem of two major saints: *Dominic and *Roch. The Dominican dog is black and white and holds a torch in its mouth. The dog is a visualization of a Latin pun (*Domini canis*, 'dog of the Lord'), and its appearance reflects the monks' black mantles and white robes; the torch is the truth they proclaim, the light of which will spread throughout the world. The origin of the image is said to have been a dream experienced by Dominic's mother before he was born.

The dog that accompanies St Roch may have a loaf of bread in its mouth; this alludes to the episode in which the saint, suffering from the plague, withdrew to the isolation of the woods, where food was brought to him by a dog. *See also* hound.

The only scriptural canine to receive a good press, the dog owned by Tobias (Tobit 5:16), is frequently shown with his master on their travels in paintings of the popular subject of Tobias and the angel.

dominations Spiritual beings ranking below *virtues and above *powers in the order of *angels. As embodying the universal dominion of God, they wear kingly crowns and are invested with the insignia of royalty (*sceptre and *sword).

Dominic, St (1170–1221) Spanish-born founder of the Order of Friars Preachers (Black Friars). His mission only became apparent in the early years of the 13th

century, when he was sent to preach to the Albigensian heretics in southern France. Dominic realized the value of reinforcing his message by example, and in 1206 he took the first steps towards establishing a religious order whose purity and austerity of life would rival those practised by the heretics themselves. His carefully drawn-up plans received papal approval in 1216, and Dominic devoted the rest of his life to missionary journeys and to spreading his Order throughout Europe. By the time of his death at Bologna, groups of his friars were operating even as far afield as England.

Dominic's renown as an organizer and preacher attracted many to his tomb at Bologna. Fra Angelico is among the famous artists who depicted scenes from his life. His earliest emblems were a star (as in Fra Angelico's mid-15th-century fresco of the Transfiguration (Museo di San Marco, Florence)), an allusion to the story that one appeared on his forehead when he was baptized, and a *dog with a torch in its mouth. Later artists often gave him the attribute of a *rosary, due to the erroneous belief that he was responsible for introducing this form of devotion.

dominions *see* dominations.

Donatian, St (Donas) (late 4th century) Bishop of Reims *c.* 389. Confusion with other saints and martyrs called Donatianus or Donatus tends to obscure any attempt at a biographical account of Donatian. His legend says that he was born in Rome and as a child was thrown into the River Tiber. He was located when a wheel with five candles set at right angles to the rim was floated downstream and stopped over the spot on the riverbed where he lay. His body was then retrieved and revived by prayer.

Donatian's relics were translated from Reims to Bruges in the 9th century, and the Netherlands became the centre of his cult. Because of his legend he was invoked against inundations and other damage by water. In art he appears as a robed and mitred bishop holding the wheel with its five candles, as in Jan van Eyck's *Madonna of Canon van der Paele* (1436; Groeninge Museum, Bruges).

donkey *see* ass.

Doom *see under* Last Judgement.

door The symbol of Christ as the only route to salvation: 'I am the door: by me if any man enter in, he shall be saved' (John 10:9). This accounts for the frequent placing of an image of Christ over the main entrance to a church. In the Eastern Orthodox Church it may take the form of a painting or mosaic over the central door from the narthex to the nave; in the romanesque architecture of the Western Church a sculptured relief of Christ in glory very often occupies the tympanum over the main external door.

A fallen door or gate is often shown under Christ's feet in the *Harrowing of Hell, particularly in Orthodox icons of the scene. A Byzantine homily for Holy Saturday makes the point that the doors of hell were broken down by (Christ) the Door.

'Behold I stand at the door, and knock' (Revelation 3:20) is the text for the door symbolism in William Holman Hunt's painting *The Light of the World* (1851–4; Keble College, Oxford). Here the human heart is a door, which can either be shut against Christ or opened to him.

Dormition The 'falling asleep' of the Virgin Mary, who, according to New Testament apocryphal writings, was received body and soul into heaven at the end of her earthly life (*see also* Assumption). In the Eastern Church, where it is known as the *Koimesis* (Greek, literally 'falling asleep'), it is celebrated on 15 August as one of the twelve great feasts and is thus a frequent

subject with artists; in churches with a traditional decorative scheme, a mosaic or fresco of the *Koimesis* is normally placed on the west wall of the nave.

In the art of both Eastern and Western Churches, the Virgin is usually shown lying on a bed, surrounded by the apostles in various attitudes of grief. St *Peter stands at her head or feet. Special prominence may also be given to St *John the Evangelist into whose care Jesus commended his mother at the Crucifixion. According to legend, an angel appeared to the Virgin shortly before her death to tell her that she would die within three days and handed her a heavenly palm frond as a token. She in turn gave the branch to St John, who is sometimes shown holding it in this scene.

Behind or above the bed is the figure of Christ, accompanied by angels, who has come to receive his mother into heaven. Sometimes Mary's soul is shown in the likeness of a child in Christ's arms; a poignant reversal of the Virgin and Child image. Angels and bishops may also be in attendance, and a figure hurrying in late is St *Thomas, who has had to travel back from India for the event.

An embellishment found in some versions of the Dormition concerns a Jew called Jephonias who touched the bier on which the Virgin was lying. An angel promptly cut off the offender's hands. The legend was found in 4th-century texts and Byzantine writings but seems only to have featured in art in the later Middle Ages. One of the earliest surviving Dormitions to show the Jephonias incident is the early 13th-century fresco in the monastery of the Panagia Mavriotissa at Kastoria, northern Greece.

The whole dramatic sequence of Dormition, Assumption and Coronation of the Virgin can sometimes be found in a single work of art, as in Veit Stoss's carved altarpiece for the church of Our Lady in Cracow (1477–89); in it the death of the Virgin fills the lower part of the central panel, with the Assumption immediately above it, and the Coronation under the topmost canopy.

Dorothy, St (early 4th century) Virgin martyr, probably of Caesarea in Cappadocia (Asia Minor). Nothing is known of her life, and the legend attached to her death, although attractive enough, is less circumstantial than the comparable legends of SS *Catherine of Alexandria and *Barbara. Her emblem is a *basket of fruit or flowers or perhaps flowers held in her skirt; in Ambrogio Lorenzetti's picture of her with the Virgin and Child (early 14th century; Pinacoteca, Siena), she also holds up a posy of flowers. Her remains were believed to have been brought to Rome for burial in the church dedicated to her there. She was popular in Italy and also in Germany, where she sometimes appears among the *Fourteen Holy Helpers.

dove The form under which the Holy Spirit is generally represented in Western art. The four gospel accounts of the *Baptism of Jesus in the River Jordan all agree that the Holy Spirit descended 'in a bodily shape like a dove upon him' (Luke 3:22), and the artistic convention of portraying the Holy Spirit in this guise dates from at least as early as the 4th century. The Baptism is the only scene in which Orthodox artists regularly depict the Holy Spirit as a dove, since gospel authority is lacking for its appearance in this form at either the *Annunciation or at *Pentecost. Western artists, however, often represent the Holy Spirit as a white dove in Annunciation scenes to embody the angel Gabriel's words to Mary: 'The Holy Ghost shall come upon thee, and the power of the Highest shall overshadow thee' (Luke 1:35).

In the highly stylized medieval conventions for the depiction of the *Trinity the dove was very often used to signify the Third Person, the Holy Spirit.

The inspirational power of the Holy Spirit is associated with several saints, notably *Theresa of Avila, over whose head a dove is sometimes shown hovering. The dove, as the Holy Spirit dictating what is to be said or written, is associated with SS *Gregory and *David. A dove and book symbolize the work of the Holy Spirit in the missionary endeavours of St *Samson of Dol.

According to the 4th-century Spanish poet Prudentius, from whose Latin hymn in her honour details of the cult of the virgin martyr *Eulalia are derived, a white dove flew out of her mouth at her martyrdom. A similar story attaches to the deaths of SS Reparata (virgin martyr and patron saint of Florence) and *Scholastica. This ties in with a widespread convention in early Christian art that depicted the souls of the blessed as doves.

A dove may be associated with St *Joseph, who was selected as the husband of the Virgin when a dove burst out of the rod that he was carrying and perched on his head.

The dove with an *olive branch in its beak, which returned to Noah in the Ark is a token that the flood was subsiding (Genesis 8:11), is the universal promise of peace and reconciliation.

dragon A fabulous reptilian monster with scaly wings, whose form was assumed by *Satan. It is the commonest embodiment of evil in Christian art and literature. The imagery is based particularly on the passage in Revelation (12:9), in which Satan is called 'the great dragon' and 'that old serpent, called the Devil'. The archangel *Michael, as captain of the heavenly hosts in the war against the dragon, is often shown running the monster through with his spear and trampling it underfoot. So too are the warrior saints *George and *Theodore.

Less warlike are Pope *Sylvester I, who appears with a chained dragon, and the 6th-century Celtic saints Armel and Tudwal who needed only their ecclesiastical stoles to control the dragons they conquered. St *Martha's conquest of the tarasque, a monster that terrorized the area around Tarascon in the south of France, is commemorated by showing her with the creature in the form of a dragon being led along by a sash.

Female saints who overcame the Devil in dragon form are the 4th-century virgin martyr Juliana, the 5th-century nun St Elizabeth the Thaumaturge (who, significantly, was head of a nunnery of St George at Constantinople) and the rather better-known *Margaret of Antioch. In the case of Margaret, the confrontation was a debate that ended in her being swallowed by the dragon, but Margaret prayed and the dragon's guts burst, throwing her out alive and unharmed. These saints appear in art with the vanquished dragon at their feet. *See also under* snake.

Dunstan, St (909–88) English Benedictine monk, archbishop of Canterbury (960–88). As abbot of Glastonbury in the 940s he was responsible for the reform of the monastery there and later for the revival of the Benedictine Rule throughout England after the years in which the Danish invasions had virtually extinguished monastic life and learning. After his death his cult spread all over England (although most of the twenty ancient churches known to have been dedicated to him are in the south), and Canterbury and Glastonbury both claimed to possess his body.

In addition to his public role as Church reformer and adviser to the English kings, Dunstan enjoyed a formidable reputation as a polymath: musician, scribe, painter, bell-founder and metalworker. The last of these particularly stirred the imagination of artists, who showed him as a bishop with a pair of metalworking *tongs, as in a stained-glass window at Ludlow in Shrop-

shire. One popular story tells how in an encounter with the Devil Dunstan caught the fiend ignominiously by the nose with his tongs. He is the patron saint of locksmiths, farriers, jewellers and other metalworkers.

E

eagle One of the *Four Evangelical Beasts, the traditional symbol of St *John the Evangelist.

With wings outstretched to support a book, an eagle in wood or metal often forms the top of a lectern. Shown with a snake in its talons, it is a symbol of the triumph of good over evil.

Ecce Agnus Dei (Latin, 'Behold the Lamb of God') The exclamation of St *John the Baptist when he saw Jesus coming to him for baptism (John 1:29). The words sometimes appear on a scroll held by John. *See also under* Lamb of God.

Ecce Homo (Latin, 'Behold the Man') The words of Pilate when he showed Jesus to the Jews before the Crucifixion (John 19:5). The phrase occurs as a title for pictures or sculptures of Jesus wearing the crown of thorns.

Eden, Garden of The paradisal garden in which God placed Adam. For details of its topography artists drew upon Genesis 2:8–15, depicting the trees 'pleasant to the sight, and good for food; the tree of life also in the midst of the garden, and the tree of knowledge of good and evil' (2:9) and the *river, with its four branches, that watered the garden.

The inhabitants of Eden, apart from *Adam and Eve, were 'every beast of the field, and every fowl of the air' (2:19), who, before the *Fall of Man, all lived together there in harmony; the motif appealed to many artists and reached its most elaborate expression in the medleys of exotic birds and animals painted by Renaissance artists like Jan Breughel the Elder (1568–1625) and Roelandt Savery (1576–1639). Adam is sometimes shown naming the animals (Genesis 2:19), but otherwise the main human activity in the garden was tending the plants there.

Edmund, St (841–69) King of East Anglia and martyr. When the Danes invaded his kingdom, Edmund led an army against them, but was defeated and captured. According to an account purporting to come from an eyewitness, Edmund refused any compromise with his captors, and was tied to a tree and shot to death with arrows. His head was then cut off and the Dane hid it in thick brambles, intending that it should suffer the dishonour of remaining unburied. A wolf found it and guarded it from harm until Edmund's followers, searching through the wood and calling 'Where are you?', were guided to the spot by the head's response, 'Here, here.' Head and body were then reunited for burial.

Edmund's tomb at Bury St Edmunds in Suffolk later became the centre of a thriving cult, and over sixty English churches were dedicated to him. In art he usually appears either holding an *arrow, or with his *crown lying on the ground with an arrow across it. His crowned head is sometimes shown separately, guarded by the wolf. Depictions of Edmund are frequent in East Anglian churches, sometimes together with those of the other regional saint, *Alban.

Edward the Confessor, St (*c*. 1004–66). King of England (1042–66). His title of

'Confessor' (i.e. one whose life bears witness to the faith) distinguishes him from the other English saintly monarch, *Edward the Martyr. His reputation for sanctity has somewhat overshadowed his reputation as a strong and capable ruler in troubled times. It was he who started the tradition of English monarchs' ability to heal scrofula (the King's Evil) by their touch. He was a great benefactor, particularly to the abbey church at Westminster, where he is buried; in the pre-Reformation period, his shrine there was magnificent and popular. He was accounted co-patron of England with St *Edmund, until their role was largely usurped by St *George.

Edward the Confessor appears in the Bayeux Tapestry and there are numerous other early depictions of scenes from his life. In the late 14th-century Wilton Diptych he is shown holding the finger *ring which is his most constant emblem. He sometimes also appears with a model *building in acknowledgement of his patronage of Westminster Abbey.

Edward the Martyr, St (*c.* 962–79) King of England (975–9). He was stabbed to death with a *dagger at Corfe Castle in Dorset by retainers of his half-brother and rival for the throne. In the century after his death his legend was embellished with details laying the blame for his murder on his beautiful but wicked stepmother. Miracles were soon reported at his obscure tomb at Wareham, so his remains were translated to a more fitting shrine at Shaftesbury (980) and by the early 11th century his cult was widely observed in England.

egg A near-universal symbol of regeneration and revival, sometimes appearing in Christian art as a symbol of the Resurrection.

elders *see* Twenty-four Elders.

Eleousa In the Orthodox Church, an icon type of the Virgin and Child. The Greek word broadly means 'compassionate', but both it and its Russian counterpart *Umileniye* have connotations of 'tenderness' or 'loving kindness' that cannot be precisely translated into English. The post-medieval Greek name for this kind of icon, 'Glykophilousa', is also sometimes encountered.

The Virgin Eleousa probably evolved from the *Hodegetria icons and was established as a distinct type by the 10th century. It is particularly popular in Russia, where one of the most famous of all miracle-working icons, the Vladimir Mother of God (late 11th/early 12th century), is of this type. The Virgin Eleousa usually holds the Child on her right arm, drawing him close to her and bending her head to touch his cheek, and the Child turns towards her and puts his arms around her neck.

Elijah (Elias) Old Testament prophet. He was sent by God to admonish the evil and idolatrous King Ahab of Israel and his wife Jezebel. Hiding from Ahab in the desert, Elijah was fed by ravens (1 Kings 17:4–6), an episode that was seen as epitomizing God's power to care for those who put their trust in him. Artists also chose to depict Elijah's contest with the pagan priests in which fire from heaven consumed the sacrifice prepared by Elijah while the worshippers of Baal were unable to kindle their offering (1 Kings 18:17–40). Most popular of all was his assumption into heaven in a fiery chariot from which he let fall his mantle to be taken up by *Elisha (2 Kings 2:11–13).

Elijah appeared with Moses talking to Christ at the *Transfiguration, an event that the gospel narratives agree took place on a mountain. Because of this, Elijah is associated in Christian tradition with high places, and chapels on mountaintops in Greece often turn out to be dedicated to him. Another reason for this is that

Elijah's name in Greek (Elias) is very close in spelling and sound to the name of the classical sun god Helios; sites on summits that in pagan times were sacred to the sun god were thus easily Christianized by a dedication to 'Saint Elias'. A further coincidence is between the fiery chariot of Elijah and the chariot of the sun in which Helios was thought to make his daily journey across the heavens.

Elisha Old Testament prophet; *Elijah's chosen successor. He is shown in art as the witness of Elijah's miraculous departure into heaven, when he received Elijah's mantle and 'a double portion' of his spirit (2 Kings 2:9–15).

Elmo, St *see* Erasmus, St.

Eloi, St (Eloy, Loy, Eligius) (*c*. 588–660) Gallo-Roman bishop. Eloi's talents as a metalworker first brought him to the attention of the Frankish king Chlotar II, for whom he made two thrones out of the quantity of gold originally designated for one. Chlotar's son Dagobert I made Eloi bishop of Noyon (641) in northern France; in this role he founded religious houses and promoted missionary work among the heathen Germanic tribes.

None of the famous examples of the goldsmith's art definitely attributed to him survive. His cult however spread over much of Europe and he was well known in England, being invoked in Chaucer's *Canterbury Tales* by the Prioress. The scarcity of English dedications to him (only one known) is perhaps explicable in that his function as patron saint of metal-workers was duplicated by the native saint, St *Dunstan. Eloi, like St Dunstan, may be shown holding the fiend by the nose with a pair of tongs, but Eloi's more usual emblem is a *horseshoe, often with a horse's leg attached.

Elphege, St *see* Alphege, St.

Entombment The laying of Christ's body in the tomb. It is one of the *Sorrows of the Virgin.

All four gospels recount how Joseph of Arimathea approached Pilate after the Crucifixion for permission to bury the body of Christ. The other mourners vary from gospel to gospel. Tradition, reinforced by the practice in mystery plays, generally accepted a group of seven people at the burial: Joseph himself, Nicodemus, the Virgin Mary, St John the Evangelist and the *Three Marys. Joseph (distinguished by the *purse at his girdle) and Nicodemus stand at the feet and head of the body in accordance with their role in the burial as described in John 19:40–2.

Entry into Jerusalem Jesus' triumphant ride into Jerusalem before his arrest and Passion. In the liturgical year it is celebrated on Palm Sunday, which is one of the great feasts of the Orthodox Church and marks the start of Holy Week. All four gospels contribute details: Jesus riding upon an *ass, the applauding multitude before the city gate, branches and garments spread in his path. John 12:13 specifies 'branches of palm trees', hence the name 'Palm Sunday' and the rituals associated with it.

Envy One of the *Seven Deadly Sins.

Epiphany (Greek: *epiphaneia*, 'an appearing') In the Christian context Jesus' manifestation of himself as divine. It is commemorated in the Church calendar on 6 January, but Eastern and Western Churches link it with different gospel events. One of the oldest of the Church's festivals. Epiphany ranked in importance with Easter and Pentecost by the 4th century. In the Western Church the Epiphany, connected with the visit of the *Three Magi to the baby Jesus at Bethlehem, is a less important feast than Christmas, by which is has been largely superseded. The East-

ern Church however retains the Epiphany as one of the twelve great feasts, associating it with the *Baptism of Jesus. The theme in either case is the same: the 'showing' or manifestation of Christ to the world.

The feast of the Epiphany is also known as Twelfth Day, being twelve days after Christmas and the traditional end of the Christmas holiday period. Twelfth Night, the evening of 5 January, was formerly an occasion for revelry and traditional ceremonies.

Erasmus, St (Elmo) (died ?303) Bishop and martyr, possibly of Syrian origin. He is believed to have died at Formia, near Naples, after various tortures and miraculous transportations around the eastern Mediterranean. His relics were transferred to nearby Gaeta, where the cathedral was dedicated to him in 1106.

Erasmus' unruffled demeanour when threatened by a thunderbolt while preaching caused him to be adopted as the patron saint of sailors; the electrical discharges that sometimes appear at the mastheads of ships in stormy weather are called St Elmo's fire and were believed to signify his protection. In this role Erasmus' attribute is a windlass or capstan, which probably gave rise to the later medieval legend that he was martyred by having his intestines wound out of his body with a windlass.

ermine The stoat in its winter fur of white, with a black-tipped tail. As the fur worn only by royalty and by high officials in Church and State, it is an emblem of nobility. It is also a symbol of purity, as the writers of medieval bestiaries perpetuated the belief that an ermine would prefer to die rather than allow its exquisite white coat to be sullied. The combined associations make ermine fur doubly appropriate to virgin saints of royal or noble birth, such as St *Ursula.

Etheldreda, St (Audrey) (*c.* 630–79) Anglo-Saxon queen, abbess of Ely. Although twice married for reasons of state, she was believed to have consummated neither marriage. In 673, after leaving her second husband, she founded a monastery at Ely to house both monks and nuns. Her shrine at Ely was a popular pilgrimage centre, which survived until 1541. In art Etheldreda is shown crowned, carrying an abbess's pastoral staff and accompanied by two *deer. The word 'tawdry' is a corruption of 'St Audrey', reflecting the cheap and nasty quality of the goods offered for sale at St Audrey fairs.

Eulalia, St (died ?304) Spanish virgin martyr. Her legend describes her as a twelve-year-old girl of Merida, who reproached the pagan governor for his persecution of Christians and who was then tortured and burnt to death when she refused to honour the pagan gods. Her cult was particularly strong in Spain, but also spread to Italy and France. The poet Prudentius, born about fifty years after her death, describes how a *dove flew out of her mouth at her death and snow covered her body until it was buried.

Eustace, St (Eustachius) Martyr of unknown date and locality. His legend tells of his conversion when he encountered a *stag with a crucifix between its antlers while out hunting. This episode was later taken over into the legend of St *Hubert, with whom Eustace shares the patronage of hunters.

His legend, which makes him a Roman general in the time of Trajan, has many fanciful elements of a kind common to romances, such as the family lost and found again. He was said to have perished by being roasted to death inside a brazen bull. This circumstantial fiction doubtless contributed to the great popularity Eustace enjoyed all over Europe. He is

patron saint of the city of Madrid and one of the *Fourteen Holy Helpers.

Many artists portrayed the scene of Eustace's encounter with the stag in a forest landscape with his hounds and horse. Less common is his portrayal as a single figure, as on the lefthand wing of Dürer's Paumgärtner altarpiece (*c.* 1500; Alte Pinakothek, Munich) where he holds a banner on which is depicted the stag's head and crucifix. Despite the strong similarities between Eustace and Hubert in art, the two saints can sometimes be differentiated by their dress, as Eustace often wears a soldier's armour and Hubert does not. Moreover, Hubert is very much linked to northwestern Europe, while Eustace appears over a larger geographical area.

Evangelists *see* Four Evangelists.

Eve *see* Adam and Eve.

eye A symbol of God's all-seeing power, sometimes placed in a triangle or cloud. In the Apocalypse the seven eyes of the mystic *Lamb are 'the seven Spirits of God sent forth into all the earth' (Revelation 5:6).

St *Lucy is shown in late medieval art holding her eyes on a stalk or dish. According to the account of the beheading of St *Alban, the executioner's eyes fell out as he struck the fatal blow; a mid-13th-century manuscript illumination (Trinity College, Dublin, MS 177) shows the soldier wielding his sword in his right hand while deftly catching the falling eyes in his left.

F

Faith *see under* Three Theological Virtues.

Faith, St (Foy) (?3rd century) Virgin martyr. What little is known of St Faith suggests that she suffered martyrdom at Agen (southwestern France). Her legend tells how she was tortured by being roasted on a brazen bed (or *gridiron) and then beheaded.

Her relics were transferred to Conques in central France, where they were housed in the 11th-century abbey church of Sainte-Foy. Conques became a major stopping point on one of the pilgrim routes to Santiago de Compostela, and from there returning pilgrims spread her cult to Italy, Spain and England. St Faith's popularity in England can be gauged from the fact that twenty-three ancient church dedications to her are recorded. Her role as protector of travellers is well illustrated in the story attached to the foundation (*c.* 1105) of the Benedictine priory of Horsham St Faith, founded in gratitude by Robert and Sybil Fitzwalter; they had been captured by bandits while on pilgrimage in the south of France and miraculously rescued by the saint.

St Faith is generally depicted with the instruments of her passion: a gridiron and/ or sword. Her identity, however, has been confused and sometimes partly merged with the personification of Faith as one of the *Three Theological Virtues.

falchion A short, slightly curved, thick-bladed medieval sword. It is an emblem of the apostle *Simon, who according to the version of his death given in the 13th-century compilation of saints' lives, *The Golden Legend*, was hacked to death with falchions by pagan priests.

falcon The emblem of St Bavo (died *c.* 653), a nobleman who abandoned worldly delights such as falconry to become a hermit near Ghent (in modern Belgium), the cathedral of which is dedicated to him. He is the patron saint of falconers.

Fall of Man The disobedience of Adam and Eve when, in defiance of God's prohibition, they ate the fruit of the tree of the knowledge of good and evil in the Garden of Eden (Genesis 3:1–6). The serpent tempting Eve to take the fruit was often shown with a human female head and bust in medieval representations of the scene; in other cases it has a horned devil's head. Later artists usually opted to portray it as wholly snake. The fruit itself may be an *apple or another fruit (the Bible does not specify).

The essential components of the biblical narrative – Adam, Eve and the tree with the serpent in it – occur in countless stained-glass windows, wall-paintings, illuminated initials, embroidered roundels, prints and in fact every artistic medium. The immediate consequences of the Fall are shown in the shame and confusion of the man and woman, clutching fig leaves to conceal their nakedness. In more elaborate compositions the artist sometimes includes the mayhem that broke out after the Fall among the animals of the garden which had previously lived there together in perfect harmony. Also often shown is the final scene of the story

(Genesis 3:23–4), the expulsion of Adam and Eve from the garden, either by God himself or by the angel with a flaming sword who is sent to guard the gate and prevent their return.

Feeding of the Five Thousand The multiplication of 'five loaves and two fishes' (Matthew 14:17) to provide enough food for the multitude who had followed Jesus to a 'desert place'. It is the only miracle of Jesus that is narrated in all four gospels. Matthew (15: 32–8) and Mark (8:1–9) also relate another occasion on which four thousand were fed from similar meagre stores. In the version in John 6, the spokesmen for the perplexed disciples are *Philip and Andrew; it is for this reason that Philip occasionally has *loaves of bread as his emblem. The scene is sometimes appropriately sited in the refectory of a monastery (*compare* Last Supper).

feet Vanishing into a cloud, they represent Christ at the moment of his *Ascension (Acts 1:9). A further refinement of this convention eliminates even the feet and indicates the event by just a pair of footprints on top of a stylized Mount of Olives. *See also* Washing of the Feet.

Fiacre, St (7th century) Irish-born hermit; patron saint of gardeners. He spent most of his life near Meaux in France, which became the centre of a cult that enjoyed particular popularity in the 17th and 18th centuries. In token of his renown as a gardener, St Fiacre's emblem is a *spade.

On account of his own strict avoidance of women, refusing to allow them anywhere near his hermitage, his help was especially invoked by those suffering from venereal disease. A chance association is with the light four-wheeled horse-drawn carriages formerly available for hire from a point near the Hôtel St-Fiacre in Paris; hence 'fiacre' as a word for 'cab'.

fig A tree sometimes considered to have been the tree of knowledge of good and evil in the Garden of *Eden. Although the Bible story does not specifically identify this tree, it does state that the leaves with which Adam and Eve sought to conceal their nakedness after the *Fall were fig leaves (Genesis 3:7). Like other *fruit associated with the Fall, the fig sometimes appears in pictures of the Virgin and Child or the Nativity.

The association of the fig with sin is reinforced by the gospel story of Jesus' cursing the fig tree that bore no fruit (Matthew 21:19–21; Mark 11:13–14).

fingers *see under* gesture.

fire A manifestation of the Holy Spirit and hence a symbol of divine inspiration. The biblical source is the description of the Spirit's descent upon the apostles at *Pentecost: 'there appeared unto them cloven tongues like as of fire . . . And they were all filled with the Holy Ghost, and began to speak with other tongues as the Spirit gave them utterance' (Acts 2:3–4). Hence fire is also sometimes associated with particularly eloquent preachers, such as St Antony of Padua. Pictures of the first Pentecost in both the Eastern and Western Church show each apostle with a flame hovering over his head.

A fiery heart is the emblem of St *Augustine of Hippo, signifying his burning love of God. In pictures of the subject known as the Mass of St *Martin, a globe of fire hovers over the saint's head. *See also* bush, burning.

fish One of the most ancient of all Christian emblems. The letters of the Greek word ICHTHUS ('fish') were interpreted in the early Church as standing for the initial letters of IESOUS CHRISTOS THEOU HUIOS SOTER ('Jesus Christ, Son of God, Saviour'), and early Christian writers referred to new converts as 'little fishes', follow-

ing Jesus' promise to make Peter and Andrew 'fishers of men' (Matthew 4:19). At a period when Christians were still facing persecution, a drawing of a fish, sketched for instance on the walls of the catacombs, was a convenient and discreet sign of their affiliations. At a slightly later date the fish was also taken to symbolize the Eucharist, and so was depicted with the Eucharistic *chalice, as in a 5th-century mosaic in the church of the Acheiropoietos, Thessaloniki.

Biblical scenes in which fish appear prominently are the *Feeding of the Five Thousand and the Miraculous Draught of Fishes (John 21:1–14). In the apocryphal book of Tobit, Tobias, acting on the advice of the disguised archangel Raphael, catches a giant fish from the River Tigris and by burning its heart and liver rescues his kinswoman Sarah from the demon Asmodeus; pictures of Tobias with the angel frequently show him catching or carrying the fish.

A fish is also the occasional symbol of St Peter in his role as fisherman and of the 4th-century bishop St Zeno of Verona. Fishy legends are attached to St Antony of Padua (reputed to have preached to an audience of fish) and to the Cornish saints Neot (died *c.* 877) and Corentin (date unknown), of both of whom it is said that they fed off a fish that miraculously never dwindled in size. The Breton abbot St Winwaloe (6th century) sometimes appears with a fish and the bell with which he used to summon it.

A salmon with a ring refers to a story told of the Celtic bishop St Kentigern (alias St Mungo) (d. 612), who evangelized areas of northern England and southern Scotland. A certain queen gave her husband's ring to her lover, and when the king discovered her guilt he hurled it into the sea, telling her that she must find it again within three days. St Kentigern advised that she should have confidence that all would be well, and sure enough the ring

turned up safely inside a salmon caught by one of Kentigern's monks. The legend is commemorated in the civic arms of Glasgow, which show a fish with a ring.

fishing net An emblem of the apostle St *Andrew, recalling his vocation before Jesus summoned him and Peter to be 'fishers of men' (Matthew 4:19).

Five Joys of the Virgin *see* Joys of the Virgin.

Five Thousand, Feeding of the *see* Feeding of the Five Thousand.

Five Wounds of Christ *see* stigmata.

flask As a container for water, a necessary part of a pilgrim's equipment and therefore a symbol of pilgrimage in general. It is particularly associated with St *James the Great, who is often shown in art dressed as a pilgrim to his own shrine at Compostela, either holding the flask or with the flask attached to his belt. *See also* ampulla.

As part of a medical practitioner's equipment, a flask (used for collecting urine) may be an emblem of SS *Cosmas and Damian.

Flight into Egypt The escape of the Holy Family from the massacre of the *Holy Innocents ordered by King Herod (Matthew 2:13–15), after Joseph had been warned by an angel to flee. Mary is usually shown carrying the baby Jesus on a donkey, led along by Joseph, while soldiers search in the background or execute the children left behind in Bethlehem. Sometimes they are accompanied by Joseph's son or sons by a previous marriage.

A related subject is the Rest on the Flight into Egypt, usually an idyllic scene with the child asleep, but often with the same menacing background of armed men. In either subject there may be peasants sowing or reaping corn, in allu-

sion to the so-called 'grain miracle'. Knowing that Herod's soldiers are in close pursuit, the Virgin has asked some peasants whom they passed sowing corn in their fields not to betray the family to their pursuers; the grain miraculously springs up and ripens immediately, so that when the soldiers come up and ask the peasants if they have seen a mother and child pass by the field, they can truthfully reply, 'Not since we were sowing this corn.' Understandably misled, the soldiers abandon the chase.

Versions of this legend, which has roots in the pagan rites of a goddess who made the fields fertile by walking over or around them, are attached to certain fugitive female saints (St Milburga in England, St Radegund in France) and became part of the story of the Flight into Egypt at least as early as the 12th century.

Florian, St (died ?304) Martyr. He was a Roman soldier in the province of Noricum (part of modern Austria), who converted to Christianity. During the persecution of Christians by Emperor Galerius Florian was martyred by being thrown into the River Ems with a millstone tied to him. His protection is invoked against fire, as he is said to have extinguished a great conflagration by throwing a single bucket of water over it. The centre of Florian's area of influence is in Austria and Bavaria, where artists show him as a Roman soldier or medieval knight in armour, often with a banner marked with a cross; as attributes he may have either millstone or bucket, the latter more especially in statues commemorating his intervention against a fire.

flowering staff *see under* staff.

flowers In a *basket, or held in her skirt, the emblem of St *Dorothy. In a posy, an emblem of St *Zita. *See also* iris; lily; rose.

footprints Left on a mountain-top, a sign

of Christ's *Ascension in some medieval versions of the scene.

Fortitude *see under* Four Cardinal Virtues.

Forty Martyrs of Sebaste (*or* Forty Armenian Martyrs) Christian soldiers of the Roman 'Thundering Legion' (Legio XII Fulminata), martyred in 320 at Sebaste (modern Sivas in eastern Turkey). They were made to stand naked overnight in a frozen lake, with fires and baths of hot water on the bank to tempt them to apostatize. All but one held out, and his place was promptly taken by another soldier, who had been inspired by their heroism to declare himself a Christian. By the morning most had died of exposure, and those few who had survived were then killed.

The Forty Martyrs of Sebaste are greatly honoured in the Orthodox Church, with a feast day on 9 March, and are a popular and striking subject for icons. However their commemoration (10 March) was dropped in 1969 from the Western calendar. The icons follow a rigid formula, with the main element in the scene the forty half-naked men of assorted ages huddled together on the ice, with some of them already fainting with the cold. In the background may be a bath-house and blazing fires, while suspended over their heads may be seen forty tiny crowns, the reward of martyrs. An icon of uncertain date in St Catherine's monastery, Sinai, also shows the apostate soldier darting into the bath-house, while in the opposite corner the man who took his place is flinging off his garments.

fountain A symbol of God's life-giving power. In art a fountain giving rise to the *Four Rivers of Eden is usually shown in the centre of the Garden and that is equated with the 'fountain of the water of life' in Revelation 21:6. *See also under* deer.

Medieval artists often depicted the Virgin Mary in an enclosed *garden in which there is a fountain, an allusion to the passage in the Song of Songs that describes the beloved as 'A garden enclosed . . . a spring shut up, a fountain sealed' (4:12).

Four Cardinal Virtues Prudence, Temperance, Justice and Fortitude. These secular virtues, first extolled by the pagan Greek philosophers, were taken over by early Christian moralists, and were held by them to be complementary to the *Three Theological Virtues.

In personified form the most familiar of the Cardinal Virtues is Justice: a woman blindfolded (to symbolize impartiality) and holding scales (to weigh the truth) and a sword (to carry out her judgements). The attributes of Temperance are a bridle and bit (to symbolize restraint and self-control) and, less often, an hourglass or clock. Prudence grasps a mirror and a serpent or sometimes a sieve (all symbols of wisdom, caution, reflection); she is sometimes shown with two faces, one old and one young (signifying that she keeps watch over both the past and the present). Fortitude wears armour, ready to withstand all troubles and temptations.

Four Crowned Martyrs (*or* Four Crowned Saints) (d. ?306) Martyrs, whose identity has been much debated. They are frequently referred to under their Italian title of the 'Quattro Coronati'. Their crowns are the symbol of their martyrdom, but they also sometimes carry the tools of the stonemason's trade, such as a saw or hammer.

There appears to have been confusion between a group of five stonemasons killed at Sirmium (modern Mitrovica in former Yugoslavia) and four Roman soldiers reputedly put to death for refusing to honour a pagan statue. The names of the martyrs vary in the different accounts (Simpronian, Claudius, Nicostratus, Castorius or Severus, Severianus, Carpophorus, Victorianus). According to the legend of the martyrs of Sirmium, the men refused to make a statue of the god Aesculapius and were drowned by being thrown into the River Sava in leaden boxes.

Two factors ensured the growth of their fame: the translation of their relics to Rome, where, by the second half of the 6th century, a famous church on the Caelian Hill was dedicated to them, and their adoption as patrons by medieval guilds of stonemasons. The Roman church probably inspired the dedication to them of a church in Canterbury, mentioned by Bede as being saved from fire in 619 by the prayers of Archbishop Mellitus. Their longstanding connection with stonemasons is memorialized in the name of the Quatuor Coronati lodge of Freemasons in London.

Four Daughters of God Mercy, Truth, Righteousness and Peace. They are normally personified as two pairs of young women, greeting each other: 'Mercy and truth are met together; righteousness and peace have kissed each other' (Psalm 85:10).

Four Evangelical Beasts The symbols of the *Four Evangelists. Their identity derives from the four creatures seen in the vision of the throne of God in Revelation: 'the first beast was like a lion, and the second beast was like a calf, and the third beast has a face as a man, and the fourth beast was like a flying eagle. And the four beasts had each of them six wings about him; and they were full of eyes within' (Revelation 4:7–8). This description is based on the Old Testament account of the four living creatures in the vision of Ezekiel (1:5–14). They constantly appear around the figure of Christ in majesty in the tympana of romanesque and Gothic churches, for example over the main portal of the church of St-Trophime, Arles (c. 1180).

The beasts are among the most universal symbols in Christian art, appearing either independently or together with the evangelist they represent: the lion for St Mark, the calf (*or* ox) for St Luke, the man for St Matthew and the eagle for St John. The tradition connecting them with the evangelists apparently originated with St Irenaeus of Lyons (2nd century), but in that earliest scheme the lion is assigned to St John and the eagle to St Mark; although uniformly discarded in the West, this contrary tradition continued to have some currency in the East, surviving in Russia as late as the 16th century.

Four Evangelists SS *Matthew, *Mark, *Luke and *John (the Evangelist). In art they very often appear together or set around the four corners of a scene or of a page in an illuminated manuscript. They are differentiated from each other by their particular symbols (*see* Four Evangelical Beasts) or their symbols may simply appear in their stead. A common convention, particularly in manuscripts, was to show them writing at their desks.

When they are depicted along with the apostles or other figures they may be distinguished by holding scrolls or books in their hands as evidence of their special status as the writers of the gospels.

Four Greek Doctors SS *Athanasius, *Basil (the Great), *Gregory Nazianzus (the Theologian) and *John Chrysostom, the four most venerated teachers in the Eastern Church. As bishops, they are shown in icons wearing their episcopal robes, with the *omophorion as a notable feature of their vestments. The differing cuts and colours of their *beards are traditional and are a useful distinguishing characteristic. Very often, like their Western counterparts, the *Four Latin Doctors, they hold books in token of their revered position as scholars and writers.

Four Horsemen of the Apocalypse Famine, war, pestilence and death, according to the traditional interpretation of Revelation 6:2–8. The passage describes the white, red, black and 'pale' horses whose riders will be given power to afflict the world. One of the most famous interpretations of them is Dürer's woodcut (1497–8) showing them riding down a group of terrified people.

Four Last Things Death, judgement, heaven and hell. They appear together in sets as subjects for meditation in medieval and Renaissance art.

Four Latin Doctors SS *Ambrose, *Augustine of Hippo, *Gregory (the Great) and *Jerome, the four most venerated teachers in the Western Church. Like the *Four Greek Doctors, they are shown individually or as a group holding books or writing materials or engaged in writing. They can often be differentiated by their different ecclesiastical robes; Gregory, for instance, may appear anachronistically in the full regalia of a medieval pope.

Four Living Creatures *see under* Four Evangelical Beasts.

Four Rivers of Eden The four branches of the river that flowed out of Eden: Pison, Gihon, Hiddekel and Euphrates (Genesis 2:10–14). They featured on maps as late as the 17th century, for instance in Sir Walter Raleigh's *History of the World* (1614). *See also* river.

Fourteen Holy Helpers A group of saints and martyrs, known also as the Auxiliary Saints, whose prayers on behalf of others at their deaths endowed them with special power to help people in distress, notably those about to die or suffering from various diseases. Their collective cult flourished in 14th-century Germany and

spread to Hungary and Sweden, but fell into disfavour with the Roman Catholic reformers of the Council of Trent in the mid-16th century.

The roll call of the Fourteen Holy Helpers varied slightly from place to place; usually on the list were SS *Acacius, *Barbara, *Blaise, *Catherine of Alexandria, *Christopher, *Cyricus, *Denys, *Erasmus, *Eustace, *George, *Giles, *Margaret of Antioch, *Panteleimon and *Vitus, with SS *Antony, *Dorothy, *Leonard, *Nicholas, *Sebastian and *Roch occasionally usurping a place.

fox A universal symbol of guile. Numerous folk-tales concerning the artfulness and predatory ways of foxes – from Aesop's fables onwards – were reinforced in the religious context by the 'little foxes, that spoil the vines' in the Song of Songs (2:15); these were interpreted by Christian commentators as the powers of evil that steal the fruits of the soul. A 12th-century floor mosaic in the basilica of Sta Maria e Donato on the island of Murano in the Venetian lagoon shows a fox, bound and carried off helpless by two cockerels, an emblem of guile defeated by vigilance.

Foy, St *see* Faith, St.

Francis of Assisi, St (1182–1226) Italian mystic and founder of the Franciscan Order of friars. His life and miracles are most fully illustrated in Giotto's frescoes (1297–1300) in the upper church of the basilica built in Assisi within a few years of his death. Among the famous incidents depicted are the saint's restoration of his clothes to his father (in token of his casting off worldly obligations), his sermon to the birds and his receiving the *stigmata. The way in which he is depicted in these murals set the pattern for later artists: wearing the tonsure and the coarse brown robe of his order, usually barefoot and showing the stigmata.

fruit With flowers in a *basket, the emblem of St Dorothy.

In pictures of the Virgin Mary the frequent presence of fruit is a reminder of her position as the Second Eve; as sin and death came into the world through Eve taking the forbidden fruit, so grace and life are restored to it by Mary bearing Jesus. In this case the *apple and *fig are direct allusions to the fruits connected with the *Fall, while the *cherry and *pomegranate have more positive associations with the work of redemption and the *orange is a reference to the Virgin herself.

In a more general sense, fruit alludes to the numerous New Testament passages in which it used as a metaphor for actions: 'Ye shall know them by their fruits . . . every good tree bringeth forth good fruit' (Matthew 7:16–17)

furnace *see under* Daniel.

G

Gabriel The *archangel sent by God to foretell the births of *John the Baptist (Luke 1:11–20) and Christ (Luke 1:26–38; *see* Annunciation). In the apocryphal *Gospel of James* he is also the angel of the annunciation of the birth of the Virgin Mary to Joachim and Anna. The angel who speaks to the women (*see* Three Marys) at Christ's empty tomb (Matthew 28:1–7), although unnamed, is often identified with Gabriel and given his attribute of a lily or a fleur-de-lis on a sceptre. Gabriel also appears in the book of Daniel (8:15–26, 9:21–7) to explain to Daniel the meaning of the visions he had seen, and Jewish tradition identifies him with the angel who foretold the birth of Samson (Judges 13:2–23).

gammadion *see under* swastika.

garden A setting often associated with the Virgin Mary. Late medieval and Renaissance artists liked to show her seated in an enclosed garden (Latin: *hortus conclusus*) or 'paradise', signifying at once her perfect detachment from worldly pollution and her fruitfulness. The allusion is to the verse in the Song of Songs: 'A garden enclosed is my sister, my spouse' (4:12). A typical late medieval (1410) interpretation of this motif in art is *The Paradise Garden of the Virgin* by the so-called Oberr-heinischer Meister (1410: Städelsches Kunstinstitut, Frankfurt).

Identification of the Virgin with the garden gave rise to elaborate allegorical interpretations in the Middle Ages, and the flowers, fruit and other objects were all endowed with their own particular mean-ing. From these paradise gardens of the Virgin, animals were usually excluded, in contrast to the situation in the Garden of *Eden. *See also* bower; fountain; gate.

Garden of Eden *see* Eden, Garden of.

Garden of Gethsemane *see* Gethsemane, Garden of.

gate A symbol of the passage from one state to another. Thus in medieval art the angel chasing Adam and Eve from Eden into the outer world drives them through an elaborate gate and then stands guard before it. In contrast, the paradise *garden of the Virgin Mary, accessible only to the Holy Spirit, has no gate or only one that is firmly locked against the world. The narrow gate that leads to eternal life – as opposed to the broad highway to destruc-tion (Matthew 7:13–14) – also sometimes appears in an allegorical context.

Broken-down gates with shattered locks and bars lie at the feet of the triumphant Christ in scenes of the *Harrowing of Hell (*see also* door). The imagery derives from several biblical passages, notably Psalm 107:14,16: 'He brought them out of dark-ness and the shadow of death, and brake their bands in sunder . . . For he hath broken the gates of brass, and cut the bars of iron in sunder.' Matthew 16:18 also refers to 'the gates of hell', meaning the powers of death and sin that will never overcome the Church.

Geneviève, St (Genovefa) (died c. 500) Abbess and virgin; patron saint of Paris. Dedicating herself to the religious life

from an early age, Geneviève was encouraged on her chosen path by St *Germanus of Auxerre. Her legend recounts how she won the respect of the Frankish rulers of Paris and when the city was menaced by the invading Huns it was her prayers that caused them to turn aside to attack Orléans instead. After her death she continued to protect the city in emergencies. She appears almost exclusively in the art of northern France, dressed as a nun and holding a lighted *candle, usually with a small devil hovering about her.

George, St (?early 4th century) Martyr; patron saint of soldiers, archers and others, such as ironworkers and armourers, whose trades have military associations. Legends accumulated around him from an early date; the core of this fanciful history suggests that he may have been a soldier from Palestine who was tortured and beheaded during the persecution of the Christians under Emperor Diocletian. By the early 6th century his supposed tomb at Lydda (modern Lod) was a cult centre with a reputation for miraculous cures.

Despite the factual doubts about his life, George is honoured in both East and West. In the Orthodox Church he has the honorific title of 'the Great Martyr'. A play on the Greek roots of his name (*georgos*, 'one who tills the earth', i.e. a farmer) won him a place of patronage in the farming calender. In Greece farm labourers' contracts used to run from St George's day (23 April, as in the West), and he is still considered the patron of shepherds.

The tale of how St George killed the dragon and rescued the king's daughter is a late addition to his legend, popular from the 13th century onwards; the tale has strong similarities to the pagan myth of Perseus and Andromeda and may well have been taken over from the legend of St *Theodore. It is this episode that primarily captured the imagination of Western artists, who showed St George as a knight in full armour on horseback. His shield usually bears his identifying badge of a red cross on a white background. (This – and the fact that he lacks the angelic wings – distinguishes scenes of his slaying the dragon from the very similar ones of the archangel *Michael overcoming the Devil.) By tradition, his horse is usually white, following an interpretation of Revelation 6:2 ('behold, a white horse . . . and he went forth conquering and, and to conquer') as applying to a martyr.

In the icons of the Eastern Church George appears as a warrior saint, either on horseback or on foot, wearing the characteristic armour of a Roman or Byzantine soldier. Sometimes a tiny figure appears seated behind him on the rump of his horse, representing a slave boy freed by the saint; the boy may hold a cup, because he was rescued at the moment when he was serving wine to his master. The saint's white charger helps to distinguish him from St *Demetrius, who generally has a dun or bay mount. Icons of St George slaying the dragon became a speciality of Cretan artists in the 15th century and remained popular for the next two centuries. However, in the level of the iconostasis that represents the saints in heaven, military gear would be inappropriate, so there George appears in civilian dress, with the martyr's red robe or tunic.

The significance of St George in the Middle Ages was enhanced by his being adopted as the patron of chivalry – the chivalric twin ideals of valour and the protection of women being epitomized in the story of his dragon-slaying – and of horsemen generally. St George was known in Western Europe from at least as early as the 7th century; for instance, the purported miraculous appearance of his relics on the western coast of the Cotentin peninsula in France in the mid-8th century brought him a considerable number of church dedications along that seaboard

(twenty-two in Manche alone).

However, his real rise to prominence seems to date from the time of the First Crusade, when a vision of SS Demetrius and George heralded the Christians' capture of the town of Antioch (1098). George was enrolled among the *Fourteen Holy Helpers, and Barcelona and Genoa are among the many cities and towns that put themselves under his care. He was also associated with the Spanish effort to rid Spain of its Muslim overlords: Marzal de Sax's Valencia altarpiece (early 15th century; Victoria and Albert Museum, London) imagines him, red cross prominent on his surcoat and horse trappings, fighting in the thick of the Moorish host alongside King James I of Aragon-Catalonia at the battle of Puig de Cebolla (1237).

During the Third Crusade (1190s) Richard I of England placed his troops under George's protection, and the saint's cult flourished under the influence of the returning crusaders. By the mid-14th century he was supplanting the earlier English kings, *Edward the Confessor and *Edmund, on the way to becoming the principal patron saint of England. Around two hundred parish churches are still dedicated to him and he also appears on scores of 20th-century war memorials. His long-running appeal to all levels of English society is further demonstrated in the popularity of the mummers' play *St George and the Dragon*, which formerly existed in many different versions up and down the country.

Gereon, St (Geron) (3rd century) Soldier saint and martyr. Like St *Maurice, Gereon was an officer in the Theban Legion. He and his companions suffered martyrdom at Cologne, where the church named after him was the centre of a strong local cult. Gereon, who appears in military dress with a cross on his breastplate, is seldom found in art outside Germany.

Germanus of Auxerre, St (*c.* 378–448) Bishop of Auxerre from 418. He was a significant force in the affairs of both the French and the British churches and twice visited Britain to combat heresy. His tomb in Auxerre was a famous pilgrimage attraction and his name lives on in church dedications in both France and England. (The famous church of St-Germain-de-Près in Paris is not however connected with him, but with Germanus of Autun, bishop of Paris in the 550s.)

The episode from Germanus' life that most attracted artists was the death and revival of the *ass that had carried him on a visit to the Empress Galla Placidia at Ravenna shortly before his own death.

Gertrude of Nivelles, St (626–59) Abbess and benefactress. At an early age Gertrude became abbess of a double monastery (i.e. for both men and women) built by her mother at Nivelles (now in Belgium). She was renowned for her generous encouragement of missionary endeavour among the local pagans and for the holiness of her life.

Various folklore elements attached themselves to her cult, for instance the belief that she protects the dead on the first stage of their journey to the other world. In art she appears with an abbess's pastoral staff and a mouse; it is uncertain exactly how her connection with rodents occurred, but her assistance was commonly sought against plagues of rats and mice. Her cult spread through the Low Countries to England, Germany and beyond; she is depicted, for instance, on a fine late 15th-century altarpiece commissioned by a cloth trade guild in Tallinn (Estonia).

Gervase and Protase, SS Italian martyrs of unknown date, whose bodies were discovered in Milan by St *Ambrose in 386. In the course of being transferred from their former resting place to Ambrose's

new basilica, in the crypt of which they still remain, the relics accomplished various miracles, described by St *Augustine (*Confessions* ix.7). The spread of their cult to France was assured when Ambrose gave some of the relics to the bishops *Martin of Tours and Victrice of Rouen when they passed through Milan on their way back from the Council of Rome (386). There were twenty-nine very ancient dedications to Gervase and Protase in Normandy alone (the cathedral at Séez was dedicated to them but later rededicated to the Virgin), but only one (Little Plumstead, Essex) in England.

Gervase and Protase appear together in art. They have no special emblem and, as nothing is known of their lives, their *Acts* are a fabrication. They are in the not uncommon category of 'twin' saints who some scholars believed were a Christianized form of the pagan cult of Castor and Pollux, known as the Dioscuri.

gesture A stylized vocabulary of body language was available to the medieval artist to convey specific emotions, reactions and situations. For instance, the way in which the fingers are held in the gesture of blessing had symbolic significance. One of the best-known hand positions was adopted from a gesture associated in pagan Rome with orators, judges and teachers: thumb, index finger and middle finger of the right hands extended and the fourth and fifth fingers bent inwards to the palm in a gesture that simultaneously arrests the viewer's attention and asserts the gesturer as a figure of authority. Medieval Christians interpreted this as the two outstretched fingers and the thumb signifying the Trinity, and the two other fingers the dual nature of Christ as both human and divine.

There were a number of variations. Sometimes the thumb was bent across the palm to touch the fourth finger, the gesture associated in the art of the Western Church with the bestowal of a blessing. A variation on this has the third and index fingers separated to make a V, as in Churchill's V-sign. *See also under* hand; *orans*.

Gethsemane, Garden of The garden on the outskirts of Jerusalem that was the traditional scene of Jesus' anguished vigil and arrest prior to his Passion. The vigil, known as the Agony in the Garden, and the actual arrest were subjects that appeared both independently and as part of a Passion sequence; often the Agony in the Garden includes a background vignette of the troop sent by the Jewish religious authorities to arrest Jesus.

The principal figures in the Agony in the Garden are Jesus himself and, a little distance away, the sleepy apostles Peter, James and John (Matthew 26:36–46). Other followers, also asleep, may be shown further off. The eucharistic cup or chalice very often appears as the literal embodiment of Jesus' prayer in anticipation of his suffering: 'O my Father, if it be possible, let this cup pass from me' (Matthew 26:39). On the authority of Luke's gospel, an angel may also be present, 'strengthening him' (Luke 22:43). Known as a subject in art from the 4th century, the Agony in the Garden gets full treatment in the mosaics of St Mark's, Venice (*c.* 1220). Byzantine artists show Jesus both in prayer and admonishing the disciples; Western artists tend to concentrate on the praying Jesus.

The actual arrest is treated as high drama by Renaissance artists; lit by the light of torches, the 'great multitude with swords and staves' presses round Jesus while *Judas Iscariot identifies him to his captors (Matthew 26:47–50). A subsidiary incident mentioned in all four gospels is the cutting off of an ear of a servant of the high priest; John (18:10) identifies the disciple who wielded the sword as Peter and gives the servant's name as Malchas.

Luke (22:51) asserts that Jesus touched the ear and healed it.

giant St *Christopher, described in his legend as a giant, was commonly depicted as larger than a normal human being.

*David is more often shown with the severed head of the Philistine giant Goliath than with the living giant.

Giles, St (Aegidius) (?early 8th century) French hermit, about whose life little is known. He probably lived at or near St-Gilles-du-Gard (Provence), where a fine romanesque church, damaged in the 16th century and much altered in the 17th, was the centre of his cult.

Giles sometimes appears just as a hermit, holding a staff, but is often also seen with an arrow and/or a deer. These allude to the most famous incident in his legend, in which Giles was maimed by an arrow as he was protecting a hind from some hunters. He was therefore adopted as patron saint of cripples (and, by extension, beggars) and of nursing mothers. In Germany Giles was accounted one of the *Fourteen Holy Helpers, as it was believed that his prayers were particularly effective, even on behalf of sinners who had not fully confessed. His cult was famous all over Europe, and in England alone over a hundred and sixty churches and more than a score of hospitals bore his name. His feast day (1 September) was associated with fairs at Winchester and Oxford, the latter still surviving.

Giles was also patron of the work of blacksmiths, and a church dedicated to him was sometimes sited near an exit from a town, close by a forge; travellers could visit the church while their horses were being shod for a journey.

girdle As an item of women's clothing, often invested in legends with talismanic powers. An embellishment to the original apocryphal narratives (attributed to SS

John the Divine and Joseph of Arimathea), from which belief in the Virgin's *Assumption is derived, describes how the Virgin Mary, at the moment of her being taken into heaven, threw down her girdle to St *Thomas to convince him of her bodily ascension.

The throwing down of the girdle appears as an incident in late medieval and Renaissance depictions of the Assumption, the story itself having apparently originated in Italy some time around 1200. The relic known as the Sacred Girdle was brought from the Holy Land to Prato (near Florence) in 1141 and is preserved there in the Duomo; it is probable that the episode of St Thomas and the girdle was added to the Assumption narrative in connection with the Prato cult.

The subject appears in various media and in varying degrees of elaboration. The 15th-century Sienese artist Matteo di Giovanni shows the enthroned Virgin being borne skywards by angels while the girdle slithers down from her lap into the hands of Thomas who stands below by her tomb (painting in National Gallery, London). A much simpler version can be seen in the stained glass (c. 1325–50) of the church at Beckley, Oxfordshire, where the Virgin, lifted upwards in a semi-lying position, leans over to drop the girdle to the praying Thomas below.

In England, enthusiasm for the motif in church art of the early 14th century was probably related to the recent acquisition by Westminster Abbey of a girdle relic. The cult of the girdle was also known in the East, where the monastery of Vatopedi on Mount Athos too has possessed a wonder-working girdle of the Virgin since the 14th century.

The knots in the girdle worn by monks are reminders of their monastic vows and may serve, like the *rosary, as an aid to prayer.

globe Surmounted by a cross, the symbol

of domination over the world. Both God the Father and Christ enthroned in majesty very often hold such an orb, and it is also an attribute of Christ in his role of *Salvator Mundi. Byzantine artists also give it as an attribute to the Christ Child in his mother's arms, instead of or in addition to a *scroll.

In the Orthodox Church it is also an attribute of the *archangels, and in this case the globe often has inscribed upon it the Greek letters IC XC NI KA (*I[esu]S CH[risto]S NIKA*, 'Jesus Christ conquers') set between the four arms of a Greek cross. *See also* ball.

Gluttony One of the *Seven Deadly Sins.

Glykophilousa *see under* Eleousa.

goats Symbols of the souls of the wicked, contrasted with *sheep at the *Last Judgement. The source of the imagery is in the words of Jesus: 'he shall set the sheep on his right hand, but the goats on his left' (Matthew 25:33).

God For the different conventions governing the depiction of God the Father, God the Son and God the Holy Spirit *see under* Trinity.

Golden Calf The idol created by *Aaron from gold ornaments donated by the Israelites in the desert while Moses was on Mount Sinai receiving the Ten Commandments from God (Exodus 32:1–6). The ensuing scenes of orgiastic worship were a favourite with painters. The calf itself is usually shown mounted on a column.

goldfinch When associated with the Virgin and Child, a foreshadowing of Christ's Passion. It appears next to the Child in the centre foreground of Ghirlandaio's *Adoration of the Shepherds* (late 15th century; Sta Trinità, Florence), but more commonly it is held in the Child's hand, as in

Tiepolo's *Madonna of the Goldfinch* (National Gallery of Art, Washington, D.C.). The bird's diet of thistles and other spiny weeds was associated with the crown of thorns.

Good Samaritan The hero of one of Jesus' most famous parables (Luke 10:30–6), told in response to the questioning of a certain lawyer, who asked Jesus, 'And who is my neighbour?' (10:29). The point about choosing a Samaritan as the 'neighbour' to the man who fell among thieves on his journey was that there was no love lost between Jews and their geographical neighbours the Samaritans, whom observant Jews despised and shunned as ritually impure.

The stage of the story usually shown in art is the point when the Samaritan has put the wounded man upon his own 'beast' (usually shown as a donkey) and brought him to the door of the inn. It was a subject interpreted several times by Rembrandt, who also treated the earlier scene of the Samaritan finding the man on the road.

Good Shepherd *see under* shepherd.

goose The emblem of SS *Martin and Werburga. In the case of St Martin the connection seems to have arisen through the date of his feast day (11 November), the time of year when geese were penned for fattening. The legend of the 7th-century English abbess St Werburga credits her with restoring a dead goose to life.

gourd As a water container, the dried fruit was part of a medieval pilgrim's or traveller's equipment. St *James the Great, when shown in the guise of a pilgrim, often carries a gourd, as may the journeying archangel *Raphael.

Three scenes from the *Jonah story were given a prominent place in the funerary art of the early Christian centuries, the final one of the three depicting the vine of

the gourd (Latin: *cucurbita*) that God caused to grow over the 'booth' that sheltered the prophet from the heat (Jonah 4:5–11). God's power to make the gourd spring up as a shelter was interpreted as an allegory of his power to refresh the soul in paradise; Jonah lying at rest under the vine was therefore often depicted on early Christian sarcophagi.

grail *see* cup; Holy Grail.

grain *see under* corn.

grapes Symbol of the sacramental wine of the Eucharist. They are a frequent motif in Christian art, often appearing in pictures of the Virgin and Child. When grapes are depicted along with ears of *corn, the latter stands for the Eucharistic bread. *See also under* vine.

Green Man A grotesque figure found in many medieval churches, consisting of a human head surrounded by foliage, often with the leaves sprouting from the mouth, cheeks or forehead. As a decorative element, the Green Man derives from masks set into acanthus scroll ornament, which appeared in many parts of the Roman empire from the 2nd century AD onwards. It is a versatile motif for filling awkward spaces, and may appear on roof bosses or corbels, under misericord seats, on capitals and in spandrels and the smaller lights of stained-glass windows. In the form of an acanthus-leaf mask it appears as a console (support) beneath the rider statue in Bamberg Cathedral (*c.* 1237). Other carvers used indigenous Western European plants for the foliage, oak and hawthorn being particularly popular.

The identity and significance of these figures, which appear very widely in England, France and Germany, are debated. Often they have a sinister, demonic aspect, perhaps recalling some woodland spirit from the pre-Christian past. The Green Man's connection (if any) with the jack-in-the-green (a man encased in a framework covered with leaves) who features in traditional May games is obscure. Besides being the colour of regeneration and fertility, green is associated with magical beings.

Three-headed versions of the Green Man seem intended to call to mind Beelzebub, 'prince of devils' (Matthew 12:24). An ancient tradition, dating at least from the apocryphal *Gospel of Nicodemus* (?5th century), visualized Beelzebub with three heads guarding the gates of hell against Christ, either as a sort of anti-Trinity or, by association with the guardian of the pagan Hades, the triple-headed dog Cerberus.

Gregory I (the Great), St (*c.* 540–604) Pope (590–604), one of the *Four Latin Doctors of the Church. Gregory was born into a noble Roman family and enjoyed a successful secular career, but then became a monk (*c.* 574) at the monastery of St Andrew on the Caelian Hill in Rome, which he had founded himself out of his great wealth. He held various important ecclesiastical appointments, including that of papal envoy to the court of Constantinople before becoming pope. Among his many major achievements was the mission of St *Augustine of Canterbury to convert the Anglo-Saxons. Over thirty pre-Reformation English churches were known to have been dedicated to him. He was also a prolific and influential author.

In art he is usually shown anachronistically in the robes and triple crown of a late medieval pope. Because his inspiration as a writer was believed to come directly from God, he may also appear in the act of writing, with the Holy Spirit in the form of a *dove dictating to him. A third tradition, especially popular in northern Europe at the close of the Middle Ages, was the Mass of St Gregory, in which the pope is shown celebrating the Eucharist while a vision of

Christ, either on the Cross or displaying his wounds, appears over the altar as confirmation of the doctrine of the Real Presence at the Eucharist.

Gregory Nazianzus (the Theologian), St (329–89) Writer and scholar; one of the ★Three Holy Hierarchs and ★Four Greek Doctors of the Church. He was born in Cappadocia (Asia Minor) and despite being temperamentally unsuited to public life – he resigned as bishop of Constantinople after only a few weeks – his writings and orations were instrumental in ensuring the final overthrow of the Arian heresy. In art his distinguishing personal characteristic is a luxuriant grey beard.

greyhound The emblem of St Ferdinand (Ferdinand III of Castile (1199–1252)). He succeeded to the throne of Castile in 1217 and united it with Leon in 1230. Under him the process of recovering Spanish territory from the Muslims gained an unstoppable momentum with the reconquest of most of Andalusia. His cult as a warrior king spread spontaneously all over Spain, although his formal canonization had to wait until 1671.

gridiron The emblem of SS ★Laurence, ★Faith and ★Vincent of Saragossa. The way that the gridiron is treated in art varies from a full-sized bed to a tiny barred rectangle held by the saint (as in the early 14th-century painting on the east wall of the chapel of St Faith, Westminster Abbey, or in the St Laurence window on the north side of the nave of Malvern priory church). The popularity of St Laurence ensured the existence of numerous depictions of his martyrdom in painting, stained glass and sculpture. A late 15th-century English alabaster panel (Castle Museum, Nottingham) shows him chained to the gridiron while assistants stoke the flames beneath.

H

habit The dress of monks, friars and nuns. Saints who were members of religious orders are generally shown wearing the appropriate habit, and this can be a useful pointer to their identity.

St *Catherine of Siena is usually dressed in the black and white habit of a Dominican tertiary. St *Theresa of Avila and her namesake *Theresa of Lisieux wear the dark brown habit and black veil of the Carmelite Order. St Rita of Cascia (1377–1447), a popular saint invoked worldwide, particularly by women with errant or violent husbands, wears the habit of an Augustinian nun. In France a nun wearing a crown may be St *Bathild.

SS *Francis of Assisi and *Antony of Padua wear the brown robes of the Franciscan Order. St *Benedict wears either the black habit of the original Benedictines or the white of the reformed order. St *Nicholas of Tolentino is among those generally shown in the black habit of the Augustinians, while a white one may indicate St *Bernard of Clairvaux or one of his Cistercian followers. A black-habited elderly monk with a blue tau *cross marked on the habit is most likely to be St *Antony of Egypt.

Hagar The Egyptian servant of Sarah, wife of *Abraham. Before Sarah's own son Isaac was born, Hagar conceived a child by Abraham, whom he called Ishmael. After Isaac's birth Sarah insisted, despite Abraham's reluctance, that Hagar and Ishmael should be driven out into the desert. There they would have died had not God intervene to provide them with water (Genesis 21:9–21).

Rembrandt was among the numerous artists who have been attracted to the human drama of the rejection of Hagar. Artists have also shown the moment at which an angel reveals to Hagar the whereabouts of the life-saving water.

hair In women saints, long flowing hair is an attribute of the virgin martyrs, but also of the reformed prostitutes SS *Mary Magdalene and *Mary of Egypt. In the case of the latter the hair is so abundant as to serve as substitute clothing (like the *beard of St Onuphrius). Hair very elaborately dressed is often the sign of a courtesan in Italian Renaissance art; thus Veronese's painting of Mary Magdalene in the house of Simon the Pharisee (Reale Gallery, Turin) shows her with her hair intricately braided, and the *Samarian woman whom Jesus met at Jacob's Well may be similarly adorned.

Hair colour and style, together with those of the *beard, are useful indicators of identity among male saints, particularly in cases, like that of the *Three Holy Hierarchs in Orthodox icons, in which the subjects are similarly clothed. Many of the traditions concerning appearance are extremely ancient, as are those relating to the apostles *Peter, *Paul and *Andrew.

The form of tonsure most commonly seen in the Western Church involves the shaving of the top of the head, leaving a circle of hair that is interpreted as a reminder of Christ's crown of thorns. The extent of the shaven area varies between the different religious orders. It is also seen on priests and *deacons and saints who held those positions.

halberd A long-handled weapon combining a spear point and axe-head. It is the occasional emblem of three apostles, SS *Matthew, *Jude and *Matthias. Some versions of the legends of Matthew and Matthias, which became confused and intermingled in the course of the Middle Ages, describe a halberd as the instrument of their martyrdom. St Jude too, according to some sources, was beheaded with a halberd.

halo The ring of light around the heads of the Persons of the *Trinity, the *Virgin Mary, *angels, saints and other holy persons. When this light surrounds the whole body it is known as a nimbus or aureole (*see also vesica piscis*). Haloes vary from unadorned golden discs or lightly sketched rings to patterns with rays and, particularly in the International Gothic art of the 15th century, elaborate and solid-seeming decorative surrounds like that round the head of the Virgin in Stefan Lochner's *Virgin of the Rose Bower* (*c.* 1440; Wallraf-Richartz Museum, Cologne).

A triangular halo, symbolizing the Trinity, is occasionally worn by God the Father, but otherwise he has a circular one. Christ's halo is very often divided by the arms of a cross within the circle. Square haloes are assigned to the living, for example, to donors.

In some 15th-century Netherlandish pictures the formal halo is dispensed with in favour of some other object that visually fulfils the halo's function. For example, in Robert Campin's *Madonna and Child before a Firescreen* (National Gallery, London) the firescreen creates a halo behind the Virgin's head, and a transparent canopy does the same in Petrus Christus' painting of the Virgin and Child with St Barbara and a Carthusian (Kaiser Friedrich Museum, Berlin).

hand Emerging from clouds, either to bless or to reprimand and restrain, indicates the presence of God. This convention arose through the frequent Old Testament references to the 'hand of God' as a metaphor for divine power.

A hand writing upon the wall is the divine portent of the downfall of the Babylonian empire seen at Belshazzar's feast and interpreted by Daniel (Daniel 5:5–28).

A hand is the emblem of the Tiburtine Sibyl, who was thought to have foretold the buffeting of Jesus by the soldiers (John 19:3); she is seen holding a disembodied hand in the early 16th-century stained-glass windows of Auch Cathedral (southern France). (*See also under* sibyls.)

Hands covered by a veil or cloth were a conventional means of indicating reverence or worship. In the 6th-century apse mosaic in San Vitale, Ravenna, St Vitalis advances with his mantle over his hands towards the enthroned Christ to receive the crown that is being held out to him, while on the other side of the throne Bishop Ecclesius holds a model of the church in similarly covered hands. The convention is also observed by the worshipping archangels around the dome in the mid-12th-century mosaic at La Martorana, Palermo. *See also* gesture; *orans*.

handkerchief *see under* cloth.

harp The attribute of the Hebrew king *David. He was renowned for his skill on the instrument and as a young man was summoned to soothe King Saul by his playing when the latter was troubled by an evil spirit (1 Samuel 16:14–23). The harp is also appropriate to David in his traditional character as the composer of the Psalms.

Harrowing of Hell The medieval English name for Christ's descent into the realm of the dead immediately after the Crucifixion. This realm was generally visualized as a limbo where the dead slept, rather

than a hell of fire, brimstone and physical torment; there he liberated from the powers of death and sin the souls of the righteous who had died before him.

The New Testament authority for this event was little more than a hint (e.g. Matthew 27:52 and 1 Peter 3:19), but corroboration was found in Psalm 24:7 ('Lift up your heads, O ye gates; and be ye lift up, ye everlasting doors; and the King of glory shall come in'), which was read as a prophecy of Christ's breaking down the *gate of hell. However, an apocryphal text known in Latin as the *Descensus Christi ad Infernos* (composed possibly as early as the 2nd century) elaborated on the episode with much circumstantial detail; the descent into hell became an article of belief incorporated into versions of the Creed in the mid-4th century, and shortly afterwards the *Descensus* was combined with an account of Christ's trial known as the *Acta Pilati* (?4th century). Later these two became known as the *Gospel of Nicodemus* (*Evangelium Nicodemi*).

The *Gospel of Nicodemus* provided the text for the Harrowing of Hell as treated in medieval art and drama. In England it was known in Latin to Bede (early 8th century) and was translated into Old English prose and verse. There are early dramatic treatments of the subject in Norman French and German, and the earliest English play seems to date from the mid-13th century. The Harrowing of Hell plays in the English miracle cycles at Towneley and York are among the liveliest episodes, with an opportunity for much buffoonery on the part of the fiends, discomfited at the rescue of their victims. The staging of these plays was an important influence on artists' representations of the subject.

In art the Harrowing of Hell has Christ as the central figure trampling the shattered gates of hell beneath his feet, often with Satan lying in chains amid their ruins. The 'spirits in prison' (1 Peter 3:19) crowd towards him, led by Adam and Eve and the other patriarchs and prophets of the Old Testament. Two crowned figures, either alone (as at Hosios Lukas, Phocis) or prominent in the throng are Jesus' human ancestors, the kings *David and Solomon (*see under* Tree of Jesse). They were first included in the scene probably after the 8th century, and some later treatments also include *John the Baptist. Devils may be seen fleeing or gesticulating in impotent rage. In some versions of the scene, as in the early 14th-century fresco in the church of the Chora (Karye Djami), Istanbul, Christ grasps the wrists of Adam and Eve, physically wrenching them from their tombs.

In the Eastern tradition all the significance of Easter as Christ's triumph over death and sin is concentrated into this one scene, known as the *Anastasis* (Greek, 'resurrection'); *see also under* Resurrection.

hat Headgear, like other items of clothing, can be a useful aid to identification. The wide-brimmed, shallow-crowned red hat of a *cardinal, with its elaborate strings, is the emblem of several eminent churchmen. It is most commonly encountered as an attribute of St *Jerome, either being worn or hanging up nearby while he works or prays. In the case of St Bonaventura, it is said that when the legates arrived from the pope carrying the hat in token of his elevation to the cardinalate, Bonaventura was washing dishes, and, as his hands were wet, he asked his visitors to hang the hat on a nearby tree until he had finished his menial task.

The wide-brimmed hat of the medieval pilgrim is a standard part of the pilgrim accoutrements of St *James the Great. In narrative scenes, headgear of characters specifically conceived of as Jewish (for instance the priest Zacharias in the *Presentation of the Blessed Virgin Mary) can take the very distinctive forms

favoured by a contemporary Jewish community with which the artist was acquainted.

head Saints who were beheaded and whose bodies subsequently walked about carrying their severed heads include the 6th-century Welsh monks Decuman and Nectan, as well as the better-known *Denys and *Juthwara. An early 15th-century roof boss in the north walk of Norwich Cathedral cloister shows St Denys, mitred head in hand, presenting himself at the door of the abbey of St-Denis in Paris, where he was buried. The head of the murdered king of the East Angles, St Ethelbert (died 794), was buried at Westminster but the pilgrimage shrine where his body was buried was at Hereford; medieval representations show him holding his crowned head in his hand. A crowned head in a wolf's jaws refers to St *Edmund.

The 11th-century English missionary bishop St Sigfrid holds not his own head but the heads of his three nephews, during his absence from his church at Vaxjo.

The heroine of the apocryphal Old Testament book of Judith was a popular subject in art, holding the severed head of the Assyrian general Holofernes. When the Assyrians invaded Israel and reduced the inhabitants of Judith's home town of Bethulia to despair, Judith went to Holofernes' camp, tricked her way into his confidence and then cut off his head with his own sword while he was in a drunken slumber. Another enemy of Israel who received the same treatment was the Philistine giant Goliath, whose head appears as a trophy in the hand or under the foot of the youthful *David (1 Samuel 17:20–54).

From the New Testament, the death of *John the Baptist (Matthew 14:3–12) provides a sequence of scenes culminating in the presentation to Herodias of the Baptist's head on a large dish. The head on the dish is one of the emblems of John the Baptist, but in the late Middle Ages the motif took on an independent life of its own as a devotional object. Plaques known as St John's Heads, which displayed the severed head upon its dish, were part of the stock-in-trade of the 15th-century alabaster carvers of the Nottingham area in England, whose wares were exported all over Europe.

For an impression of Christ's head on a cloth *see under* Veronica, St. For a head surrounded by leaves *see* Green Man.

heart Held in the hand and burning with flames, an emblem of ardent love for God; as such it is particularly associated with SS *Augustine of Hippo and *Catherine of Siena. The heart pierced with an *arrow (signifying repentance) is also associated with St Augustine. A heart surmounted with a cross, indicating the possessor's devotion to Christ, is associated with several saints, but especially the two Sienese, Catherine and the Franciscan preacher Bernardino (1380–1444). The personification of Charity (*see under* Three Theological Virtues) sometimes holds a heart.

Helen, St (Helena) (*c.* 255–*c.* 330) Roman empress, wife of Constantius Chlorus and mother of Constantine the Great. Although rejected by her husband in 292, she was loved and honoured by her son. The date of her conversion to Christianity is unknown, but after Constantine's edict of toleration (312), she was active in promoting her faith. On a visit to the Holy Land (326) she founded a number of churches and was associated, though on doubtful grounds, with the discovery (also called the Invention) of the True Cross. This incident was a favourite subject in decorative schemes for the vast number of churches that claimed to possess fragments of the True Cross among their relics. A cross is St Helen's personal emblem.

She was a popular saint in northern

England, perhaps on account of her son's association with York; it was here that Constantine succeeded to his father's share of the empire (306). More than one hundred and thirty British churches are dedicated to her, mainly in the north, and her discovery of the True Cross was the subject of the Anglo-Saxon poem *Elene*. Such popularity led the 12th-century chronicler Geoffrey of Monmouth to claim that she was a British princess, daughter of King Coel of Colchester. This notion was widely accepted in Britain in the Middle Ages, although sober history suggests that her birthplace was actually in Asia Minor.

Hell, Harrowing of *see* Harrowing of Hell.

hell-mouth A monstrous head with gaping jaws into which the bodies of the damned are gleefully shovelled and dragged by devils in scenes of the *Last Judgement. Its appearance derives ultimately from Roman accounts of the entrance to the underworld, Avernus, which Latin writers described as being a noisome cave, belching forth smoke and fumes and guarded by the fearsome three-headed dog Cerberus. The representation of hell-mouth in frescoes and paintings also owed something to the hell-mouths that were used as stage props in medieval religious drama for plays such as the *Harrowing of Hell. These are known from lists of props such as that from Rouen dating from 1474: 'Hell made in the manner of a great mouth which closes and opens as needed'.

hen With chicks, a symbol of Christ and his flock, for whose welfare he is as solicitous as a hen with her brood.

hetimasia see *under* throne.

Hierarchs *see* Four Greek Doctors.

hive *see* beehive.

Hodegetria (Hodigitria) In the Orthodox Church, an icon type of the Virgin and Child. The original was an icon said to have been painted from life by St *Luke and sent by him to the 'most excellent Theophilus' (Luke 1:3) in Antioch. In the mid-5th century the icon was moved to Constantinople where it was housed in the church of the Commanders (*ton Hodegon*). Its miraculous powers established it as the city's most precious possession; Byzantine emperors prayed before the icon when they were about to march out on military expeditions and it was credited with repelling attackers from the city walls. Brought to a church near the walls to inspire the defenders in their last desperate struggle against the Ottoman Turks in 1453, the icon was destroyed in the subsequent sack of the city.

The fame of this icon ensured that it was widely copied. In both Greek and Russian churches, the Virgin Hodegetria is one of the most frequently seen icon types and several famous miracle-working icons are of this kind. The Virgin, shown either full- or half-length, carries the Child on her left arm and gestures towards him with her right hand. (The icon title is sometimes given in English as 'The Virgin Who Shows the Way'.) The Child, who appears more as a small adult than an infant, sits upright and holds a scroll in his left hand and blesses with his right. Both gaze directly out at the viewer or into the distance (*compare* Eleousa).

Holy Family Jesus as a child, the Virgin and St Joseph. The infant St *John the Baptist is sometimes included in pictures with this title, as is his mother St Elizabeth or the Virgin's mother St Anne.

Holy Grail The cup in which the blood of Christ was collected at the Crucifixion. It passed into the keeping of St *Joseph of Arimathea, whose emblem it sometimes is. The Grail subsequently became the

focus of an elaborate legend which itself became linked with the cycle of stories about King Arthur and the knights of the Round Table.

Holy Innocents The children of Bethlehem, aged two years and under, who were slaughtered by Herod the Great. His intention was to kill among their number the infant king of the Jews about whom the *Three Magi had told him (Matthew 2:1–18). Honoured as martyrs, the Holy Innocents are commemorated in both Eastern and Western Churches shortly after Christmas. The scene of the massacre appears either as an independent work of art or as a background detail in paintings of the *Flight into Egypt.

Holy Women *see* Three Marys.

Homobonus, St *see* Omobono, St.

Hope *see under* Three Theological Virtues.

horn, hunting An attribute of St *Hubert.

horns On the head of a venerable man, an identifying mark of *Moses. The presence of horns in many medieval and Renaissance depictions of Moses was the result of a mistranslation in the Latin Bible (Vulgate) of Exodus 34:29–30, where the meaning of the Hebrew original is that Moses was unaware that rays of light shone from his face after he had spoken with God on Mount Sinai. The Vulgate text (which was the standard medieval version of the Bible known all over Europe) reads '*et ignorabat quod cornuta esset facies*', of which a literal English rendering would be 'and he did not know that his face was horned'. Michelangelo's statue (1513–16) of Moses in San Pietro in Vincoli, Rome, is perhaps the most famous image of the prophet with this attribute, but the horns are very

commonly seen in medieval pictures of him.

horse Fiery horses drew the chariot of fire that took *Elijah up to heaven. The chargers of such warrior saints as *George and *Demetrius, who are depicted as knights, frequently accompany them in art. *See also under* Four Horsemen of the Apocalypse; horseshoe; knight.

horseshoe The emblem of St *Eloi. The saint was once challenged to shoe a horse possessed of the Devil, which had trampled all those who had previously attempted to handle it. Eloi sensibly cut off its leg, shod the hoof at his leisure and then reattached the limb to the animal's body. A mid-15th-century English alabaster panel (Castle Museum, Nottingham) shows the saint in his bishop's robes and mitre standing in the forge surrounded by blacksmithing tools, with the leg conveniently placed on the anvil in front of him. The carver of the early 16th-century choir-stalls at Auch (southern France) showed him in lay dress holding the lower portion of the horse's leg.

hortus conclusus *see under* garden.

Host The consecrated bread of the Eucharist, usually in the form of a specially made and stamped wafer. The word 'Host' derives from *hostia* (Latin, 'sacrifice'), referring to Christ's sacrifice of himself. *See also* monstrance.

hound Several hounds are usually to be seen in illustrations of the legends of the patrons of hunters, SS *Eustace and *Hubert. The latter in particular is associated with dogs. *See also* dog; greyhound.

hourglass An emblem of Temperance (*see under* Four Cardinal Virtues).

Hubert, St (died 727) Bishop of

Maastricht (Netherlands). His legend tells how he was on a pilgrimage to Rome when an angel brought news to the pope of the murder (*c.* 705) of Hubert's mentor St Lambert, together with the instruction that Hubert be installed in his place. Hubert himself saw a vision of St Peter, in which the apostle handed him one of his keys, and another in which the Virgin Mary sent him a *stole.

Hubert became an active missionary in the Ardennes area and the patron saint of the hunters of the region; his aid was also invoked against rabies. In the later Middle Ages the legend originally associated with St *Eustace – of how, while he was out hunting, he saw a stag with a crucifix between its antlers and was converted to a better life – was attached to him. Although St Eustace had an almost Europe-wide popularity, untitled representations of the scene with the stag from the northern France-Netherlands area are more likely to be of Hubert than Eustace.

St Hubert usually appears in the regalia of a bishop with the stag as his primary attribute. He also sometimes holds a hunting horn or has one lying on the ground at his feet to symbolize his rejection of the pastime. The hunting horn was the emblem of the many medieval guilds that adopted St Hubert as patron, and it also appears on the pilgrim tokens associated with his shrines. At the château of Amboise in the Loire valley, France, the lintel over the main door (late 15th century) of the chapel attached to this royal hunting lodge shows St Hubert on his knees before the stag, his hounds and horse starting backwards in amazement.

Hugh of Lincoln, 'Little' St (died 1255) Boy saint who met a violent death by unknown hands. The discovery of his body in a well resulted in accusations of ritual murder by crucifixion against the Jews of Lincoln. The boy's body was buried in the cathedral and miracles were reported at his tomb, giving rise to an active, though unofficial, cult.

Hugh of Lincoln, St (*c.* 1140–1200) Burgundian-born bishop and Carthusian monk. As the redoubtable bishop of Lincoln from 1186, Hugh was also an influential figure at the courts of Henry II and Richard I, undauntedly withstanding the royal will in order to protect the ordinary people from oppression and exactions. He initiated the rebuilding of Lincoln Cathedral, later the thriving centre of his cult. However, as the first Carthusian to be canonized (1220), he was also honoured in Charterhouses in the Netherlands, Germany, France, Spain and Italy. He kept a tame swan, which became his emblem in art.

Hypapante *see* Presentation in the Temple.

I

Ignatius of Loyola, St (*c.* 1491–1556) Founder and first General of the Jesuit order. He was born in Spain, of Basque stock, and followed the career of a soldier until an injury sustained in 1521 maimed him for life. During his convalescence he turned for the first time seriously to religion and to study. After various false starts he gathered round himself in Paris a group of six disciples who became the founder members of the Society of Jesus, which was formally approved by the pope in 1540. They based their rule on the *Spiritual Exercises* drawn up by Ignatius, and their aims included missionary work, for which the Order became famous. Successive popes employed Jesuits extensively as agents of the Counter-Reformation, which accounts for the suspicion with which they came to be regarded, particularly in the Protestant countries.

In recognition of Ignatius' role as an educator, he is patron saint of numerous Roman Catholic schools and colleges. Paintings and sculptures of him show an austere, black-clad figure usually holding in his left hand the rule book of the Society of Jesus on which may be inscribed the motto **Ad majorem Dei gloriam*.

IHS An abbreviated form of the word Jesus, deriving from the Greek version of the name. (The form C, often seen instead of S at the end, is a variant form of the Greek letter sigma.) The letters were sometimes fancifully interpreted as the initials of three separate words, most commonly the Latin phrase *Iesus Hominum Salvator* ('Jesus, Saviour of men'). IHS displayed on a plaque surrounded by rays is the attribute of the Franciscan preacher St Bernardino of Siena (1380–1444), who used to hold up such a plaque at the end of his sermons so that his audience might venerate it.

The Adoration of the Name of Jesus became a popular subject in late medieval and Renaissance art under the influence first of the Franciscans and later of the Jesuits; the latter, adopting IHS as the device of their order, interpreted the letters as signifying *Iesum Habemus Socium* ('we have Jesus as our companion'). It is the subject of one of El Greco's greatest works, showing Philip II of Spain at the forefront of the multitude kneeling in adoration (Escorial).

Immaculate Conception The conception of the Virgin Mary. The ecclesiastical feast of the Conception of the Virgin was celebrated from at least the 7th century and had reached England from the East by the early 11th century. Later the dogma ran into difficulties with the medieval French theologians, and it was only in the mid-15th century that the Catholic Church's objections to the idea that the Virgin was free not only from sin but also from the original sin of natural human conception were finally put aside. The feast of the Immaculate Conception is observed in the West on 8 December; in the East the doctrine of the Immaculate Conception is not recognized, but the conception of the Virgin is nonetheless celebrated on 9 December. For the background to this event and the way it is depicted in art *see under* Anne, St.

Incredulity of St Thomas *see under* Thomas, St.

Infant Jesus *see* Christ Child.

Innocents, Holy *see* Holy Innocents.

INRI The initial letters of the Latin inscription written by Pilate to be placed on the Cross of Jesus (John 19:19–22): *Iesus Nazarenus Rex Iudaeorum* ('Jesus of Nazareth, King of the Jews').

Instruments of the Passion The set of objects associated with Christ's suffering and Crucifixion. They appear in medieval churches carved in stone or wood and in stained-glass windows. Such sets include all or most of the following, which are either mentioned in or can be inferred from the gospel narratives: crown of thorns, reed, nails, hammer, pincers (for removing the nails), ladder, Cross, scourge, pillar (to which Jesus was tied for scourging), sponge (and reed), spear, seamless robe, dice. In the highly stylized schemes of Byzantine art the Instruments of the Passion may be assembled on or around an empty *throne (hetimasia);* the intention of this scheme is to contrast the symbols of Christ's first and second comings, the first suggesting suffering and humiliation, the second triumph and judgement.

instruments, surgical The emblems of the physician saints *Cosmas and Damian.

Invention of the True Cross *see under* Helen, St.

iris A flower associated with the Virgin Mary, particularly in the work of Flemish and Spanish painters. When blue, it is appropriate to her in her role of Queen of Heaven; when white, as an emblem of her purity, like the *lily. Like the gladiolus or sword lily, with which it was sometimes confused, the iris has sword-shaped leaves that recall the words of Simeon to the Virgin, warning of future sorrow: 'Yea, a sword shall pierce through thy own soul also' (Luke 2:35).

Isaac The only son of *Abraham and Sarah, born to them in their old age (Genesis 12:1–8).

So perfect was Abraham's obedience to God that he was willing to sacrifice Isaac as a burnt offering at the divine command, but when he was about to kill the boy an angel intercepted the knife blow (Genesis 22:1–14). The Sacrifice of Isaac was a frequent subject in art, not only because of its intrinsic dramatic qualities but also because it was seen to be the Old Testament parallel to the sacrifice of God's only Son upon the Cross. It appears in many media and from the earliest Christian era: early 4th-century wall-painting in the catacomb of the Via Latina, Rome; statue in Chartres Cathedral (*c.* 1230); etching by Rembrandt (1655), to name just three.

Abraham, Isaac, the donkey that carried the wood for the fire and the ram that became the substitute sacrifice are usually depicted. The divine intervention that forestalled Abraham's blow is shown either as the *hand of God appearing from the clouds or, following the biblical narrative, as an angel.

ivy Because it is evergreen, a symbol of eternal life. It also has associations of fidelity, as it clings so closely to its support. It was therefore thought particularly appropriate to Nativity scenes, in which it sometimes is juxtaposed with a *fig tree: ivy as the promise of salvation and life contrasted with a reminder of sin and death.

J

James (the Great), St (died 44) Apostle and martyr. He is called 'the Great' to distinguish him from the other apostle called James (*see* James (the Less)).

James and his brother *John the Evangelist were fishermen by trade, and it was while they were mending their nets with their father Zebedee that Jesus called them to follow him (Matthew 4:21–2). Jesus gave the two brothers the surname 'Boanerges', which is interpreted as 'sons of thunder' (Mark 3:17). Their zeal as disciples sometimes outweighed their discretion, as when they claimed the seats next to Jesus in glory (Mark 10:35–45), but he singled them out from the other disciples, together with *Peter, to be witnesses of his *Transfiguration (Matthew 17:1–9) and asked them to watch with him in the Garden of Gethsemane before his arrest (Matthew 26:37). James was the first apostle to be martyred, being put to the sword on the orders of King Herod, who saw that persecuting the Christians was the way to win popularity with the Jews (Acts 12:1–3).

Although James had died in Jerusalem, a story began to circulate in early medieval Spain that he had visited that country and proclaimed the gospel there. Furthermore, it was claimed that his body had been brought to the town of Compostela in the northwest, where it was 'discovered' in the 820s. Compostela (subsequently known as Santiago de Compostela) developed into the third great pilgrimage centre of the Middle Ages, after Jerusalem and Rome. James became the patron saint of Spain and the champion of the Spanish Christians in their long struggle to drive out their Muslim overlords. At critical moments of great battles, the vision of the saint on a white horse, with the battle-cry 'Santiago Matamoros', inspired the Christian forces until their final victory with the reconquest of Granada (1492).

His close association in the medieval mind with the prestigious pilgrimage shrine of Compostela led to James himself being depicted as a pilgrim, with staff, wide-brimmed hat, flask, purse and scallop-shell badge.

James (the Less), St (died ?62) Apostle and martyr. He is referred to as 'James the son of Alphaeus' in the list of the twelve whom Jesus chose as his first disciples (Mark 3:14–19). However, subsequent biblical references to a James who is not *James the Great do not make it clear whether this James or another of the same name is meant. If he is to be identified with 'James the Lord's brother' (Galatians 1:19) whom Paul saw in Jerusalem, he may have been a close relative of Jesus. According to rather doubtful traditions, he was the first bishop of Jerusalem and the general epistle of James is sometimes attributed to him.

James the Less shares his feast day (1 May) with *Philip and the two apostles' names are also generally linked in church dedications. James's emblem in art is the instrument of his martyrdom, a fuller's *club.

Januarius, St (Gennaro) (died ?early 4th century) Italian bishop and martyr; patron saint of Naples. Little is definitely known about him except that he was bishop of

Benevento. It is said that when he was beheaded some of his blood was caught on a sponge and thus preserved. Since 1389 the blood, kept in the cathedral of San Gennaro, Naples, has been recorded as miraculously liquefying on or around his feast days (first Saturday in May, 19 September, 16 December).

Januarius is shown in bishop's regalia and holding a book on which the two phials containing the blood are displayed. Later depictions of him may also show flames around his feet as he was credited with having averted from the city a potentially catastrophic eruption of Mount Vesuvius in 1631.

jar The emblem of St *Mary Magdalene. All four gospels relate slightly differing versions of the story of the woman who brought 'an alabaster box of very precious ointment' (Matthew 26:7) and annointed Jesus with it as he sat at table. In art the container was often metamorphosed into a small lidded jar similar to those used by medieval apothecaries.

jaws (of hell) *see* hell-mouth.

Jerome, St (Hieronymus) (*c.* 342–420) Scholar and churchman; one of the *Four Latin Doctors of the Church. Jerome was born near Aquileia, not far from the modern city of Trieste. He was baptized at Rome and his early life alternated between travel, with visits to both Western Europe and the Holy Land, and periods during which he withdrew to the wilderness as a solitary hermit. On his return to Rome (382–5) he served Pope Damasus as secretary; it was believed that the pope created him a cardinal, which gave rise to the later medieval convention of depicting Jerome with the cardinal's red hat and robes. After the pope's death Jerome returned to the Holy Land to settle in the monastery at Bethlehem, where he passed the rest of his life in study, theological controversy and

the work for which he is best remembered and most honoured, his translation of the Bible into Latin. His Latin text, the Vulgate, became the definitive edition of the Bible in the West.

The two settings for Jerome's life – the study and the desert – attracted artists in almost equal measure. Often the two are combined, the study being set up in the corner of a bizarre desert landscape. Jerome himself may be presented either as a scholar preoccupied with his books and writing or as an emaciated ascetic, beating his breast with a stone.

The lion which is Jerome's constant companion in art was said to have come one day to the Bethlehem monastery, lame with a thorn in its paw; Jerome removed the thorn and the grateful beast remained with him, carrying out odd jobs around the monastery, somewhat to the dismay of Jerome's fellow monks. This story seems first to have been told in the late 6th/early 7th century of a 5th-century Palestinian abbot called Gerasimus, and it seems likely that St Jerome took over Gerasimus' lion through a confusion arising out of the similarity of their names.

Jesse, Tree of *see* Tree of Jesse.

Joachim *see under* Anne, St.

Joan of Arc, St (1412–31) Warrior saint; patron saint of France. From an early age she experienced visions and heard heavenly voices prompting her to redeem the fortunes of France, then at a low ebb in the Hundred Years' War with England. Eventually she persuaded the French dauphin to allow her to lead an expedition to raise the English siege of Orléans. Her success revived the morale of the French and enabled the dauphin to be crowned king (1429). She was taken prisoner the following year, tried on charges of witchcraft and heresy and then burnt at the stake at Rouen.

Joan is usually shown in the white armour she wore at the siege of Orléans, with a banner displaying a symbol of the Trinity or the fleur-de-lis of France.

John the Baptist, St (died *c.* 30) The cousin of Jesus, whose imminent appearance he proclaimed through his ministry of baptism in the River Jordan.

The circumstances of John's birth are narrated in Luke 1. While John's father, a priest called Zacharias, was burning incense in the Temple, the angel Gabriel appeared and told him that his wife Elizabeth, a cousin of the Virgin Mary, would bear a son, although she was 'well stricken in years'. Zacharias lost the faculty of speech because he doubted the angel's word, and it was only restored at the baby's birth, when he broke his silence to announce its name. The visit of the Virgin to Elizabeth took place during their pregnancies, and the association of the narratives of the two miraculous births gave artistic licence for including the infant St John in pictures of the *Holy Family. The annunciation to Zacharias, the *Visitation and the birth and naming of John the Baptist form the first of the three sets of scenes associated with John in art.

John's preaching in the desert and his baptizing of the people in the River Jordan are the subjects of the second set of scenes, culminating in his *Baptism of Jesus. The gospel writers presented him as the fulfilment of the prophecy of Isaiah (40:3): 'The voice of him that crieth in the wilderness, Prepare ye the way of the Lord, make straight in the desert a highway for our God.' In art he sometimes carries a scroll with these words in Latin: VOX CLAMANTIS IN DESERTO: PARATE VIAM DOMINI. Artists also followed the gospel writers in showing him 'clothed with camel's hair, and with a girdle of a skin about his loins' (Mark 1:6).

The final scenes of John's life involve his imprisonment and beheading on the orders of Herod Antipas ('the Tetrarch'). He had incurred the king's wrath and the loathing of Herod's wife Herodias by denouncing their union as incestuous. At his birthday feast, Herodias' daughter Salome danced before the king and so delighted him that he promised to grant her any request. Prompted by her mother, she asked for 'John Baptist's head in a charger' (Matthew 14:8). Herod reluctantly ordered John's execution and his head was duly delivered to Herodias on a large dish (*see also under* head).

In both narrative and non-narrative depictions John usually appears conspicuously unkempt and emaciated and wearing his camelskin garment. His attributes in Western art are the *Lamb of God and/or a scroll with the words ECCE AGNUS DEI (Latin, 'Behold the Lamb of God'). His head on the dish is also sometimes shown beside the living saint. He generally carries a tall, very slender cross.

In the Greek Church John the Baptist is often simply called 'Prodromos', which means 'forerunner'. A cloak wrapped over his skin garments may make him appear less dishevelled than in the West. He is almost invariably prominent in the decorative scheme of an Orthodox church (*see* Deisis), and no fewer than four feast days celebrate his birth and death, conception and role as baptizer (the first two of these feasts being also observed in the West). John was believed to fulfil the Old Testament prophecy, 'Behold I will send my messenger, and he shall prepare the way before me' (Malachi 3:1). In Greek the same word signifies both 'angel' and 'messenger', so John is sometimes shown winged like an angel in Orthodox icons of the 16th century and later; in this type his head usually appears on a dish on the ground before him, while in the background an *axe lies against the roots of a tree.

John the Baptist is one of the most frequent church dedicatees, with nearly five hundred ancient dedications in Britain alone.

John the Evangelist, St (John the Theologian *or* John the Divine) (1st century) Apostle and evangelist, to whom is attributed the authorship of the fourth gospel, three epistles and the book of Revelation. A good deal of biographical detail about John can be pieced together from the New Testament, although there is debate as to whether the same John is meant throughout. In particular, modern scholars doubt whether the fourth gospel and the book of Revelation (from the title of which John takes his name 'the Divine') could have been by the same author. Medieval writers and artists however tended to assume that the apostle John was concerned in both and put together a more or less coherent biography for him.

During the earthly ministry of Jesus, John was closely associated with his brother St *James (the Great). John is identified with the disciple whom Jesus loved, who was leaning on Jesus' bosom at the *Last Supper (John 13:23) and into whose care Jesus entrusted his mother at the Crucifixion (John 19:26–7). He was also the first of the disciples to see the empty tomb (John 20:2–5). In Acts he appears as the companion of Peter, healing the lame man at the temple gate (Acts 3:1–11) and undertaking a mission to Samaria (Acts 8:14–25).

If John the apostle is the writer of the book of Revelation he must have spent some time (?in 96 AD) on the Greek island of Patmos (Revelation 1:9), where the cave in which he is said to have received the vision is still visible near the great monastery that bears his name. At this time the Roman emperor Domitian was persecuting the Christians, and an apocryphal tradition narrates how John, visiting Rome, was plunged into a cauldron of boiling oil, from which he emerged unscathed. The spot near the Latin Gate where this took place is marked by a chapel, San Giovanni in Oleo; nearby is the 5th-century church of San Giovanni a Porta Latina, whose dedication (6 May) was formerly kept as a festival in the Western Church. John's major feast in the West is now 27 December.

Early writers assert that John eventually settled in the great pagan cult centre of Ephesus, on the western coast of Asia Minor. His tomb was reputed to lie just outside the city at the place now called Selcuk; dust from it was thought in the Middle Ages to heal all kinds of disease. In the 6th century the Byzantine emperor Justinian built a magnificent church over the shrine, remains of which are still visible.

In art John may appear either as a young beardless man in gospel scenes or as a white-haired, white-bearded sage in his role as author of Revelation. As an evangelist, John is shown writing, reading or holding a book, and he is the patron saint of all those who are involved in book production. A popular subject in Orthodox art is St John in the cave on Patmos dictating his divinely inspired text to a young disciple called Prochoros. John's evangelistic symbol is the *eagle, which alone of all the birds was thought to be able to gaze full on the sun, as John might be said to have done in the Revelation. Elsewhere, in allusion to an incident at Ephesus, John may hold a *cup or chalice. In scenes of the *Dormition, he is distinguished among the mourners by the *palm frond that he holds (here not to be confused with the palm frond of martyrdom).

John Chrysostom, St (*c.* 347–407) Theologian, bishop, and liturgist; one of the *Three Holy Hierarchs and Four Greek Doctors of the Church. He was born and educated in the thriving pagan culture of Antioch, but on becoming a monk led an austere life as a hermit. He was ordained priest (386) and his exceptional skill as a preacher led to his acquisition of the name 'Chrysostom' ('golden-mouthed'). Many sermons of his have survived.

Appointed Patriarch of Constantinople in 398, he exhibited a zeal for reform that antagonized both the court – in particular the empress Eudoxia – and the clergy. His banishment in 404 failed to satisfy his enemies, and, by compelling him to travel on foot to a distant place of exile in bitterly cold weather, they eventually managed to kill him.

He is traditionally held to be the author of the most generally used liturgy of the Orthodox Church, and is honoured as such in the course of the service. In art he wears a bishop's robes (sakkos) and is distinguished from the other Doctors of the Church, in whose company he often appears, by a wispy, sparse or close-clipped beard.

John Climacus *see under* ladder.

Jonah Old Testament prophet who was sent by God to preach the destruction of the city of Nineveh. The story of his adventure with the *whale after he had tried to evade his divine mission (Jonah 1–2) was taken to show that God's purposes cannot be thwarted, as was the subsequent episode with the *gourd.

In early Christian art the three vignettes of Jonah swallowed by the whale, Jonah spewed up by the whale and Jonah resting under the vine of the gourd are very commonly found as a sequence illustrating death, resurrection and the reward of the blessed in heaven. In the later Middle Ages the scenes with the whale predominate.

Joseph, St (1st century) The husband of the Virgin Mary. He is described as a descendant of King *David (Luke 2:4), 'a just man' (Matthew 1:19) and a carpenter by trade (Matthew 13:55). It is generally assumed that he died before the Crucifixion, else Jesus would not have asked a disciple to take the Virgin Mary into his care.

There is no biblical justification for regarding Joseph as an elderly man, but this was inferred from the apocryphal *Gospel of James (Protevangelium)* in which he is portrayed as a widower with grown sons. The Middle Ages, however, intrigued by his predicament – particularly with respect to the doctrine of the perpetual virginity of Mary – chose to depict him as aged. In medieval drama he verges on that perennial figure of fun, the old man married to a young girl. Honoured in the East from the 4th century, Joseph became significant in the West only at the beginning of the 12th century; the late medieval phenomenon of intense adoration of the Virgin helped to counteract the aura of buffoonery, enabling a cult of St Joseph to grow up.

Later, devotion to him was promoted by spiritual leaders such as *Theresa of Avila and *Ignatius Loyola. He became the patron saint of craftsmen and those who work with their hands. In art he often appears with the tools of his trade. Hospitals and hospices are dedicated to him on the basis of a promise which the early medieval *History of Joseph the Carpenter* says was made to him by Mary and Jesus: that they would have under their special protection all those who did good deeds in his name.

In late medieval Western art Joseph features in Nativity scenes and is fully involved with the main group of mother and baby. In Byzantine Nativities he is often positioned a little to one side, more an observer of the scene than a participant in it. He is most prominent in the depictions of the *Holy Family and the *Flight into Egypt. After the incident in which he remained at the Temple in Jerusalem to dispute with the learned men there, Jesus' comment, 'wist ye not that I must be about my Father's business?' implicitly denied that Joseph was his father (Luke 2:41–50).

In addition to these gospel subjects, Joseph also appears in the scene, popular with Italian Renaissance painters, showing

the Betrothal/Marriage of the Virgin, the details of which were drawn from the *Protevangelium*. According to this, respectable widowers were asked to present themselves at the Temple in Jerusalem, each bearing a rod; the one held by Joseph burst into leaf and/or a dove burst out of it and perched on his head to indicate that he was the one selected (*compare* the Old Testament story of the rod of *Aaron). One of the disappointed suitors may be shown breaking his rod, as in Raphael's *Sposalizio* (Brera, Milan).

Joseph of Arimathea, St (1st century) Jewish elder. The gospels describe him as 'a rich man . . . who also himself was Jesus' disciple' (Matthew 27:57) and 'an honourable counsellor' (Mark 15:43). After the Crucifixion, Joseph went to Pilate to ask permission to remove the body of Jesus for burial. When this was granted, he wrapped the body in linen and placed it in the rock-cut tomb that he had had prepared for himself (Matthew 27:59–60). Joseph is almost invariably present in scenes of the *Deposition and *Entombment. He is identifiable by the purse hanging at his side, as befits 'a rich man'.

In the Middle Ages legend accumulated around him. He was believed to have kept in his possession after the Crucifixion two *cruets containing the sweat and blood of Jesus, and these are his common emblems in art. When he was sent on a missionary journey to England he and his followers settled at Glastonbury, and the cruets appear in the decoration of several West Country churches. Later medieval writers embellished the story, mentioning Joseph's miraculous staff which blossomed when it was stuck in the ground and became the famous Holy Thorn of Glastonbury in Somerset. A French variation on the legend associated Joseph with the *Holy Grail.

Josse, St (Judoc, Joost, Joce) (7th century) Breton-born hermit. Josse was the son of King Juthael of Brittany but renounced his royal privileges in order to become a priest and subsequently a hermit at the place later called St-Josse (Pas-de-Calais). His corpse was found to be uncorrupted after death and was a copious source of relics. At the beginning of the 10th century his body was brought to Winchester, hence his cult in England. He was also honoured in the Netherlands and as far afield as Austria.

In art he generally holds a pilgrim's staff; at his feet lies his crown, symbolizing his rejection of worldly pomp.

Joys of the Virgin Glad events in the life of the Virgin Mary identified in the later Middle Ages as forming a set for devotional purposes. The list and its extent may vary: the *Annunciation, the *Nativity and the Virgin's own *Assumption/Coronation are constantly present, but other items are selected from the *Visitation, the homage of the *Three Magi, the *Presentation in the Temple, the *Resurrection and *Ascension of Christ and the descent of the Holy Spirit at *Pentecost.

Such sequences of five or seven Joys were a frequent topic in medieval devotional literature. They also often appear in painting or sculpture, although in this case the number may vary for artistic reasons; for example, the late 15th-century carver of the alabaster Swansea Altarpiece (Victoria and Albert Museum, London) chose to represent just four of the Joys (Annunciation, Nativity, Ascension and Assumption), two on each side of the central panel of the Trinity. On the other hand, Veit Stoss showed these plus the visit of the Magi, the Resurrection and Pentecost to make up the more conventional number of seven in the altarpiece he carved for the church of Our Lady in Cracow (1477–89).

The Five Joys or Five Joyful Mysteries became the first sequence (or 'chaplet') in the devotion of the *rosary, and in this case

they are reckoned to be Annunciation, Visitation, Nativity, Presentation in the Temple and the finding of Jesus in the Temple (Luke 2:42–51).

Judas Iscariot (1st century) The apostle who turned traitor and betrayed Jesus to the Jewish authorities for thirty pieces of silver (Matthew 26:14–16). At the *Last Supper Jesus told the twelve disciples that he knew that one of them would betray him and indicated that he knew that it was Judas (Matthew 26:20–5; John 13:21–30 has a rather more circumstantial account). Judas directed the officers of the high priest to the place where Jesus had gone to pray (*see* Agony in the Garden) and identified him to them, with a kiss, according to Mark 14:43–5. Judas soon repented of his treachery and tried to return the thirty pieces of silver to the priests; they refused to accept it, whereupon Judas threw the money down at their feet and went out and hanged himself (Matthew 27:3–9).

Judas may be identified at the Last Supper in various ways: sometimes seated on the floor or otherwise set rather apart from the other disciples, sometimes reaching for the food (common in Orthodox icons or in depictions under Byzantine influence, such as the romanesque murals of Sant'Angelo in Formis), sometimes eating the 'sop' that Jesus gave him (John 13:26–7) or leaving the table with the 'bag' (John 13:29–30). He is prominent in the troop approaching Jesus to arrest him in the garden, a scene shown by artists in Passion cycles from the 4th century onwards, usually at the moment when Judas moves to kiss Jesus. Judas' repentance, his abortive attempt to return the money to the priests in the temple and his suicide are found from the 5th and 6th centuries onwards. One of the earliest-known Crucifixion scenes, on an ivory casket from northern Italy (*c.* 400; British Museum, London), juxtaposes Christ upon the Cross with Judas hanging from his tree, the money spilling onto the ground beneath his feet.

Jude, St (Judas Thaddeus) (1st century) Apostle and martyr; the epistle of Jude is attributed to him. His identity is by no means clear in the gospels; Matthew (10:3) calls him 'Lebbeus, whose surname was Thaddeus', and Mark (3:18) simply 'Thaddeus'. ('Judas' and 'Thaddeus' are both names that can be interpreted as 'praise of the Lord'.) Luke calls him 'Judas the brother of James' to differentiate him from *Judas Iscariot. His only recorded words were spoken at the Last Supper: 'Lord, how is it that thou wilt manifest thyself unto us, and not unto the world?' (John 14:22).

Jude/Judas is mentioned with *Simon as one of the 'brethren' of Jesus (Matthew 13:55), but otherwise there is no biblical justification for their association. In the Western Church they have a joint feast day (28 October), perhaps the date of the translation of their relics to St Peter's, Rome; their rather meagre church dedications are similarly shared. In the East Jude is commemorated alone on 19 June. According to apocryphal writings, they went on a joint mission to Persia, in the course of which both were martyred, Jude being beaten to death with a club. On some occasions, for instance in the mid-15th-century east window at Malvern (Worcestershire), Jude's emblem is a boat.

For fear of confusion with Judas Iscariot, very few people invoked the name of Jude, and this is believed to be the origin of his patronage of lost causes, since only the desperate would call upon him. These ill-omened associations linger in Thomas Hardy's choice of name for the hero of his novel *Jude the Obscure* (1895).

Julian the Hospitaller, St Penitent; patron saint of innkeepers, ferrymen and itinerants. Julian's legend, which is a farrago of elements taken from folklore

and other saints' lives, was very popular in the Middle Ages, but it is probable that its hero is totally fictitious. Part of the secret of his survival may lie in the fact that he was confused in popular belief with genuine saints called Julian, especially the 3rd-century French martyr, Julian of Brioude (Haute-Loire), who is patron saint of the Auvergne.

According to the legend, a stag that Julian was hunting was miraculously granted the power of speech and warned him that he would kill his father and mother. To avert this catastrophe Julian fled into a distant country. His parents came seeking him and Julian's wife allowed the couple to rest in her own bed; Julian, believing that he had caught his wife with a lover, killed them both before he discovered their identity. Riven with guilt and remorse, Julian went out into a wild place where he tried to expiate his crime by helping people across a difficult ford and building a shelter for poor and ailing travellers. One day a leper came to the ford and was cared for by Julian until he died. Julian had a vision of the leper ascending into heaven and heard at the same time a voice telling him that Christ had accepted his penance. The bizarre 15th-century figure of a leprous Christ in the basilica of St Julian of Brioude, at Brioude, alludes to this episode from the legend of the Hospitaller and incidentally shows how thoroughly merged the two Julians had become.

Because of his popularity, there are many versions of the legend of Julian the Hospitaller in art, and some episodes in his life lend themselves to confusion with SS *Eustace and *Hubert (the stag) or with St *Christopher (the assistance offered to travellers).

Justice *see under* Four Cardinal Virtues.

Justina, St (Giustina) (4th century) Virgin martyr; patron saint of Padua. Left an orphan at the age of sixteen, she was put to death for her faith by being stabbed with a sword or dagger, which is shown embedded in her breast. This and the usual martyr's crown and palm are her normal attributes; a *unicorn may lie at her feet. She is sometimes confused with the abbess St Justina of Antioch (?also 4th century) who is commemorated with her fellow townsman St Cyprian; their relics are kept in Rome.

K

Kenelm, St (9th century) English prince, honoured as a martyr. The few known historical facts about Kenelm, his father King Coenwulf of Mercia and his sister do not tally at all with the legend that Kenelm succeeded his father as a child and was immediately murdered by his sister. Nonetheless he was accorded a shrine at Winchcombe (Gloucestershire), churches were dedicated to him and his feast day was observed in several places in the western and midland areas of England. He is portrayed as a crowned youth.

keys The ubiquitous emblem of St *Peter, in reference to Jesus' words: 'I will give unto thee the keys of the kingdom of heaven' (Matthew 16:19). St Peter's keys are usually two in number.

Female saints such as *Martha and *Zita, who were particularly known for their domestic activities, carry bunches of keys at their waists in the manner of medieval housewives. St Petronilla, a Roman martyr of unknown date, whose wholly fictitious legend makes her the daughter of St Peter, also carries keys, presumably taken over from her supposed father.

king *see* crown; Three Magi.

knife A short-bladed flaying knife is the emblem of St *Bartholomew, alluding to the manner of his martyrdom.

knight In the Middle Ages a powerful symbol of the Christian struggle against the powers of evil (*see also* armour). The image of the embattled but ultimately triumphant Christian warrior is strikingly embodied in Dürer's engraving, *The Knight, Death and the Devil* (1513).

St *George has generally been depicted as a medieval knight on a white horse in Western Christendom, and often appears as the Byzantine equivalent of the knight in Orthodox art. St *Gereon likewise is usually shown with the arms and armour of a knight.

Koimesis *see* Dormition.

85

L

labarum *see under* chi-rho.

ladder The emblem of SS *Bathild, John Climacus and Romuald.

Jacob's dream vision of a ladder on which angels passed to and fro between heaven and earth (Genesis 28:12) influenced many mystical and theological writers. Among these was the 7th-century Palestinian monk John, who wrote a treatise known as *The Ladder to Paradise*; his surname of Climacus is derived from the Greek *klimax*, 'a ladder'. The treatise was very well known throughout the Orthodox world, and artists soon translated it into visual terms, showing monks ascending its thirty rungs, watched over by angels on one side and hampered, or even pulled off the ladder, by demons on the other.

In the West a similar dream was experienced by the Benedictine reformer St Romuald of Ravenna (*c*. 950–1027), who was a close student of the desert fathers. His vision of monks dressed in white ascending a heavenly ladder prompted him to decree that the members of his austere Camaldolese Order should henceforth wear white robes.

A ladder also appears in paintings of the *Deposition and among the *Instruments of the Passion.

ladle One of the domestic utensils sometimes seen attached to the person of St *Martha, who was 'cumbered about much serving' (Luke 10:40) when Jesus and his followers lodged in her house.

lake, frozen *see under* Forty Martyrs of Sebaste.

lamb The emblem of St *Agnes. *See also under* Adoration of the Shepherds: Lamb of God; Last Supper; sheep.

Lamb of God (Latin: *Agnus Dei*) The image of Christ as the sacrificial lamb. Its history goes back to the early centuries of Christianity. In 692 the ecclesiastical Council in Trullo at Constantinople tried ineffectually to ban representations of *John the Baptist pointing to Christ in the form of a lamb. However, about the same time the liturgical formula known as the *Agnus Dei* was established by the pope in Rome as an independent section of the Mass. A little later, in the early 9th century, a wax medallion with the image of a lamb upon it was being made at Rome on the Saturday before Easter out of the remains of the previous year's Easter candle.

The representation of Christ as the Lamb originates in the words of the prophet Isaiah, 'he is brought as a lamb to the slaughter' (53:7), which were taken as foretelling Christ's death on the Cross. When John the Baptist saw Jesus approaching him to be baptized he exclaimed, 'Behold the Lamb of God, which taketh away the sin of the world' (John 1:29); consequently the Lamb of God is the usual emblem of John the Baptist. It is normally depicted with a halo and often appears with the *banner of the Resurrection and/or a chalice; sometimes it is shown lying on a book held by the saint.

A sacrificed lamb also appears on the table in contexts that symbolize the Eucharist, such as the *Philoxenia, and at the *Last Supper itself. *See also* Adoration of the Lamb.

Lamentation A group composition depicting the mourning over the dead body of Christ. In a cycle of Passion scenes it appears between the *Deposition and the *Entombment and features the same group of relatives and followers. *Compare* Pietà.

lamp An occasional attribute of several saints, symbolic of their role as shedders of light in darkness. St *Lucy is sometimes appropriately equipped with a lantern, while SS *Geneviève and Gudule may have one instead of their more usual *candle.

In the imagery of the book of Revelation seven burning lamps or candelabra represent the seven churches in Asia (Revelation 1:20) and the seven spirits of God (Revelation 4:5). Thus they sometimes appear in depictions of the *Last Judgement.

lance *see under* spear.

lantern *see* lamp.

Last Judgement (*or* Doom) God's final judgement of humanity after the general resurrection of the dead and the passing away of earth and heaven. It forms part of the apocalyptic vision of St *John the Divine: 'I saw the dead, small and great, stand before God; and the books were opened . . . and the dead were judged out of those things which were written in the books, according to their works' (Revelation 20:12) and 'whosoever was not found written in the book of life was cast into the lake of fire' (Revelation 20:15).

In mural schemes in Western churches the Last Judgement was generally placed over the arch or screen separating the nave of the church from the sanctuary, so that its powerful images were always before the eyes of the congregation in the nave. In churches under the influence of the Byzantine tradition the Last Judgement was often on the west wall of the nave (for example, in mosaic (early 12th century) in Sta Maria Assunta at Torcello and fresco (1072–87) at Sant'Angelo in Formis), so that it was the image that the congregation took with them as they left the building by the west door.

The Last Judgement was also employed on altarpieces; Rogier van der Weyden's *Last Judgement* polyptych (1443; Hôtel-Dieu, Beaune) incorporates most of the standard elements of the subject. Christ appears in glory seated upon a rainbow, flanked by angels (in this case holding the *Instruments of the Passion) and attended by the apostles and other saints. As the dead rise from their graves in the general resurrection, the virtuous are welcomed into the joys of heaven at his right hand and the damned are dispatched to hell on his left. The archangel *Michael, surrounded by trumpet-blowing angels, weighs souls and the Virgin Mary and John the Baptist intercede on their behalf.

Other compositions may not be as elaborate as this but still include many of the details of the Revelation account: the seven golden candlesticks (1:12), the sharp two-edged sword from Christ's mouth and the seven stars in his hand (1:16) and the book sealed with seven seals (5:1) all appear in a stained-glass quatrefoil in Bourges Cathedral (early 13th century).

An alternative image of judgement is based on the separation of the *sheep from the *goats (Matthew 25:31–46).

Last Supper Jesus' celebration of the Jewish Passover with his disciples in Jerusalem before the Passion. At this meal he instituted the Eucharist (Matthew 26:26–8; *see also* Communion of the Apostles), and because of the supreme importance of the Eucharist in the ritual life of the Church, the Last Supper was a frequent subject for artists, both on its own and as part of a cycle of Passion scenes.

Appropriately enough, a Last Supper often forms the main decoration of the

refectory (dining hall) of a monastery. In the East it is known as the Deipnos. The most famous Last Supper of all, Leonardo da Vinci's mural painted in the 1490s for the refectory of the monastery of Sta Maria delle Grazie in Milan, captures the moment of consternation among the disciples when Jesus announces that one of those eating with him will betray him (Matthew 26:21– 5). *Judas Iscariot, as the secret traitor, is set somewhat apart from the other disciples, or is even stealing away out of the door holding the disciples' joint purse, following the account given in John 13:26–30 ('Judas had the bag . . .'). The other disciple distinguished from the rest by position or action is St *John the Evangelist, traditionally identified with the disciple 'whom Jesus loved', who 'was leaning on Jesus' bosom' as they ate (John 13:23).

The lamb served up on the table in front of Jesus accords with the prescribed ritual menu for the Jewish Passover (Exodus 12:3–10), but is also a visual allusion to Jesus as the sacrificial lamb (*see under* Lamb of God). Bread and wine, as for the Eucharist, are also on the table or being brought to it, as in the Last Supper carved on the late 16th-century calvary in the churchyard at Guimiliau (Brittany), which also shows Judas clutching the bag.

Laurence, St (died 258) Roman martyr. The few certain biographical facts known about St Laurence are that he was a deacon in Rome and was killed during the persecution under Valerian, shortly after the pope, Sixtus II, was martyred. His cult was strenuously promoted by early Christian writers and spread all over Europe. His remains were preserved in the early 4th-century basilica of San Lorenzo fuori le Mura in Rome. Nearly two hundred and forty pre-Reformation churches were dedicated to him in Britain.

According to Spanish tradition, St Laurence was a Spaniard by birth, and

Philip II dedicated the Escorial to him in gratitude for the Spanish victory over the French at St Quentin, fought on the saint's day (10 August) in 1557. St Laurence is sometimes called 'the courteous Spaniard' on the basis of a legend that when the remains of St *Stephen were brought to Rome to be buried beside him he moved over to make room and held out his hand to the newcomer. In art the two are often paired.

St Laurence appears in art wearing the liturgical robes of a *deacon and holding a gospel book. The purse which he sometimes wears at his side alludes to the deacon's duty of dispensing alms to the needy. His usual emblem is a *gridiron, on which he was believed – with no historical basis – to have been roasted alive.

Lazarus (1st century) The brother of Mary and *Martha of Bethany, whom Jesus raised from the dead in one of his most dramatic miracles (John 11:1–46). The gospel narrative says that 'Jesus loved Martha, and her sister, and Lazarus' (John 11:5), and when he learnt of Lazarus' illness and death he set out for their home, against the advice of the disciples who were fearful of the hostility of the local Jews. Lazarus Saturday, the day before Palm Sunday, is a festival of the Orthodox Church, hence the frequency with which the Raising of Lazarus is seen in Byzantine and post-Byzantine art.

Because of its appropriateness to the theme of death and resurrection the subject occurs in funerary art from the 3rd to the 5th century. The catacomb artists focused on Jesus as wonder-worker, waving his staff over the shrouded body. From the 6th century artists began to take their cue from the details of the gospel narrative: 'the grave . . . was a cave and a stone lay upon it' (11:38) and 'And he that was dead came forth, bound hand and foot with graveclothes: and his face was bound about with a napkin. Jesus saith unto

them, Loose him, and let him go' (11:44). Artists also took note of practical Martha's objection, 'by this time he stinketh' (11:39), and, as the stone is removed and the body is drawn out of its resting place by the long bandage-like graveclothes, the bystanders shield their noses from the stench. The group is completed by the figure of Mary who kneels at Jesus' feet (11:32). All these features are present in the classic versions of the scene in both East and West, but the grave from which Lazarus emerges may be a vertical, rock-cut tomb (the 'cave' of John's account, as in most Byzantine icons) or a sarcophagus or even a grave under a church floor (as in the mid-15th-century panel, now in Berlin, by the Dutch painter Albert van Ouwater).

Like his sisters, Lazarus had a lively post-gospel existence in Christian legend: according to one tradition he became a bishop in Cyprus, but an 11th-century French legend makes him bishop of Marseille, and his remains are reputed to lie in the catacomb-like crypts under the basilica of St Victor there.

leek The popular emblem of St *David of Wales, and hence worn by Welshmen on St David's Day (1 March). The practice is very old and is alluded to by Shakespeare in *Henry V*, where the Welshman Fluellen says to his fellow Welshman the king. 'I do believe your Majesty takes no scorn to wear the leek upon Saint Tavy's day' (IV vii). Various attempts to account for the association include a legend that the saint told the Welsh to adopt the leek as their badge to distinguish them from their Saxon foes. This in turn may be a Christian rationalization of a pagan practice connected with a Celtic deity.

leg, horse's *see under* Eloi, St.

leg, human *see under* Cosmas and Damian, SS; Roch, St.

Leonard, St (6th century?) French hermit; patron saint of prisoners. Nothing is known for certain about St Leonard's life; his biography is based on an 11th-century account which has little or no historical value. *See under* chains.

leopard As a treacherous and devouring beast of prey, a guise of the Devil. A monstrous leopard-like beast is one of the manifestations of the powers of evil in the book of Daniel (7:6) and in Revelation (13:1–2). 'Can the Ethiopian change his skin, or the leopard his spots?' asks Jeremiah (13:23), meaning that such transformations are as unlikely as the habitual evildoer's transformation into a force for good.

leviathan A sea monster (Psalm 104:25–6). It was often equated with the whale that swallowed *Jonah, and thus acquired a more sinister aspect. Its bad reputation was perpetuated in medieval animal lore, as it was thought to lure sailors to destruction; unwary mariners would tie their boats to the huge back of a basking leviathan, believing it to be an island, or even disembark and walk about on it, and the creature would then suddenly plunge down into the deep, drowning them all. This deception made it an apt analogy for the Devil, the arch-deceiver, who lulls men into a false sense of security and so effects their ruin. *Hell-mouth in the art and drama of the Middle Ages was often portrayed as leviathan's engulfing jaws. In art leviathan is generally endowed with fishy fins and a serpentine tail but equally may appear more like a whale or dolphin.

Isaiah describes leviathan as 'that crooked serpent' (27:1) and it is therefore also linked with the Devil through the imagery of the *snake. An early 15th-century English poem explicitly refers to the first fiend who was cast out of heaven under the name of Leviathan.

light The universal symbol in all major religious traditions of the unknowable power, beauty and mystery of God. A biblical passage that influenced artists, writers and mystics in this respect is the description of God in the epistle of James: 'the Father of lights, with whom is no variableness, neither shadow of turning' (1:17). Christ too is described in terms of light: 'the true Light', according to John 1:9. A painting (*c.* 1120) from the Catalan church of San Clemente de Tahull shows Christ *Pantocrator with a book inscribed with the Latin text EGO SUM LUX MUNDI ('I am the light of the world' (John 8:12)). A similar composition in mosaic, dating from the late 12th century, survives in the apse at Monreale, Sicily.

Rays of light are used in art to indicate the presence of God, often emanating from a cloud or surrounding a *hand, *eye or *IHS monogram.

lily The flower most frequently associated with the Virgin Mary, especially in *Annunciation scenes. The white (or Madonna) lily is also an emblem of several virgin saints, notably St *Catherine of Siena, and those others like SS *Francis, *Dominic and *Antony of Padua who were noted for their purity of life. It is the attribute of the Erythraean Sibyl, who was believed to have foretold the Annunciation (*see* sibyls).

The lily and the two-edged *sword issuing from the mouth of Christ in Rogier van der Weyden's polyptych of the *Last Judgement symbolize respectively the reward of the innocent on his right hand and the guilt and punishment of those on his left.

lion One of the *Four Evangelical Beasts, the traditional symbol of St *Mark.

Of the other saints with leonine connections, St *Jerome is the one most often seen accompanied by his pet lion. Two lions sometimes appear with St *Paul the Hermit whose grave they dug at the request of St *Antony of Egypt. There are similar stories of lions digging graves in the desert associated with SS *Mary of Egypt and *Onuphrius.

In the case of the shadowy early martyr St Prisca, two lions refer to an attempt to put her to death by throwing her to the wild beasts; this failed when the lions refused to attack her. A similar story attaches to St *Thecla. The lions of St *Panteleimon may be no more than an over-imaginative reaction to the Italianized form of his name – Pantaleo(n) – with its leonine ending. A hero of Cypriot folk legend, the hermit St Mamas (identifiable with the shepherd Mamas of Cappadocia in Asia Minor, an early martyr of unknown date) hitched a ride on a lion when being taken under arrest to answer charges of non-payment of taxes; when he rode the beast into the court, the local ruler was so disconcerted that he readily acceded to the saint's view that cave-dwelling hermits should be exempt from property tax.

A lion with cubs is an emblem of the Resurrection. This arises out of the old belief, aired in medieval bestiaries, that lion cubs are born dead and that life is breathed into them on the third day by their sire, as God raised Jesus from the dead on the third day. Typical of the symbolic placement of this image, the lion with its cubs appears on the arm-rest of the throne of God in the *Trinity* panel of a diptych by Robert Campin (early 15th century; Hermitage, St Petersburg).

The Old Testament hero Samson can sometimes be identified by the lionskin that he wears, a trophy he obtained by killing a young lion with his bare hands (Judges 14:5–6). For the lion as a symbol of evil *see under* adder. For Daniel in the lions' den *see under* Daniel.

loaves The emblem of St *Mary of Egypt and the apostle *Philip. According to the

legend of St Mary of Egypt, she purchased three loaves of bread to take with her when she retired as a penitent into the desert. When St Philip is shown holding loaves the allusion is to his role in the *Feeding of the Five Thousand.

The loaves carried by St *Olaf of Norway are of stone. This is in reference to the story that he came across a maidservant who had been compelled to bake a batch of bread instead of attending to her prayers. Olaf thereupon turned three of her loaves to stone. *See also under* basket.

Longinus, St In ancient popular tradition, the *centurion who was in command of the Roman soldiers at the Crucifixion and later at the sepulchre. The name is based on the word's similarity to the Greek word meaning 'lance', as the centurion was identified with the soldier who pierced Jesus' side with his spear (John 19:34). A fabulous account of Longinus' later acts and martyrdom was soon in circulation; in the *Gospel of Nicodemus* he is improbably described as having been blind and as having his sight restored when blood from Jesus' side fell on his eyes, so he is sometimes shown raising his hands to his face.

Longinus became patron saint of Mantua and his cult flourished in parallel with that of the relic of the Holy Lance. It grew greatly in popularity after the First Crusade, in the course of which the Holy Lance (or, rather, one of the several claimants to be the Holy Lance) was discovered amid much controversy and publicity at Antioch.

Lot The nephew of *Abraham, who chose to settle in the city of Sodom in the Jordan valley. When God decided to destroy Sodom on account of the wickedness of its inhabitants, angels warned Lot to escape with his wife and daughters. However, Lot's wife looked back at the fire and brimstone as they rained down from heaven on Sodom and Gomorrah and was turned into a pillar of salt (Genesis 19:15–26). Many artists painted this dramatic scene, and moralists used Lot's wife to stand for all sinners who turn back to their sin even when offered grace and forgiveness.

In the sequel to Lot's escape from Sodom, also narrated in Genesis 19, he hid with his two daughters in a mountain cave. The daughters, realizing that they would find no husbands there and desperate to bear children, made their father drunk and committed incest with him; the sons born of these unions were the ancestors of the Moabites and Ammonites. Lot with his daughters was also a popular subject among artists.

Lucy, St (Lucia) (died 304) Virgin martyr from Syracuse in Sicily, of which she is patron saint. Having refused several suitors and given her wealth to the needy, she was denounced to the officers of the persecuting emperor Diocletian as a Christian. She survived various trials and torments unscathed but was eventually killed with a sword. Her legend relates that her torturers gouged out her eyes but that they were miraculously restored. An alternative version has her plucking out her eyes herself when a love-lorn suitor complained that their beauty was tormenting him. Hence she is sometimes shown displaying her eyes on a dish, and her aid is sought against diseases of the eye. The stories concerning her eyes are a late embellishment of her legend, prompted by her name (Latin: *lux*, 'light').

The cult of St Lucy was established at an early date in Italy. Her relics were taken to Constantinople but brought back to Venice by Venetian crusaders in 1204 and housed in a church that was demolished in 1863 to make way for the railway station which still retains her name; the relics are now housed in the nearby church of San Geremia. Her cult also spread at an early

date to northern Europe. Her feast day (13 December), being near the winter solstice and therefore the darkest time of the year in the northern hemisphere, has been turned into a festival of light in Sweden.

Luke, St (1st century) Evangelist; author of the third gospel and of the Acts of the Apostles. Of the four evangelists only Luke was a non-Jew, which perhaps accounts for the distinctive character of his gospel, as he was a gentile writing for a gentile audience.

Very early traditions present Luke as a Greek from Antioch who was a doctor by profession ('Luke, the beloved physician', Colossians 4:14). He appears in Acts as the companion of St *Paul on some of his missionary journeys and, writing from Rome, Paul tells Timothy that 'Only Luke is with me' (2 Timothy 4:11). Nothing is known for certain about Luke's later life, but according to one tradition he died at a great age in Greece. His relics were preserved at Thebes in Boeotia until 537, when Justinian had them removed to Constantinople.

Like the other evangelists, Luke is often depicted holding a book or scroll or writing at a desk. His evangelistic symbol is the *ox, the sacrificial beast, considered appropriate to him because his gospel begins with the story of the sacrifice of Zacharias in the Temple.

Predictably, Luke is the patron saint of doctors; less expected is his patronage of artists. A Byzantine tradition relates that Luke painted a portrait of the *Virgin Mary with the Christ Child on her left arm, and that the Virgin bestowed her blessing on the painting. Luke sent the picture to the 'most excellent Theophilus' in Antioch, along with the text of his gospel. Subsequently the icon was taken to Constantinople, where it became known as the Virgin *Hodegetria, perhaps the most famous of all icons. A prayer to St Luke is still recommended to icon painters in the Orthodox tradition before they embark upon a new icon.

In the late Middle Ages and Renaissance the subject of St Luke painting the Virgin and Child attracted several major Flemish and Italian artists. St Luke also gave his name to the medieval trade guild that embraced painters, sculptors, goldsmiths and other artists.

Lust One of the *Seven Deadly Sins.

lute A frequent attribute of St *Cecilia in late medieval art.

M

Madonna (Italian, 'my lady') A title of the *Virgin Mary, mainly, but not exclusively, used in the Roman Catholic Church, and also used of pictures and statues of the Virgin (with or without the Christ Child).

Maestà (Italian, 'majesty') A picture of the *Virgin Mary enthroned in glory and holding the Christ Child, with saints and angels in attendance. The composition seems to have evolved in Italy in the latter part of the 13th century, and works by Cimabue and Giotto (both in Uffizi, Florence) and by Duccio and Simone Martini in Siena are the earliest masterpieces on this theme.

Magi *see* Three Magi.

man One of the *Four Evangelical Beasts, the traditional symbol of St *Matthew. He is frequently shown as having wings but can be distinguished from an angel by the context in which he is found; this can be in association with the other three evangelists and their beasts – ox, lion and eagle – or else as an adjunct to a depiction of the evangelist at his writing desk.

mandorla *see under vesica piscis.*

Mandylion *see under acheiropoietos.*

Man of Sorrows A representation of Christ displaying his wounds, sometimes accompanied by the *Instruments of the Passion. Generally the upper part only of the figure is visible, standing in the open tomb. The head may be slumped in death,

eyes shut; the hands either hang limply or are crossed. Alternatively Christ may gaze directly at the viewer and gesture to the wound in his side.

The title is taken from Isaiah's prophecy relating to the figure known as the Suffering Servant, which was interpreted as foretelling the sufferings of Christ: 'He is despised and rejected of men; a man of sorrows, and acquainted with grief . . . Surely he hath borne our griefs, and carried our sorrows' (Isaiah 53:3–4). Paintings and sculptures of the Man of Sorrows were often employed as devotional objects.

The image is also known as the Christ of Pity. An early 14th-century mosaic icon in Sta Croce, Rome, was the probable prototype of the image in the West, but it had evolved some time before that in the Greek Church where it is known, also from the Isaiah passage, as the Akra Tapeinosis (Greek, literally 'peak of humiliation').

In Robert Campin's version of the Mass of St Gregory (Musées des Beaux-Arts, Brussels) the Man of Sorrows appears on the altar instead of the more usual *crucifix.

Margaret of Antioch, St (Marina) (? late 3rd century) Virgin martyr of Antioch in Pisidia (central Turkey); patron saint of women in childbirth.

Despite papal disapproval, beginning with Pope Gelasius in 494 who declared her legend to be apocryphal and ending with the banning of her cult in 1969, Margaret was one of the most venerated female saints in the later Middle Ages. With over two hundred and fifty church

dedications in England, she was only just outside the top ten dedicatees; the dedication to her of over a hundred English medieval bells is further evidence of the strength of her cult. In the Eastern Church she is honoured under the name of Marina, and her likeness was painted at the entrance to churches and later sometimes even on the 'royal doors' to the sanctuary, as it was considered able to ward off the powers of evil and forbid them entrance to the holy places. In this role she holds a small cross and gestures as if to repel an unwelcome approach. Marina is instantly recognizable by the bright red covering (*maphorion*) over her head and shoulders.

If Margaret existed at all, the core of her history has been totally engulfed by romantic embellishments. Her father, a pagan priest at Antioch, turned her out of his house when she became a Christian. She lived in obscurity as a shepherdess but nonetheless attracted the attention of Antioch's Roman governor who tried to seduce her or force her into marriage. When she defied him and proclaimed her Christianity she was tortured and thrown into prison. While in prison she had a debate with the Devil in the form of a dragon, who swallowed her alive. In response to her prayers, the dragon's entrails burst and Margaret escaped unharmed. In art she is therefore generally shown with the dragon writhing under her feet. Eventually she was beheaded.

Many versions of the legend of St Margaret survive from the Middle Ages. Her popularity was largely ascribable to the promises she made just before her death to the effect that those who called upon her or fostered her cult, in particular by building a church in her name, would be rewarded in heaven. For instance, a heavenly crown awaited those who read or copied her legend, a factor no doubt contributing to the large number of surviving versions. She also promised to help and preserve women in childbed and their infants, and this patronage was later extended to a more general concern with fertility and gynaecology. Because of the potent promises in her last words, she is generally numbered among the *Fourteen Holy Helpers.

Mark, St (died *c.* 74) Evangelist; author of the second gospel. There is a tradition that identifies him with the young man who was the last to persist in following Jesus after his arrest in the Garden of Gethsemane when all the other disciples had fled; he too eventually ran away, leaving behind his only garment in the hands of those who tried to detain him (Mark 14:51–2).

More definite biographical data emerge in Acts. 'John whose surname was Mark' accompanied Peter, Paul and Barnabas on various missions, and his mother Mary made her house available as a meeting place for the early Christians in Jerusalem (Acts 12:12). 'Marcus' is described as the nephew of Barnabas (Colossians 4:10) and as being with Paul during his imprisonment at Rome. Peter apparently refers to him with the affectionate phrase 'my son' in his first epistle (1 Peter 5:13). A very early tradition mentions Mark as Peter's 'interpreter', which gave rise to the notion of his gospel as being essentially the inspiration of Peter, to whom Mark acted as secretary.

The ecclesiastical historian Eusebius (*c.* 260–*c.* 340) augments the New Testament information with the statement that Mark later became the first bishop of Alexandria, where he eventually suffered martyrdom. Around 828 a body, claimed to be his, was discovered by Venetian merchants in the catacombs at Alexandria and carried off, with various miraculous incidents en route, to Venice. There he was adopted as patron saint, and the doge's private chapel was converted to house the precious relic. The present basilica of St Mark's, built around his sumptuous shrine, dates from the late 11th century.

As well as being the subject of some surviving mosaics in the basilica, the legend of the finding of St Mark's body was interpreted by several Venetian artists, among them Tintoretto.

Mark's evangelistic symbol, the winged *lion, became a familiar token of Venetian dominion over much of the eastern Mediterranean. The inscription on the open book which the lion usually holds reads PAX TIBI, MARCE, EVANGELISTA MEUS ('Peace to you, Mark, my evangelist'). One of the legends concerning St Mark told how, on one of his missionary journeys, he actually landed at the site where Venice was later to stand. There he was greeted in these words by an angel, who also foretold that his body would one day rest in that spot.

Like the other evangelists, Mark is often shown either writing at a desk or holding a book or scroll (*see* Four Evangelists) or else is simply represented by his emblem. He may accompany St Peter in the role of his scribe. Compared with the other evangelists, Mark was an infrequent dedicatee of English churches, with a mere six named after him.

Marriage at Cana The occasion of the first of Jesus' miracles, the transformation of water into wine at a wedding feast in Galilee (John 2:1–12). Mary and the disciples were also among the guests. It can normally be distinguished from other scenes of feasting by the prominently placed jars or other receptacles into which servants are pouring water at Jesus' command.

The event is significant not only as Jesus' first miracle, his first revelation of his divine power, but also for the turning of water into wine as a symbol of the Eucharist. In the art of the catacombs Jesus is shown pointing to the waterpots or holding his staff over them while the servants pour. Later the wedding guests and 'governor of the feast' are shown, their gestures expressing their astonishment, with Mary looking on or whispering to Jesus. In Byzantine church art the scene is set next to or balancing the *Feeding of the Five Thousand to indicate respectively the wine and bread of the Eucharist.

Martha, St (1st century) A woman of Bethany who with her brother *Lazarus and sister Mary (*see* Mary Magdalene) received Jesus in her house on several occasions. On one such visit Martha was 'cumbered about much serving' (Luke 10:40) and complained to Jesus that Mary, engrossed in listening to his words, had left all the burden of the entertaining to her. Jesus refused her request for Mary's assistance with the words: 'Martha, Martha, thou art careful and troubled about many things: But one thing is needful: and Mary hath chosen that good part, which shall not be taken away from her' (Luke 10:41–2). Martha also featured prominently in the miracle of the Raising of *Lazarus.

An extravagant history, in which Martha played a significant part, subsequently grew up around this household of Jesus' friends. According to medieval Provençal legend, they came to the south of France in the post-gospel period and there Martha vanquished a dragon-like monster called the tarasque which had been terrorizing the town of Tarascon. She sprinkled holy water over it and, when it was subdued, wound her sash about its neck and led it to Arles to be killed. Her reputed relics (since lost) were enshrined in the church at Tarascon that bears her name.

Martha appears in art leading along the captive tarasque by her sash. She also carries about her person some of the accoutrements of a medieval housewife: bunch of keys, ladle, broom. She is the patroness of housewives and is thought of as a model for those who lead an active, practical life, as opposed to a contemplative one, offering 'simple service simply

given to his own kind in their common need' (Kipling, 'The Sons of Martha', 1907).

Martin of Tours, St (*c.* 315–97) Missionary bishop; one of the patron saints of France. The facts of his life are documented in a famous but not entirely reliable biography written by his friend Sulpicius Severus.

Martin was born into a pagan military family in the Roman province of Pannonia (now in modern Hungary). After serving as a soldier for some years he became a Christian and a conscientious objector, for which he was imprisoned and discharged from the army. In the course of his subsequent travels, Martin became a disciple of Bishop Hilary of Poitiers, the scholar and theologian who did much to defend the orthodox faith in France against the Arian heresy. He took up his abode as a solitary at Ligugé, 8 km from Poitiers; there others joined him to form the first monastic settlement on French soil.

In 372 Martin was made bishop of Tours, apparently somewhat against his will, and in the same year he founded the great monastery of Marmoutier nearby. He was an energetic and sometimes ruthless missionary and stoutly defended the right of the Church to deal with heretics against the jurisdiction of the emperor. He also gained a formidable reputation as a miracle-worker and a healer of the sick, including lepers.

The incident for which St Martin is best known took place when he was still a Roman soldier, when he cut his military cloak in half to cover a shivering beggar. He then had a vision of Christ wearing the garment he had given to the beggar, and it was this that convinced him to become a Christian. The episode recalls the parable of the sheep and the goats (Matthew 25:31–46): Christ commends the righteous – 'For I was an hungred, and ye gave me meat . . . Naked, and ye clothed me' (35–

6) – and when they ask him in puzzlement when it was that they performed these charitable acts he replies, 'Inasmuch as ye have done it unto the least of these my brethren, ye have done it unto me' (40). The subject of Martin and the beggar was immensely popular with medieval artists in many media. He was usually visualized on horseback, in the act of drawing his sword to divide the cloak.

One of the earliest of all English church dedications known was to St Martin, the Romano-British church which St *Augustine took over at Canterbury, when he arrived on his mission to the English in 597. Over one hundred and seventy other English churches were dedicated to him. His fame also spread northwards through the Low Countries (where he is patron saint of Utrecht and Groningen) and the Rhineland into Germany, southeast into northern Italy and southwest into Spain. However it was in France that St Martin was most widely venerated with over four thousand ecclesiastical dedications and five hundred villages named after him. Under the Carolingian rulers of France, who by 710 had acquired the famous cloak as a prestigious relic, Martin's tomb at Tours became a major pilgrimage venue.

In Germany Martinmas (11 November, the date of his burial) superseded a pagan festival, which accounts for Martin's being considered there as a patron of merrymaking and of reformed drunkards. In the Scottish legal calendar Martinmas was one of the quarter days, and in many places in England fairs were held around that time at which servants could be hired. The spell of fine settled weather that sometimes occurs around Martinmas is known as St Martin's Summer.

Apart from the episode with the beggar and cloak, Martin appears in art in the scene known as the Mass of St Martin, which shows him celebrating Mass with a supernatural globe of fire above his head. Elsewhere, his emblem is a goose, an

association for which various explanations have been put forward. Suggestions include the fact that Martinmas falls at the time of year when wild geese are migrating in northern Europe or when the domestic birds were penned for fattening. Alternatively, an explanation may be sought in one of the traditions about his elevation to the bishopric of Tours, which tells how Martin hid from the people who had come to summon him to his new role, but that a noisy goose betrayed his hiding place.

Mary, the Virgin *see* Virgin Mary.

Mary of Egypt (?5th century) Penitent. After living for many years as a prostitute at Alexandria, Mary joined a pilgrimage bound for the Holy Land. In Jerusalem a supernatural force prevented her from entering the church of the Holy Sepulchre and she heard a voice telling her to withdraw to the desert and repent. There she spent the rest of her days, and shortly before she died she received Holy Communion from a monk named Zosimus. On his next visit he found her dead, and he buried her with the assistance of two lions who helped dig her grave.

Mary of Egypt is depicted with hair so long that it covered her body in place of the clothes that wore out during her desert sojourn. In this respect she could be confused – and was – with *Mary Magdalene, but she is often shown also with her distinguishing attribute of three loaves of bread. These were the rations which she took with her into the desert. The lion or lions that assisted at her burial are sometimes also present, or she may be accompanied by the emaciated, bearded figure of the monk Zosimus.

Mary's cult was popular in the Greek East from an early date and was also important at Naples, from which it reached England, possibly by the end of the 7th century, certainly by the 9th century. With its emphasis on penitence,

the cult flourished in the 12th century, but was later superseded and absorbed by the cult of St Mary Magdalene.

Mary Magdalene, St (Mary of Magdala) (1st century) Disciple of Jesus. Her New Testament 'biography' brings together episodes that probably involved several different women called Mary, and it is therefore regarded with suspicion by scholars.

Mary Magdalene is referred to in the gospel accounts of Christ's Passion as being present at the Crucifixion and as one of the women who came to his tomb with spices and found it empty (*see also Noli me tangere*; Three Marys). Both Luke (8:2) and Mark (16:9) mention the fact that Jesus had previously cast out 'seven devils' from her. This gave grounds for this Mary's being identified with the unnamed 'woman in the city, which was a sinner' who anointed Christ's feet with costly ointment in the house of Simon the Pharisee and wiped them with her hair (Luke 7:36–50). However, Mary of Bethany, sister of *Martha and *Lazarus, is also described by Luke as anointing Christ's feet shortly before his final visit to Jerusalem (John 12:1–9), so she too is sometimes identified with Mary Magdalene. (Against this last identification is the description of Mary Magdalene as among the women who had followed Jesus from Galilee (e.g. Matthew 27:55–6); her home town of Magdala has been identified with Taricheae on the western side of the Sea of Galilee.)

Her post-gospel history depends largely on whether or not the identification with Mary of Bethany is accepted. If it is, she was part of the migration of the Bethany household to the South of France, where she lived the life of a solitary penitent before dying at St-Maximin-La-Sainte-Baume in the Var (Provence). Her supposed tomb was found there in the 13th century. This discovery seriously embar-

rassed the rival claim to her relics that had formerly been established by the monks of Vézelay in eastern central France.

In the East the tradition was that she joined the household of the Virgin Mary and the evangelist *John and went with them to Ephesus on the western seaboard of Asia Minor. A further embellishment to the story was later added to the effect that Mary Magdalene had been betrothed to John before he renounced all worldly considerations to follow Jesus. Her tomb at Ephesus was on display to pilgrims early in the Middle Ages.

Artists seized upon the two most recognizable and well-attested features of Mary Magdalene: her long hair (worn either elaborately dressed to signify a courtesan, as in Veronese's pictures of her, or flowing loose to signify her repentance) and her pot or jar of ointment. From the 15th century onwards these attributes clearly set her apart from the other holy women in the scenes in which she appears. Also from the 15th century onwards in Western art she may be seen clasping the foot of the Cross in Crucifixion scenes. As the patroness of repentant sinners and of those who follow the contemplative life, her cult was widespread, with scores of church and bell dedications in both France and England.

Marys, the Three *see* Three Marys.

Mass of St Gregory *see under* Gregory I (the Great), St.

Mass of St Martin *see under* Martin, St.

Matthew, St (1st century) Apostle and evangelist; author of the first gospel. Matthew followed the despised profession of tax collector (Latin: *publicanus*) on behalf of the Roman provincial government of Palestine until Jesus saw him 'sitting at the receipt of custom' (Matthew 9:9) and summoned him to be one of his twelve principal disciples. The gospels of Mark and Luke refer to him under the name of Levi.

Following the Ascension Matthew is mentioned as being with the other disciples in Jerusalem (Acts 1:13) but after that no sure information about his movements survives. He was believed to have suffered martyrdom, though accounts differ as to whether this happened in Persia or Ethiopia. Likewise, the weapon from which he received his death blow is sometimes said to have been a sword, sometimes a halberd, sometimes a spear; in art he may appear with any of them.

More distinctive are a purse, moneybag, money box or even money scales, in allusion to Matthew's former profession as tax gatherer. These items, together with money lying on a table, are also usually visible in scenes showing Jesus summoning Matthew from his post. Late medieval artists sometimes fitted Matthew out with a pair of spectacles, perhaps seeing them as appropriate to one who had engaged in clerical and accountancy work.

In his role as evangelist, Matthew is seen either writing at a desk or holding a book or scroll. His evangelical emblem is a winged man, considered especially appropriate in that the opening of his gospel deals with the genealogy of Jesus. A modest thirty-three pre-modern English church dedications were made in his name.

Matthias, St (1st century) The apostle selected by lot to fill the gap in the apostolic ranks left by the treachery of Judas Iscariot (Acts 1:15–26). He has a place in both Eastern and Western calendars (9 August in East, 14 May in West) and is patron of engineers and butchers.

Virtually nothing is reliably known of him. Differing traditions link him with Asia Minor and the Caspian Sea area and with Ethiopia. He is sometimes associated with St *Andrew in some of the latter's

more fabulous adventures, but this may be through confusion with St *Matthew, who also features in some versions of these yarns. Confusion with St Matthew may also be implicit in the ascription to Matthias of a halberd as his emblem; on other occasions Matthias appears with an axe, so the uncertainty extends even to the instrument of his martyrdom.

Maurice, St (3rd century) Soldier saint and martyr of Egyptian origin. In art he is usually shown as an African dressed in the armour of a Roman soldier. His legend makes him leader of a band of Christian Roman soldiers recruited from the Thebes area of Egypt, the so-called Theban Legion. While serving in Gaul they were ordered either to sacrifice to the pagan gods or to massacre some innocent Christians (the various accounts of the martyrdom differ). Maurice led the troops under his command in a stubborn refusal, and they were themselves all put to death at Agaunum (now St-Maurice-en-Valais in Switzerland).

Besides soldiers, Maurice is also the patron of weavers and dyers. He is particularly renowned in the regions adjacent to the site of his martyrdom, being a patron saint of Piedmont and Savoy, but churches were dedicated to him much further afield, including eight in England. He is also a patron saint of Austria and of the Italian city of Mantua.

Melchizedek King and high priest of Salem (Jersualem) in the time of *Abraham. Abraham mounted a military expedition to defeat a confederacy of Canaanite kings who had carried off his nephew Lot, and when he returned in triumph Melchizedek brought him food and wine and blessed him (Genesis 14:18–20).

The writer of the epistle to the Hebrews discusses the Melchizedek episode and interprets his dual role of king and priest as prefiguring Christ. Thus Melchizedek's

offering of food and drink came to be taken as a symbol of the Last Supper (*see also* sacrifice).

Menas, St (Mennas) (died *c.* 300) Martyr, of either Egyptian or Phrygian origin; patron saint of merchants and desert travellers. His great shrine in the Western Desert near Alexandria was a famous pilgrimage centre from the 4th century onwards, and the ampullae in which pilgrims carried away water from his sacred pool have been found in many scattered locations. By the 12th century the shrine had been wrecked by repeated Bedouin attacks; it was not rebuilt until 1959.

According to his legend, Menas was a soldier in the Roman army, who was martyred in Asia Minor for confessing his faith. A fellow Christian brought his body to Egypt, in fulfilment of the saint's last wishes, and built a tomb for him at the spot where the camel carrying the saint's body stopped and refused to go further. In art Menas usually appears in Roman military dress, accompanied by one or two camels.

menorah The seven-branched candlestick symbolic of Judaism.

mice *see* mouse.

Michael, St Archangel; captain of the angelic army that drove Satan and his followers out of heaven (Revelation 12:7–9). He is a very frequent dedicatee of churches all over Western Europe, following immediately after St Peter in the English dedication lists. His cult originated in the East and the first church known to have been dedicated to him was at Constantinople, built by the Emperor Constantine himself. The cult then established itself in southern Italy and was consolidated by the two famous apparitions of the archangel, at Monte Gargano in Apulia in the last decade of the 5th century and at Rome. From Rome it

spread to Ireland, and Irish monks brought it to England and Europe; Michael is reported to have appeared on St Michael's Mount, Cornwall, in the 8th century, and the abbey of Mont St Michel off the northern French coast (refounded 966) claimed to possess his shield and sword as relics. Michael was particularly associated with high places and, because he was considered to be the guide of souls after death, also with cemeteries. His feast day, 29 September, commemorates 'St Michael and All Angels'.

Michael is generally shown in armour, brandishing his sword or spear in a gesture of triumph and trampling the vanquished serpent or dragon underfoot.

In scenes of the *Last Judgement Michael appears with a pair of *scales in which he weighs the souls of the dead. *See also under* archangels.

milk An emblem of spiritual nourishment. It was especially appropriate to the newly baptized: 'As newborn babes, desire the sincere milk of the word, that ye may grow thereby' (1 Peter 2:2). Milk was also said to have flowed from the veins of some beheaded saints, among them SS *Catherine of Alexandria, *Panteleimon and *Paul.

millstone A secondary attribute of the martyrs *Christina, *Vincent of Saragossa and *Florian.

mirror A flawless mirror (Latin: *speculum sine macula*) is an occasional symbol of the Virgin Mary. The image derives from the Old Testament Apocrypha description of wisdom as 'the unspotted mirror of the power of God, and the image of his goodness' (Wisdom 7:26). St Geminianus (?4th century), bishop and patron saint of Modena, has as an attribute a mirror in which appears an image of the Virgin Mary.

A mirror is also the principal attribute of

Prudence (*see under* Four Cardinal Virtues), signifying the self-knowledge that comes through reflection.

mitre Since the 11th century, the pointed ceremonial head-dress of a bishop or archbishop in the Western Church. It is less commonly worn by a pope or abbot. The form of the mitre worn on feast days and most Sundays is elaborately decorated, often with jewels; a plain white silk mitre or one of cloth of gold is worn on other occasions.

A mitre is generally a distinguishing mark (with the other regalia, e.g. *crozier) for those saints who held episcopal rank. In the case of the Franciscan friar Bernardino of Siena (1380–1444) who refused three bishoprics, three mitres may lie at his feet to symbolize the rejected honours.

model *see under* building.

moneybag *or* **money box** An attribute of St *Matthew, particularly favoured by English medieval artists. *See also* purse.

monk *see* habit.

monsters *see* devils; dragon; hell-mouth; leviathan.

monstrance A receptacle in which the bread consecrated at the Eucharist may be shown to worshippers. Its usual form is a glass box set in an elaborate rayed frame on a stem and base. Alternatively, a monstrance can be used to exhibit relics. St *Clare is often portrayed as a nun holding a monstrance. In northern European art a bishop holding a monstrance may be St *Norbert. *See also* pyx.

moon *see under* sun.

Moses Jewish lawgiver; leader of the Israelites on the Exodus from Egypt and subsequent wanderings in the desert. In

Jewish tradition the first five books of the Old Testament are ascribed to him. One of the towering figures of the Old Testament, he provided plenty of subjects for narrative art in his eventful life, as described in the book of Exodus.

Hidden as a baby among the rushes of the River Nile to save him from Pharaoh's decree against male Israelite children, he was discovered by Pharaoh's daughter and brought up as her son (Exodus 2:1–10) until he killed an Egyptian and was forced to flee into the land of Midian (2:11–22). While tending the flock of his father-in-law in the desert, Moses was summoned by God who spoke to him out of a burning fiery bush (3:2–4:17) and appointed him to lead the Israelites out of their captivity in Egypt to the Promised Land.

With the aid of *Aaron, Moses brought down ten plagues upon the Egyptians and eventually compelled Pharaoh to let the Israelites go. God provided a safe passage for them through the Red Sea, but when the Egyptian army pursued them it was overwhelmed in the waters (14:5–31).

Divinely guided by a pillar of cloud the Israelites travelled through the desert, fed by manna and quails from heaven (16:11–31). When they were thirsty Moses struck water from the rock (17:1–7). On reaching Mount Sinai the Israelites made camp there and Moses ascended the mountain to receive God's commandments for his people. While he was absent the Israelites fell into the idolatry of the *Golden Calf for which they were severely punished when Moses returned. The final scene from Moses' life is his view of the Promised Land from Mount Nebo shortly before his death (Deuteronomy 34:1–6).

In the New Testament Moses appeared at the *Transfiguration, representing the Law, which Jesus had come to fulfil, and various episodes from his life were subsequently given a Christian interpretation.

For instance, the brazen serpent that Moses set upon a pole to cure the people suffering from snakebite (Numbers 21:6–9) was seen as a type of Christ upon the Cross who restores life to all who look on him. The striking of water from the rock was interpreted as prefiguring Christ's saving gift of 'spiritual drink' (1 Corinthians 10:4).

The universal attribute of Moses is the two tablets of stone on which God inscribed the Ten Commandments (Exodus 31:18). He is usually depicted as a mature and heavily bearded figure with a commanding aspect, interpreting the text that declares 'Moses was an hundred and twenty years old when he died: his eye was not dim, nor his natural force abated' (Deuteronomy 34:7). He very often has * horns on his head, less often rays of light shining from his face. A counter-tradition found in some Byzantine art has Moses as a beardless man in early maturity.

mountain In the Bible, very often a holy place. Christ's *Transfiguration and *Ascension were both mountain-top events, as was God's giving of the Ten Commandments to *Moses. Mountains were also vantage points: for instance, Mount Nebo for Moses to survey Promised Land (Deuteronomy 34:1–4), 'an exceeding high mountain' where the Devil tempted Jesus with 'all the kingdoms of the world, and the glory of them' (Matthew 4:8) and the 'great and high mountain' from which St John viewed the New Jerusalem (Revelation 21:10). A mountain with four rivers flowing from it is a symbol of Paradise.

mouse The emblem of St *Gertrude of Nivelles. *See also* rat.

Myrrophoroi *see* Three Marys.

N

nails The nails with which Jesus' hands and feet were fastened to the Cross form part of the set of *Instruments of the Passion. They may appear in a set of four but more generally they are three in number, as late medieval crucifixes show both his feet pierced by a single nail. The English medieval *boy saint William of Norwich, supposedly crucified by Jews in parody of the Crucifixion, sometimes holds three nails, and nails may also be associated with St *Helen, finder of the True Cross.

Name of Jesus *see under* IHS.

Nativity The birth of Christ, celebrated on 25 December (Christmas). Next to Easter, it is the major Christian festival. In the East, although it is one of the twelve great feasts, it is somewhat overshadowed by the celebration of the *Epiphany.

In art, the Christmas story from the gospel of Luke (2:1–20) is combined with the account of the *Three Magi from Matthew (2:1–12) to provide the dramatis personae and most of the elements of the typical Nativity scene: Virgin Mary, baby Jesus, St *Joseph, angels, shepherds and kings in a stable or barn. The stable is often shown as ruinous, symbolizing the state of the world before Christ came to redeem it. Icon painters in the East often add the figures of the midwives preparing to wash the baby and show the scene of the birth as a *cave, rather than a stable; both these features are derived from apocryphal gospels. *See also* Adoration of the Shepherds; Adoration of the Virgin; ox and ass.

Navicella *see under* boat.

necklace *see* rosary.

negro St *Maurice is usually represented as a black man wearing Roman legionary armour. *See also under* Cosmas and Damian, SS

net *see* fishing net.

Nicholas of Myra (*or* of Bari), St (4th century) Bishop of Myra on the southern coast of Asia Minor; patron saint of Russia. Greatly venerated as a miracle-worker by both Eastern and Western Churches, St Nicholas has a number of patronages and a biography in which any factual content is almost entirely overlaid by legend. His concern for the helpless, particularly children, makes him a pre-eminent example of the bishop as the good shepherd of his flock. The Russian saying, 'If anything should happen to God, we have always got St Nicholas', encapsulates both his omnicompetence and the affection with which he is regarded. In the West his character as benevolent gift-bringer, especially to the young, coupled with a feast day on 6 December, has given rise to the figure of Santa Claus.

In both East and West Nicholas is depicted in the robes of a bishop. Orthodox artists visualize him as an elderly man wearing the *omophorion, with a neat, wavy grey beard, receding grey hair and a prominent forehead. Very often he is surrounded by miniature scenes from his legend: as a baby, refusing his mother's breast on Wednesdays and Fridays;

throwing three purses of gold into the house of an impoverished nobleman (*see under* ball); stilling the storm when the ship he was travelling in nearly foundered, rescuing three sailors in similar peril; reviving three children who had been murdered and thrown into a brine tub (*see under* child). He is therefore invoked as the patron saint of children and sailors, as well as of unmarried girls and pawnbrokers.

Churches were dedicated to St Nicholas in the East from at least the 6th century and his reputation was greatly enhanced by a popular 9th-century 'biography' detailing his various miracles. When the Muslims overran Asia Minor in the 11th century, the relics of St Nicholas were taken from Myra to Bari in southern Italy (1087). There a magnificent church was built to house them and pilgrims came to his shrine from all over Europe. The so-called 'myrrh' or 'manna' produced there assured St Nicholas of yet another patronage, that of the perfumiers. As the patron of sailors, he is the dedicatee of churches in ports or close to the waterfront in many European countries. In the list of English dedications he outranks all the apostles save *Peter and *Andrew and appears immediately after *John the Baptist, with around four hundred and thirty churches.

Nicholas of Tolentino, St (1245–1305) Italian friar, named after St Nicholas of Myra, at whose shrine in Bari his parents had prayed for a son. He joined the Augustinian Order of friars, in the black habit of which he is usually depicted. In 1275 he settled at Tolentino, not far from his birthplace of Sant'Angelo in Pontara in the March of Ancona, where he gained a great reputation as a preacher and as a minister to the poor, the sick and the dying. His charitable work was epitomized in 'St Nicholas' Bread', which he is often shown distributing (*see under* basket). A star on his breast alludes to the legend that a star appeared at his birth, blazing across the sky from Sant'Angelo to Tolentino. He sometimes holds a crucifix with lilies to signify the purity of his life.

nimbus *see under* halo.

Nipter see under Washing of the Feet.

Noli me tangere (Latin, 'Do not touch me') The words of Jesus to *Mary Magdalene when he appeared to her in the garden outside the tomb, after he had risen from the dead (John 20:14–17). The words are used as the title of works of art showing this meeting.

Norbert, St (*c.* 1080–1134) German bishop; founder of the Premonstratensian Canons (also known as the White Canons on account of the colour of their habits). Norbert was a member of a noble family, and his early life and experiences as a canon gave no indication of his later rejection of worldliness. In 1115 he underwent a profound change of heart which led him to become a wandering preacher in France. He eventually settled at Prémontré near Laon in 1120 with thirteen disciples, who became the basis of his order. In 1126 Norbert was appointed archbishop of Magdeburg in northeast Germany. In all these roles he was a strenuous reformer of ecclesiastical abuses.

In art St Norbert appears in his bishop's robes either holding a *monstrance (in reference to the name of his order) or a cup with a spider on it. The latter refers to the story that one day at Mass he found a venomous spider lurking in the chalice; rather than waste the consecrated wine Norbert drank it down and suffered no ill effects.

Notburga, St (*c.* 1265–*c.* 1313) Domestic servant who passed all her life at Rattenberg in the Tyrol; patron saint of servants and labourers in the Tyrol and Bavaria. Despite her own poverty, she deprived

herself of food to help the poor. Her emblem is a sickle, which levitated out of reach when her employer tried to force her, against her conscience, to reap on a Sunday.

nun *see* habit.

O

ointment pot (*or* ointment jar) The emblem of St *Mary Magdalene.

Olaf, St (Olaf Haraldsson) (995–1030) King of Norway (1016–29) and its patron saint. In the course of a successful career as a Viking freebooter, which took him all over northern Europe, Olaf was converted to Christianity in Normandy. Having seized the crown of Norway, he imposed a strict rule of law in his turbulent country, but his strong-arm methods of forcing Christianity upon his subjects, coupled with discontent among his nobles, lost him his kingdom. An attempt to regain the throne the following year ended in his death at Stiklestad, near Trondheim.

Miracles were soon reported at the site of Olaf's grave, and after his son Magnus ousted the Danes from Norway, he enshrined Olaf's remains in the cathedral at Trondheim. There they became the focus of a thriving cult for pilgrims from the Scandinavian countries. In the areas of Britain in which Viking influence was strong more than forty churches were dedicated to him (his name may be corrupted to Olave or Ola, Tola or Tooley).

Olaf is usually depicted in art as a warrior prince holding a battleaxe and/or three *loaves.

olive branch The symbol of peace. The olive leaf that the dove brought back to Noah on the Ark when the Flood began to recede from the earth (Genesis 8:11) symbolizes the peace that God made with mankind (*compare* rainbow). Frequently seen in early Christian funerary art, the olive twig held in a dove's beak represents the peace of the departed soul.

In some paintings of the *Annunciation the angel Gabriel carries an olive branch as a token of peace, instead of the more usual *lily. This is particularly the case in works by medieval Sienese artists, who tended to shun the lily as the emblem of Siena's great rival, Florence.

olive tree In depictions of the *Ascension, olive trees may be shown to signify the location on the Mount of Olives. St *Panteleimon was beheaded under an olive tree.

Omega *see* Alpha and Omega.

Omobono, St (Homobonus) (died 1197) Italian merchant; patron saint of tailors. Omobono was born and lived at Cremona, where his charitable and pious life was a model of Christian living in the community and led to his canonization a mere two years after his death. In art he is usually shown with the clothworker's scissors as his emblem and also a purse to symbolize his charity.

omophorion The long strip of white cloth, embroidered with crosses, signifying the rank of bishop of the Orthodox Church. It is worn loosely around the neck and shoulders in such a way that one end hangs in front and the other at the back of the wearer. Traditionally the preferred material was wool, as it was interpreted as early as the 5th century as symbolizing the sheep to whom the bishop was to be the good shepherd. The comparable garment

in the Western Church is the Y-shaped
*pallium.

Onuphrius, St (4th century) Egyptian
hermit, who lived as a solitary in the desert
for sixty years. He is shown in art as a
wizened old man, with only a wreath of
leaves and his long white hair and beard to
conceal his nakedness. Sometimes two
lions are shown beside him, recalling a
legend associated with several desert
saints, that when they died lions helped to
bury their bodies.

orange Sometimes believed to be the fruit
with which Satan tempted Eve at the Fall,
instead of the more usual *apple. Like the
apple, it may appear in pictures of the
Virgin and Child to signify the redeeming
purpose of the Incarnation.

The white blossom of the orange is a
symbol of purity, and therefore associated
with the Virgin Mary, and, more general-
ly, with bridal wreaths. Both orange and
lemon trees bear blossom and fruit at the
same time and are therefore appropriate to
the Virgin in her dual role of maiden and
mother.

orans (Latin, 'praying') The posture of a
standing figure, particularly common in
early Christian funerary art, with both
hands held up at head or shoulder height,
palms outward, in prayer. On gravestones
and graffiti in the catacombs *orans* figures
represent the souls of the deceased.

The adoption of this posture in prayer
died out at the end of the late antique era,
but survived rather longer in depictions of
the Virgin Mary as a suppliant in the
convention known as the Virgin *orans*.
When shown in this pose, the image is
sometimes called the Virgin Blachernitis-
sa, apparently after a marble image housed
in the 10th century in the monastery of
Blachernai, Constantinople, which had
holy water flowing from the Virgin's raised
hands (*compare* Platytera).

orb *see under* globe.

organ In Renaissance art, the principal
emblem of St *Cecilia as patron saint of
music.

Oswald of Northumbria, St (*c.* 605–42)
Martyred king of Northumbria. Oswald
converted to Christianity in his youth
while in exile at Iona. His personal en-
couragement of the missionaries under the
Irish St Aidan (died 651) ensured the
establishment of Christianity in Northum-
bria, but he ruled only eight years before
being killed in battle by the heathen
Penda, king of Mercia. With his dying
breath he prayed for the souls of his
bodyguard, slain around him.

Parts of Oswald's body, mutilated on
Penda's orders, were retrieved as relics,
and from the 8th century onwards Anglo-
Saxon missionaries spread his cult beyond
the British Isles to Frisia, Germany and
even further afield. Miracles were also
reported from the spot where he died. His
efficiency as an intercessor is vouched for
by Bede in his *History of the English Church
and People* (iv. 14) who describes how,
some years later, on the anniversary of his
death, Oswald caused a fatal epidemic in
Britain to be halted. Around seventy
churches were dedicated to him in
England, with many others on the Conti-
nent. In art Oswald is depicted as a
crowned warrior.

owl The bird of darkness, and therefore
sometimes used in Christian art to symbo-
lize what was seen as the benighted state of
the Jews in their refusal to recognize Christ
as the Messiah. When the owl appears in
the company of St *Jerome it is more in its
ancient pagan character of the bird of
wisdom, formerly associated with the
goddess Athene.

ox One of the *Four Evangelical Beasts,
the traditional symbol of St Luke. It is also
associated with St *Thomas Aquinas.

ox and ass Beasts almost universally present in *Nativity scenes, although they are not mentioned in the gospels (or even apparently in the apocryphal gospels before the 8th century). Besides their appropriateness in a stable setting, there is Old Testament authority in the words of Isaiah for their presence at the first manifestation of the Son of God on earth: 'The ox knoweth his owner, and the ass his master's crib; but Israel doth not know, my people doth not consider' (1:3). The animals may therefore symbolize the recognition of Jesus as lord by the natural world (sometimes they are shown kneeling before him), in contrast with the Jews' rejection of him.

Alternatively, the ox may be interpreted as representing the Old Testament and the ass the New.

P

painter An artist painting a picture of the Virgin and Child is St *Luke.

pallium The white woollen band with a strip hanging down in front and behind to make a Y shape, worn round the shoulders of archbishops. It is marked with six dark crosses. As a sign of episcopal authority, bestowed by the pope, it is very frequently seen in art as a distinguishing mark of prelates. *Compare* omophorion.

palm frond The universal emblem of martyrs. The association is based on the passage in Revelation 7:7–17, describing the 'great multitude, which no man could number, . . . clothed with white robes, and palms in their hands, . . . which came out of great tribulation. . . '. Individual martyrs often carry their personal identifying emblem in addition to the palm.

For the palm frond held by St John the Evangelist, *see under* Dormition. For the palms thrown before Christ on Palm Sunday *see* Entry into Jerusalem.

palm tree The emblem of St *Paul the Hermit, who is sometimes shown dressed in palm leaves. The tree that St *Christopher uprooted to act as a staff, and which sprouted when he planted it in the ground after he had carried Christ across the ford, is also sometimes visualized as a palm tree.

Panteleimon, St (Pantaleon, Pantaleone, Pantalon) (died *c.* 305) Martyr. According to the fullest version of his legend, Panteleimon (not his original name) was the son of a pagan senator of Nicomedia in Asia Minor. He studied medicine, was converted to Christianity, and worked miraculous cures by invoking the name of Christ. He accepted no money for his treatments, so is counted among the *Anargyroi.

He was arrested and tortured, but the emperor's lions, boiling lead and swordsmen had no power against him. His prayers for his torturers earned him the name of Panteleimon (Greek, 'all-compassionate') and also a place among the *Fourteen Holy Helpers. He was eventually beheaded, and milk, instead of blood, spouted from his neck and the olive tree under which he died immediately became covered with fruit.

Apart from cycles of scenes from his life and passion, Panteleimon appears in Byzantine art as a young man, curly-haired but beardless, holding a pyramid-shaped physician's box and/or scalpel. His popularity spread to the West, and his shrine at Ravello in Italy gained particular renown for the cures worked there upon those who were apparently beyond medical help.

Pantocrator (Pantokrator) (Greek, 'all-ruling') An epithet applied to God the Father and God the Son, but especially in Byzantine art to an icon type of Christ in painting or mosaic. The figure of Christ is shown as a bust or half-length with right hand either raised in blessing or admonition or pointing to the gospel book held in his left hand. His face is bearded and the features stern and majestic; his gaze is directed towards the onlooker. A cross is inscribed on his halo, and the monogram IC XC (comprising the first and last letters

of 'Jesus Christ' in Greek) is often present on either side of his head or in the halo itself.

The image of Christ Pantocrator was frequently placed in the main dome of a Byzantine church, as the culmination of the decorative scheme. An alternative placement is over the main entrance to the nave, the idea in this case being to convey the concept of Christ as the *door to salvation.

Parousia (Greek, literally 'advent') The second coming of Christ. In early Byzantine art it is often shown in symbolic form by the *hetimasia*, the *throne prepared for Christ in glory. *See also* Last Judgement.

Passion, Instruments of *see* Instruments of the Passion.

Patriarchs Old Testament founders of the human race, including Adam, Noah, Abraham, Isaac and Jacob. They are shown, white-bearded and venerable, as one of the groups of the righteous whom Christ brought out of hell in depictions of the *Harrowing of Hell or *Resurrection.

Patrick, St (*c*. 390–*c*. 460) Romano-British bishop; patron saint of Ireland. Knowledge of his life rests largely on his own writings, which were later much embellished with legend. At the age of sixteen he was carried off as a slave by Irish pirates, possibly to Co. Mayo. During the next six years he became a practising Christian and after he was freed (or made his escape) he received instruction for the priesthood, possibly in France under St *Germanus of Auxerre. A dream recalled him to Ireland to preach the gospel there. The centre for his mission was in the north, and he established a bishopric at Armagh in 444.

In art St Patrick is shown in his episcopal robes and holds a leaf of clover (trefoil or shamrock). He is said to have used the plant to demonstrate the three-in-one nature of the Trinity to the pagans whom he was sent to evangelize. He may also be shown treading a snake underfoot, in allusion to the story that he banished snakes from Ireland. The cult of St Patrick spread to the rest of the British Isles and to the Continent and is now worldwide in every place where there is an Irish community.

Paul, St (died *c*. 65) Apostle and martyr. Much of Paul's biography is traceable through Acts and the epistles that he wrote to the fledgeling Christian communities, but his activities were also chronicled early on in some apocryphal texts, the most popular of which was the 2nd-century *Acts of Paul and Thecla*. He is honoured in both Eastern and Western Churches not only for the example of his life but also as a great Christian thinker.

Paul was brought up under the name of Saul as a devout Jew. He became a persecutor of the Christians and was present at the stoning of St *Stephen: 'and the witnesses laid down their clothes at a young man's feet, whose name was Saul' (Acts 7:58). While travelling to Damascus to extend his persecution there, he experienced a vision of Christ that temporarily blinded him and brought about his conversion. Both these incidents have attracted numerous artists.

Paul's three great missionary journeys earned him the title of 'Apostle to the Gentiles'. Details of the end of his life are obscure, but a very ancient tradition maintains that he was beheaded at Rome during the persecution of the Christians under Nero. The name of the supposed site of his martyrdom – Tre Fontane – is accounted for by the fable that his severed head rebounded three times from the ground, causing three fountains to gush forth. The site of his tomb was where the basilica of San Paolo fuori le Mura now stands. Paul shares a feast day with St *Peter (29 June),

which has probably given rise to the belief that they died on the same day, and together they are known as 'the Princes of the Apostles'. A very popular subject in art was the meeting of SS Peter and Paul just before they were put to death; their embrace signifies the harmony of the Church. Acts 28:15 describes how 'brethren' from Rome, hearing of Paul's approach as he was brought under guard on the final stage of his journey from Jerusalem, came out to meet him 'as far as Appii Forum and the three taverns'; it was assumed, although not stated in Acts, that Peter was among their number.

The tradition of depicting Paul as a distinguished-looking man with receding brown hair and pointed beard was fixed as early as the 4th century. (The conventional depiction of St Peter, with whom Paul is so often paired in art, was fixed at a similar early date.) Particularly in Byzantine art, Paul's high forehead, pronounced eyebrows, long nose and penetrating gaze are intended to convey his intellectual pre-eminence through an imposing physical presence, although the *Acts of Paul and Thecla*, on which this traditional description is partly based, also describes him as being short and bandy-legged. His two emblems are a book to denote his status as thinker and teacher and the sword of his martyrdom.

Paul very often appears in sets of the *Twelve Apostles instead of the obscure *Matthias. In cases where the apostles are divided into two groups (on either side of a church porch, for instance), he and St Peter are usually placed at the groups' heads. Because of his importance, Eastern artists in particular show him as present in scenes such as the *Ascension and *Pentecost, although, according to the historical sequence of events in Acts, both these took place before his own conversion. Although Paul is greatly honoured in both Eastern and Western traditions, his close association with St Peter and the austerity of his image as projected in the New Testament and in art have militated against the growth of an individual cult. For example, in England church dedications to Peter and Paul jointly outnumber those to Paul alone by more than six to one.

Paul the Hermit, St (Paul the Theban) (died *c*. 343) Egyptian ascetic, often credited with being the first hermit. He is sometimes called Paul the Theban on account of his having lived in the Thebaid (the area around Thebes in Egypt). The monastery called after him was probably founded at the beginning of the 5th century, and it still exists in the Eastern Desert, near the Red Sea. His relics are believed to have been taken to Constantinople, thence to Venice, and finally to Budapest, and in the 15th century the monastic order to Paulines was founded in Hungary under his protection.

Paul often appears in art with St *Antony of Egypt. His emblems are the palm tree that provided him with food and shelter, the raven that fed him in the desert and the two lions that dug his grave.

peacock The symbol of immortality. In the ancient world its flesh was thought to be incorruptible, and it was therefore an appropriate symbol of the Virgin Mary, who did not die but was taken up bodily into heaven (*see under* Dormition). It often appears in Annunciation or Nativity scenes and other portrayals of the Virgin. The bird was also appropriate to the Virgin in its regal connotations as it had earlier been the bird associated with another Queen of Heaven, the Roman goddess Juno.

In early church architecture and funerary art pairs of peacocks were a very popular motif in mosaics and relief sculpture. From the 4th century they frequently appear in paradise gardens, drinking from a fountain or well, to symbolize the eternal life of the Christian after death. This is the

significance implicit in the peacock feather sometimes held by St *Barbara.

In some depictions of *seraphim and other angelic beings their wings are covered with peacocks' feathers, the 'eyes' of which represent the eyes on the wings of the apocalyptic beasts 'full of eyes within' (Revelation 4:8)

Pedilavium *see under* Washing of the Feet.

pelican ('in her piety') The emblem of unselfish love, and thus of the love of Christ for the world. The pelican was believed to stab her own breast with her beak so that her blood might provide sustenance for her young, and was often shown in medieval art performing this act of self-sacrifice. Occasionally a pelican in her piety may be seen above the Cross in a Crucifixion scene, but more often it is carved as a motif on the finial of a staff or on a misericord or other seat.

pen (and book) *see under* writer.

pentangle A five-pointed figure also sometimes called a pentacle or pentagram. The pentangle in a circle, still seen in synagogues and also in freemasonry, is known as Solomon's seal since it was believed to have been set upon the temple built by Solomon in Jerusalem; as such it had magical associations. A five-pointed figure was also used in classical antiquity as a symbol of perfection by the Pythagoreans and others. In the Christian Middle Ages it seems to have been used as a mnemonic for the five wounds of Christ or the Five *Joys of the Virgin. The Middle English poem *Sir Gawain and the Green Knight* calls it 'the endless knot' (1.630) and it appears in this form on the south exterior wall of Adderbury church, Oxfordshire.

Pentecost (Whit Sunday) The church festival commemorating the descent of the Holy Spirit to the disciples as Jesus had promised (John 14:16–17, 26). The name derives from the Greek for 'fiftieth', as it took place on the Jewish festival of Weeks, fifty days after the Passover and thus fifty days after the Resurrection. It is one of the twelve great feasts of the Orthodox Church.

Artists took their cue from Acts 2:1–3, showing the Holy Spirit in the form of 'cloven tongues like as of fire' appearing over the heads of twelve apostles who are sitting together around a table. Artists in the Western tradition from Giotto onwards often showed the Holy Spirit in the form of a dove as well, hovering above the scene, but this tended to be avoided by artists of the Orthodox tradition as departing from the text of Acts.

Both traditions however often allow the unbiblical inclusion of St *Paul, usually in a place of honour among the disciples, next to or facing St *Peter. The two evangelists SS *Luke and *Mark may also be identifiable, although, like St Paul, neither of them had a place among the original twelve. In Orthodox icons an old man with a crown and twelve scrolls may appear in a dark space under the table; this figure represents the benighted world, whose darkness is about to be enlightened by the teachings of the apostles.

Peter, St (died *c.* 64) Apostle and martyr. With his brother *Andrew, Peter was the first of the twelve chosen by Jesus as his disciples and he played a significant part in many of the events narrated in the gospels. Originally called Simon, he was singled out for prominence when Jesus renamed him Peter (Greek: *petros*, 'stone'): 'thou art Peter, and upon this rock I will build my church' (Matthew 16:18). He emerges from the narratives as a natural leader and spokesman of the disciples, although sometimes headstrong and incautious in word or deed. He was one of the disciples

chosen by Jesus to witness the *Transfiguration.

Peter's prominence increases in the course of the Passion narrative: John describes his reaction to Jesus' washing of his feet (13:6–10) and identifies him as the disciple who struck off the high priest's servant's ear (18:10), and all four gospels recount Jesus' prophecy that before the *cock crows three times Peter will deny being one of his followers. Jesus appeared to Peter after the Resurrection, charging him to 'Feed my sheep' (John 21:15–19), and after Pentecost Peter led the disciples' ministry of preaching and healing in Jerusalem. When Herod cast him into prison he was freed by an angel and so made his escape. (The *chains of St Peter became famous and widely distributed relics.)

After the conference at Jerusalem (*c.* 50), although Peter was by then the acknowledged leader of the disciples, Acts falls silent about the later part of his life. However, in addition to the two epistles ascribed to him, there are a number of early apocryphal writings, and a very ancient tradition states that he went to Rome and suffered martyrdom there, perhaps by being crucified head downwards or, more likely, by beheading. An oratory was built over the site of Peter's tomb in Rome; this was succeeded by a basilica (dedicated 326) and eventually, in the 16th century, Bramante's and Michelangelo's great edifice. Peter is thus particularly connected with Rome and with the papacy, which derives its authority in direct succession from him, and because of this pre-eminence his cult spread rapidly throughout Western Europe. York Minster (founded 627) was among the earliest English dedications to St Peter, and over eleven hundred other churches followed suit. In the East, on the other hand, his natural eminence as leader of the apostles was somewhat diminished after the split between the Orthodox and Roman Catholic Churches on account of his intimate association with the papacy.

Peter is very often linked with St *Paul under the title 'Princes of the Apostles'. The convention of depicting Peter with short-cropped grey hair (or even a clerical tonsure) and neatly rounded beard was fixed by the 4th century, about the same time as Paul's long beard and tendency to baldness. In Bede's *History of the English Church and People* (completed 731), a boy who has seen a vision of the two apostles tells a priest that one 'was tonsured like a priest, and the other had a long beard' (iv. 14), a description that was sufficient to convince the priest of the identity of the boy's visitors. Peter and Paul often appear together in art.

Apart from his physical appearance, Peter is identifiable in art by his key or *keys. Late medieval and Renaissance artists show him in the vestments of a pope or bishop, sometimes holding a model church *building in token of his status as founder of the Church as a whole. In sets of the *Twelve Apostles he is placed at their head and he is always prominently positioned in scenes showing events at which all or several of the twelve were present. More rarely he is shown by himself with a cock as a reminder of his betrayal of Christ or suffering crucifixion on an inverted cross.

Peter Martyr, St (1205–52) Italian Dominican friar. Although himself born into a Cathar family, he made his reputation as a zealous campaigner against heresy in Milan and the surrounding areas of northern Italy. He was eventually ambushed and assassinated. As the first martyr of the Dominican Order (canonized 1253), he is particularly honoured in Dominican churches and at his burial place at Milan. Artists showed him in his friar's robes, with his fatal wounds clearly visible and very often with a sword or dagger embedded in his head or shoulder.

Petroc, St (Petrog, Petrox) (6th century) Cornish abbot. His emblem is a *stag. He is also honoured in south Wales and Brittany.

phial A small slender glass container for holy oil or blood. Two phials displayed on a book are the emblem of St *Januarius of Naples. In northern Europe a nun holding a phial is most probably St *Walburga. SS *Cosmas and Damian may hold phials as part of their professional equipment as physicians.

Philip, St (1st century) Apostle and martyr. He joined Jesus early in his ministry but after Pentecost nothing definite is known about his movements. He may have died in Asia Minor, and his relics were said to have been taken to Rome. He was associated with St *James the Less from a very early date and they shared a feast day (traditionally 1 May) and the dedication of an ancient Roman basilica (now Santi Apostoli).

In Byzantine art Philip can often be identified among the apostles by his beardlessness, although this is by no means invariable. His usual distinguishing emblem in the West is loaves of bread in reference to his role in the *Feeding of the Five Thousand. Otherwise he may carry a cross, either as the reputed means of his martyrdom or as the weapon with which, according to one legend, he overcame a great serpent.

Philip Neri, St (1515–95) Italian priest; founder of the Congregation of the Oratory. He is known as 'the Apostle of Rome' because he spent his entire life there in charitable works. Artists show him praying in ecstasy before a vision of the Virgin Mary, often with a *lily lying on the ground by him.

Philoxenia (Greek, 'hospitality') The hospitality shown by *Abraham to the three men (or angels) under the tree on the plains of Mamre when they announced that he and Sarah would have a son (Genesis 18:1–15). Byzantine commentators interpreted the three guests as the Persons of the *Trinity and the meal that they took as a foreshadowing of the Eucharist. The episode is accorded less significance in the Catholic Church and is correspondingly less frequent in Western art.

Essential to the scene are the three winged angels seated around the table on which appears the eucharistic bread or *lamb and/or a chalice. Abraham is often shown either greeting them or bringing food; in the door of a building in the background Sarah may be seen eavesdropping on the conversation.

phoenix According to classical legend, a bird of the Arabian desert that every 500 years burnt itself upon a funeral pyre and arose rejuvenated from its own ashes. In its uniqueness (only one phoenix ever existed at a time) and self-immolation it was equated with Christ as early as the 1st century. The phoenix appears in early Christian funerary art as an expression of triumph over death, and as a symbol of resurrection it remained popular in art and literature throughout the Middle Ages.

Pietà A picture or sculpture showing the Virgin Mary supporting and mourning over the dead body of Jesus.

pig The emblem of St *Antony of Egypt. The legend that explains the association of pigs with St Antony tells how the saint visited France, where the king's son had been born with a pig's head and so was disqualified from being heir to the throne. Soon after his audience with the king, St Antony saw a sow with her piglets, one of which had been born blind. In his compassion he restored the sight of the blind piglet and the sow in gratitude offered to

113

grant him anything he wished. The saint asked for the disability of the king's son to be removed, and, when he touched the prince, the animal head was immediately transformed into a human one.

A subject from the parable of the *Prodigal Son shows him as a ragged and emaciated swineherd among the pigs. The Gadarene swine, into whom Jesus sent the devils that he had exorcized from two men (Matthew 8:28–32), are a rather uncommon subject, but occasionally occur in cycles of the miracles of Jesus.

pilgrim St *James the Great usually appears in Western medieval art in the guise of a pilgrim to his own shrine at Compostela, with wide-brimmed hat, staff, wallet (scrip), bowl and scallop-shell badge. St *Roch too is generally shown in pilgrim garb. A female pilgrim may be St *Bona.

pillar To which Jesus was tied to be scourged, one of the *Instruments of the Passion. An impression of his body was believed to have transferred itself miraculously to the pillar (*see acheiropoietos*).

pincers The emblem of St *Apollonia. *See also under* tongs.

Platytera In the Orthodox Church, an icon type of the Virgin and Child. The Virgin Platytera, full- or half-length, holds her arms up in the ancient attitude of prayer (*compare orans*) and the Christ Child is displayed in front of her as a bust or full-length figure in a circular or oval disc. This type of image was known as early as the 4th century, and the epithet 'Platytera' (Greek, 'wider (than the heavens)') derives from a passage praising the Virgin in the liturgy of St Basil.

plumb rule An occasional attribute of St *Thomas in his character as architect.

pomegranate A symbol of the resurrec-

tion to eternal life. It is seen particularly in pictures of the Virgin Mary and of the Virgin and Child. In Botticelli's *Madonna of the Magnificat* (Uffizi, Florence), for instance, it takes the place of the more formal *globe in the left hand of the Christ Child; the Virgin's hand too touches it to signify her part in the work of redemption.

Medieval Christian writers also interpreted the pomegranate's many seeds within one fruit as symbolizing the many members of the Church.

pope Since 1073 the title of the Bishop of Rome as the head of the Roman Catholic Church. In earlier times other bishops also used the title. St *Peter is very often anachronistically shown in the robes and triple crown of a medieval pope. SS *Clement and *Gregory (the Great) are likewise identifiable by their papal regalia, although additional individual attributes are also usually present.

pot Lidded, the emblem of St *Mary Magdalene.

powers Spiritual beings ranking below *dominations and above *principalities in the nine orders of *angels. They were envisaged as warring against the forces of evil and therefore usually appear in full armour.

preacher Numerous saints renowned for their gifts as preachers are shown in this role. The preaching of *John the Baptist, mentioned in all four gospels, is shown in cycles depicting the Baptist's life and as an individual subject. Missionary bishops like SS Wilfrid and *David and members of the Dominican Order (who are also known as the Friars Preachers) are often shown preaching, while St *Francis preaching to the birds is also a favourite subject.

Presentation in the Temple The cere-

mony prescribed by Jewish law under which Jesus, as a first-born son, was brought to the Temple forty days after his birth. This was also the period set down for the purification of a woman after she had given birth, so the feast is alternatively known as the Purification of the Virgin. It is celebrated on 2 February and in the West is also called Candlemas on account of the ritual blessing of candles that took place then to signify Jesus' manifestation as the light of the world. In the Roman Catholic Church from the late Middle Ages onwards the Presentation in the Temple has been considered the first of the *Sorrows of the Virgin Mary because of the foreboding words spoken to her by the priest Simeon. In the Greek East the event is known as the Hypapante (literally 'the meeting (of Jesus and Simeon)') and is one of Orthodoxy's twelve great feasts.

Luke's gospel (2:22–39), the only one to describe the event, provides the basis for the usual depiction of the scene. From one side the parents of Jesus approach with the baby; Joseph or a female attendant holds the two doves which Jewish law required to be sacrificed on this occasion. Meeting them are the aged Simeon and the prophetess Anna. (Anna's age is given by Luke as eighty-four, and although Simeon's great age is not specified it is inferred from the words of the *Nunc dimittis* ('Lord, now lettest thou thy servant depart in peace') which he utters on seeing Jesus.) The Presentation is frequently conflated in Renaissance art with the *Circumcision.

The Presentation of Christ in the Temple should not be confused with the superficially similar *Presentation of the Virgin.

Presentation of the Virgin The priest Zacharias' reception of the three-year-old Virgin Mary in the Temple where she was to be brought up. Although recounted only in the apocryphal *Gospel of James* (*Protevangelium*), it is one of the Orthodox Church's twelve great feasts and is also celebrated in the West (21 November). Components of the scene in art include one or more of the following: the little girl approaching the priest in procession with her parents and an escort of maidens, running or dancing up the steps, and seated inside the Temple and being given bread by an angel.

Pride One of the *Seven Deadly Sins.

Princes of the Apostles SS *Peter and *Paul.

principalities Spiritual beings ranking immediately above the *archangels in the nine orders of *angels. They hold a drawn sword and sceptre and wear a princely crown (less elaborate than that worn by the higher-ranking *dominations).

Prochoros *see under* John the Evangelist, St.

Prodigal Son The subject of one of Jesus' most famous parables (Luke 15:11–32). The parable furnished several subjects for artists, most frequent of which are the riotous living of the Prodigal Son, his repentance when he was reduced to starvation as a swineherd and his return home, with the loving welcome given to him by his father and the feast that was made in celebration.

Prodromos (Greek, 'forerunner') The name by which *John the Baptist is commonly referred to in the Orthodox Church. He was believed to fulfil the Old Testament prophecy, 'Behold, I will send my messenger, and he shall prepare the way before me' (Malachi 3:1). Because the Greek word *angelos* means equally 'messenger' and 'angel', John the Baptist is sometimes shown winged like an angel in Orthodox icons, particularly from the 16th century onwards.

prophets The seers whose writings make up part of the Old Testament. They were conventionally divided by the Hebrew authorities into three major (Isaiah, Jeremiah, Ezekiel) and twelve minor prophets, although recent biblical scholarship casts doubt on the individual or historical existence of some. The Byzantine Church recognized four major prophets by including *Daniel in their number. (This arrangement of four major plus twelve minor prophets creates a harmonious Old Testament counterpoise for the graphically useful scheme of four evangelists and twelve apostles in the New Testament.) Some other Old Testament figures, including *Moses, *David and *Elijah, are also commonly designated prophets.

Because the early Christians scoured the Old Testament for passages that could be read as validating Jesus' claim to be the Messiah, the prophets won and retained an honoured place in Christian art and literature. They are commonly shown as venerable bearded men with no attempt at individual characterization but with scrolls containing sayings from their texts that were believed to have a bearing upon aspects of Jesus' life. They are sometimes seen with their pagan female counterparts, the *sibyls. The most frequently depicted prophets are the four major ones and *Jonah.

Prudence *see under* Four Cardinal Virtues.

Purification of the Virgin *see under* Presentation in the Temple.

purse A small bag or wallet usually worn attached to a belt or shoulder strap in the Middle Ages and Renaissance. Among the apostles it is the occasional attribute of St *Matthew. In a scene of the *Last Supper Judas Iscariot may have been shown with a purse, about to leave the room, following the account in John's gospel. 'Then said Jesus unto [Judas]. That thou doest, do quickly. Now no man at the table knew for what intent he spake this unto him. For some of them thought, because Judas had the bag, that Jesus had said unto him, Buy those things that we have need of against the feast; or that he should give something to the poor. He then . . . went immediately out' (John 13:27–30). In scenes of the *Crucifixion, *Lamentation and *Entombment, the elderly or middle-aged man wearing a purse is *Joseph of Arimathea, called 'a rich man' in Matthew 27:57.

A pilgrim's purse (often called a 'scrip' and decorated with the pilgrim's badge of a *shell) is part of the equipment of those saints like *James the Great and *Roch who appear in the guise of a medieval pilgrim. A purse may also be among the accoutrements of a female saint with domestic responsibilities, such as SS *Martha and *Zita. St *Laurence too is occasionally shown with a purse, in his case a reference to the duty of deacons to distribute alms to the poor. A similar charitable purpose is implicit in the purse carried by St *Omobono.

pyx A small lidded box marked with a cross, used to contain the Eucharist. St *Clare sometimes holds a pyx instead of the more dramatic *monstrance. In Crucifixion scenes *Longinus occasionally holds a pyx, in which he is said to have preserved drops of Jesus' blood.

Q

Quattro Coronati *see* Four Crowned Martyrs.

quill pen An occasional emblem of the *Four Evangelists or of other saints renowned for their scholarship or writings. *See also* writer.

R

Rage (*or* Anger) One of the *Seven Deadly Sins.

rainbow The token of God's pledge to Noah after the Flood that he would never again destroy the world by water (Genesis 9:12–17). When a rainbow appears in other contexts it is interpreted as a more general symbol of the reconciliation between God and humanity. In scenes of the *Last Judgement or Christ in glory a rainbow is shown around his throne, following Revelation 4:3.

Raising of Lazarus *see under* Lazarus.

ram The sacrificial substitute for *Isaac, hence interpreted as a type of Christ. *See also* lamb.

Raphael In the Old Testament apocryphal Book of Tobit, the *archangel sent to aid the family of the pious Jew Tobit. In exile in Nineveh, Tobit fell victim to poverty and blindness. Under the guise of Tobit's kinsman Azarias, Raphael accompanied Tobit's son Tobias on a journey to Media to collect money Tobit had left there on deposit. Tobias, on the angel's advice, preserved the liver and gall of a fish that he caught in the River Tigris. When he came to Ecbatana Tobias married his cousin Sarah and used the fish's liver as a charm to drive off the devil who had killed all her former husbands on their wedding night. The fish's gall he used to heal the blindness of Tobit on his return home.

Several scenes from this story attracted artists, the most popular being Tobias on his journey, accompanied by Raphael and his dog and carrying the huge fish.

rat A general symbol of evil and destruction. When associated with a female saint, it is the symbol of the Italian St Fina (13th century) who was attacked by rats as she lay paralysed.

raven As a benign bird living in desolate places, it brought food to the prophet Elijah at God's command (1 Kings 17:6). Ravens were connected in a similar role with various desert-dwelling hermits, including St *Paul the Hermit. In the context of St *Benedict the raven is a disguise of the Devil, who appeared to the saint in this shape.

reed A plant associated with *John the Baptist on account of Jesus' questions to the crowds about John's ministry in the desert: 'What went ye out into the wilderness to see? A reed shaken with the wind?' (Matthew 11:7) The thin cross that John is often shown holding can sometimes be seen to be made from reeds.

The reed appears also among the *Instruments of the Passion as the sceptre placed in mockery in Jesus' right hand and later used to beat him about the head (Matthew 27:29–30). It was also the means by which a vinegar-filled sponge was offered to him on the Cross (Matthew 27:48).

Resurrection Christ's rising from the dead on the third day after the Crucifixion. Celebrated on Easter Day, the event is fundamental to the Christian religion, but

it is depicted very differently in Eastern and Western Christian art.

In the West the Resurrection is traditionally shown as the moment when Christ actually came out from the tomb. The symbols of his Passion may still be visible (the wound in his side, the crown of thorns), but he holds in his hand the triumphal *banner or cross and pennant of the Resurrection. The other hand is generally raised in blessing. The tomb is shown as a sarcophagus (not the hollowed-out rock tomb of the gospel narrative), the lid of which has been pushed aside. Around it, in attitudes of slumber, are the guards, dressed as Roman soldiers or in contemporary military gear. The classic Western interpretation of the Resurrection is the late 15th-century fresco by Piero della Francesca in Sansepolcro (central Italy).

Medieval English versions of the Resurrection show Christ actually stepping upon a sleeping soldier (as in an alabaster panel (*c.* 1400–30) in the Castle Museum, Nottingham); this is very uncommon in Continental versions of the same period, and it may owe something to the way in which the event was depicted in the English mystery plays.

The Eastern version of the Resurrection (Greek: *Anastasis*, which means both Christ's own rising and his raising of the dead) is in the vast majority of cases the scene showing Christ's descent into Hell (*see* Harrowing of Hell), and it was this that became synonymous with Easter in Orthodox cycles of the feasts of the Church. Because of doctrinal difficulties about the nature of Christ and debate about what actually happened during the three days that he was in the grave, even this scene established itself comparatively slowly. In the very earliest Christian art the Resurrection is represented not by any figure of Christ but by the *Three Marys at the tomb. The scene of Christ's actual rising from the tomb is comparatively late and uncommon in Orthodox art, although

Dionysius of Fourna gives instructions on how to depict it in his *Painter's Manual* (compiled 1730–4). For the general resurrection of the dead *see under* Last Judgement.

ring The emblem of St *Edward the Confessor. He is actually shown crowned and holding up a jewelled finger ring, as in the late 14th-century Wilton Diptych. According to legend, the king gave his ring to a beggar at Westminster; some time later English pilgrims in the Holy Land encountered an old man, who identified himself as the apostle John and gave them the very same ring with instructions to return it to Edward and to warn him that he would die in six months' time, as duly happened.

A ring also figures prominently in the scene known as the Mystic Marriage of St Catherine, a theme of numerous Renaissance paintings. Although the original and most frequent subject was St *Catherine of Alexandria, Italian artists of the 15th century and later commemorate a similar vision involving St *Catherine of Siena, who is distinguishable from her Alexandrian counterpart by being dressed as a nun (for instance in the early 16th-century painting by Fra Bartolommeo in the Pitti Gallery, Florence). For a salmon with a ring, *see under* fish.

river The River Jordan, as the setting for the *Baptism of Christ, symbolizes baptism; hence the notion of the cleansing stream, washing away sin, extends to rivers in general.

Four rivers or streams flowing from the Garden of Eden are named in Genesis 2:10–14 as Pison, Gihon, Hiddekel (identified with the River Tigris) and Euphrates. Following an antique convention of personifying river gods, they occasionally appear in early medieval art as water-bearers, like the zodiac sign Aquarius, pouring out a stream of water

from waterskins or vases (for example, in the romanesque paintings at San Pietro al Monte Civate, near Como, northern Italy).

The rivers are shown more naturalistically not only in scenes set in Eden but also flowing out from beneath the foot of the throne of the glorified Christ; in the latter context they are a fairly common motif in early Christian art, and there they represent the four gospels, which flow from Christ to all the world. The idea that Christ is the *rock from whom these waters flow appears early in both art and literature; for instance, the so-called sarcophagus of Constantine III (early 5th century) from the Mausoleum of Galla Placidia, Ravenna, has Christ in the form of a lamb standing upon a rock from which four streams gush out.

An alternative interpretation of the four rivers, mentioned by St Augustine of Hippo, is that they represent the *Four Cardinal Virtues.

robe A purple robe contains a dual allusion to Christ's Passion (purple being the liturgical colour for the penitential seasons of Lent and Advent) and to royalty (purple being also the colour associated with the imperial power of Byzantium). John 19:2 mentions that the soldiers put a purple robe upon Jesus when they mocked him as 'King of the Jews'.

The seamless robe (or 'coat') for which the soldiers diced at the foot of the Cross (John 19:23–4) may be included among the *Instruments of the Passion. Later writers sometimes interpreted it as symbolizing the ideal unity of the Church.

Roch, St (Roche, Rock, Rocco) (*c.* 1350–*c.* 1380) French hermit who spent much of his life on pilgrimage. He tended and cured the plague-stricken but eventually caught the disease himself at Piacenza. With none to help him, he was miraculously cared for by a dog, which brought him bread. He seems to have died in prison,

either in Italy or at his native Montpellier.

Roch's skills as a healer brought him a thriving cult in Italy, France, Germany and along the Dalmatian coast; his aid was particularly invoked during epidemics of plague. In art he is shown in the traditional dress of a *pilgrim, pointing towards his leg, from which the legging has been rolled back to reveal a plague sore (bubo). Often the dog, with a loaf of bread in its mouth, is at his side.

rock The symbol of both Christ and St *Peter. The rock/Peter association, as it relies on wordplay, is less often seen in art than the rock associated with Christ (*see also under* river). The Old Testament story of Moses striking water from the rock for the Israelites in the wilderness (Exodus 17:1–6) was seen by early Christian writers as prefiguring Christ: 'for they drank of that spiritual Rock that followed them; and that Rock was Christ' (1 Corinthians 10:4).

rod Prominent in the stories of Moses and Aaron as the instruments by which they worked wonders to confound the Egyptian wizards (Exodus 4:1–4; 7:8–12; etc). When held by a monk, a rod may denote St *Benedict. St *Faith sometimes holds a bundle of rods. *See also* staff.

Romuald, St *see under* ladder.

rosary A string of beads used as an aid to prayer. Its use is particularly associated with the Dominican Order, and is the attribute of St *Dominic himself, although this is very probably an anachronism, since the cult of the rosary seems only to have gathered momentum in the later Middle Ages. Pictures of the saint receiving the rosary from the Virgin Mary in a vision were popular with Dominican artists of the 16th century onwards.

The rosary is also closely associated with another Dominican saint, *Catherine of

Siena, who may also appear in scenes of the vision of St Dominic. Monks, nuns and many other saints are commonly shown as possessing a rosary to signify their devotion to the Virgin Mary and the life of prayer, although some, like SS *Zita and *Francis of Assisi, certainly lived in the period before use of the rosary became widespread. The Virgin Mary may be seen in depictions of the *Last Judgement putting her rosary onto the *scales so that its weight may assist the soul who is being weighed there.

In the devotion of the rosary Fifteen Mysteries are commemorated; these are divided into three 'chaplets' comprising the Five Joyful Mysteries (*see under* Joys of the Virgin), the Five Sorrowful Mysteries (five events in the Passion: the Agony in the Garden, the scourging of Jesus, the crowning with thorns, the carrying of the Cross, the Crucifixion) and the Five Glorious Mysteries (the Resurrection, the Ascension, Pentecost, the Assumption of the Virgin, the Coronation of the Virgin).

rose A white rose, symbol of purity, is associated with the Virgin Mary. Writers of devotional literature sometimes called her the rose without a thorn. Medieval and Renaissance painters frequently showed her in a *bower or garden of roses, and roses and lilies were found in her tomb after she had been taken up into heaven (*see* Assumption). A garland of roses associated with the Virgin alludes to the *rosary.

The colour of a red rose recalls the blood of the martyrs. Hence garlands of red and white roses adorn the blessed souls in heaven who have surmounted their earthly trials. Roses are the emblem of several female saints, among them: Elizabeth of Hungary (1207–31), who carries them in her apron; *Dorothy, who carries them in a basket or her apron with fruit and other flowers; Rose of Lima (1585–1617), who was the first saint of Latin America; *Theresa of Lisieux.

rush *see* reed.

S

sacra conversazione A composition in which several saints are grouped, often around a Virgin and Child. It was a formula particularly favoured by Venetian artists.

sacrifice An offering made to God. Although not part of Christian religious practice, as Christ himself is held to be the one 'full, perfect and sufficient sacrifice' (Book of Common Prayer, Prayer of Consecration), scenes of sacrifice appear in Christian art as part of Jewish ritual (for example, the *Presentation in the Temple) or as incidents in the Old Testament.

The two most frequently shown scenes of sacrifice are both from the Old Testament: the sacrifices of *Cain and Abel and the intended sacrifice of *Isaac by Abraham. In the former the sheaves of corn offered by Cain and the lamb offered by Abel are shown, also the propitious outcome of Abel's sacrifice and God's rejection of Cain's. The sacrifice of Isaac is often depicted at the dramatic moment when the boy is already on the altar, with Abraham's knife raised to strike him, and the angel intervenes to stop the blow. Both scenes are intended to put the viewer in mind of Christ's sacrifice of himself.

The acceptable sacrifices made by Abel and Abraham are linked in prayer and art with the offering of *Melchizedek as prefiguring the Last Supper, as in the 6th-century mosaic showing the sacrifice of Abel and Melchizedek in the church of San Vitale, Ravenna.

salmon (with a ring) *see under* fish.

Salvator Mundi (Latin, 'Saviour of the world') An image of Christ found particularly in Renaissance art, holding a *globe in his left hand and blessing with his right. He may also wear the crown of thorns.

Samarian Woman at the Well The title given to depictions of Jesus' meeting with the Samarian woman at the well called Jacob's Well outside Sychar (John 4:5–30). The incident was illustrated on the walls of the Roman catacombs (?early 4th century) and continued as a popular theme in the art of both East and West. Their dialogue is reported in detail; in it Jesus uses the important symbolism of the 'living water . . . a well of water springing up into everlasting life'.

The woman's loose-flowing blonde locks in a late 15th-century icon from Crete suggest her dubious moral character; Italian artists, among them Veronese (picture in Kunsthistorisches Museum, Vienna), show her with elaborately braided hair, the mark of a courtesan. She was furnished with a post-gospel biography that culminated in her martyrdom along with all her family; as St Fotini (Greek: *photeini*, 'light-giving') she had a modest cult in Greece and a feast day on 25 February.

Samaritan, Good *see* Good Samaritan.

Samson Israelite leader, renowned for his physical strength. He lived during the period in which the Israelites were being harassed by their neighbours the Philistines, and his story (Judges chs 13–16) is

mainly taken up with his various successes against them.

Several elements in Samson's history have parallels with the life of Jesus, and for this reason medieval commentators and artists saw him as a type of Christ. Samson's birth, like that of Jesus, was announced by an angel (Judges 13:2–21); his killing of a lion (14:5–9) was seen as prefiguring Christ's victory over the Devil; his carrying off the gates of Gaza (16:3) paralleled Christ's breaking down the gates of hell (*see* Harrowing of Hell); his ultimate capture by the Philistines through treachery mirrored Christ's arrest.

In art Samson is often shown, like the pagan Hercules, wearing the skin of the lion that he killed. He may also be shown wielding the jawbone of an ass to kill a thousand Philistines (Judges 15:14–17) or, in the final scene of his life, breaking the pillars of the building to bring down the roof upon his own head and upon the heads of his assembled enemies (16:25–30). But the scene most favoured by artists was Samson with his Philistine wife Delilah, who eventually won from him the secret of his great strength and shaved his hair so that her countrymen could capture him (16:4–20).

Samson, St (died 565) Welsh-born missionary monk who became bishop of Dol in Brittany. His travels took him to Ireland and Cornwall before he moved to France. Some of his relics were lodged in the monastery at Milton Abbas in Dorset in the early 10th century, and his cult was established in several places in southern England, Wales and Brittany. His emblems are a dove and a book, and he usually also holds a cross or a traveller's staff.

sandals *see under* shoes.

Satan The name frequently used of the Devil in the Bible. It comes from the Hebrew word meaning 'enemy'. In art Satan is often shown in the form of a *snake (the guise in which he brought about the *Fall of Man) or *dragon (the form under which he fought in the war in heaven described in Revelation). At other times he is shown in the form of a hideous angel with scaly wings, serpent's tail and a grotesque, horned animal head.

saw An attribute of St *Simon. One of the versions of his martyrdom describes how he was cut in half with a saw. In France the association with the saw (French: *sci*) may have been reinforced by an element of wordplay ('scie-mon').

scales (*or* balance, for weighing) The emblem of Justice (*see under* Four Cardinal Virtues) and the angelic order of *thrones. In medieval paintings of the *Last Judgement the archangel *Michael holds the pair of scales in which the souls of the dead are weighed. A devil may be attempting to influence the outcome by interfering with one pan of the scales, while the Virgin Mary places her rosary in the other to assist the soul whose fate is in the balance.

Scales are also a symbol of Logic in Renaissance personifications (*see under* Seven Liberal Arts).

scallop shell *see under* shell.

scalpel A surgical instrument sometimes held by healing saints, of which SS *Cosmas, Damian and *Panteleimon are the most widespread.

sceptre A symbol of authority, hence often held by God the Father as well as by earthly rulers. The archangel *Gabriel sometimes carries a sceptre with a fleur-de-lis finial in Annunciation scenes.

Scholastica, St (*c.* 480–543) Italian virgin; sister of St *Benedict and patroness of Benedictine nunneries. Little is known

about her life. She lived near Monte Cassino, and she and St Benedict met once a year. Three days before she died, St Benedict came on his annual visit, but when she begged him to stay longer with her, to talk about the joys of heaven, he refused; Scholastica prayed, and as a result such a storm arose that it was impossible for Benedict to depart. At the moment of her death Benedict saw a vision of her soul flying up to heaven in the form of a white dove, which is often her emblem in art.

Scholastica is shown wearing the habit of a Benedictine nun, and in addition to the dove may hold a lily or crucifix. The centre of her cult was at Le Mans in northern France to which her relics were transferred from the original tomb she shared with her brother at Monte Cassino.

scissors The emblem of St *Omobono, patron saint of tailors.

scorpion A symbol of evil particularly associated with Judas Iscariot. It is also an occasional attribute of St *Demetrius, who tramples it underfoot, thus recalling Jesus' promise to the disciples: 'I give unto you power to tread on serpents and scorpions, and over all the power of the enemy' (Luke 10:19).

scourge One of the *Instruments of the Passion. A scourge is also an emblem of St *Ambrose, who compelled the Roman emperor Theodosius I to perform a severe penance after his soldiers massacred the citizens of Thessaloniki in 390 to avenge the murder of some of Theodosius' officials in that city.

The scourge belonging to the English hermit Guthlac (*c.* 673–714) was given by his sister Pega to his shrine at Crowland shortly after his death. In his case the scourge was not intended primarily for self-flagellation (although Guthlac was famous for his austere way of life) but to ward off the assaults of the devils during

his solitary life in the fenlands of Lincolnshire. The saint is sometimes shown with the scourge, or receiving it from his patron saint the apostle *Bartholomew.

scroll (*or* banderol) Saints are depicted in many media holding scrolls, and the inscriptions, when legible, are useful clues to the holder's identity or the scene that is being represented. In scenes of the *Annunciation, for example, the Latin text of the words spoken by both the Virgin Mary and the angel may be presented on scrolls.

Medieval artists frequently used scrolls to identify subjects by their names, in addition to or instead of other emblems. In sets of the *Twelve Apostles the scrolls may contain the clauses of the Creed attributed to each. In the case of early depictions of the apostles and evangelists, the scrolls were also an allusion to their role as teachers (*see also under* Pentecost); later the same allusion was achieved by having them carry *books. Old Testament *prophets and the *sibyls very often hold scrolls inscribed with their prophetic texts.

A scene of Christ handing a scroll to St Peter, found in reliefs and mosaics of the 4th and 5th centuries, represents the transmission of the New Law, as Moses receiving the tablets of stone from God upon Mount Sinai represented the transmission of the Old Law. Christ may even be placed upon a small hill to make the analogy clearer. In a mosaic in the baptistry of the Soter, Naples (*c.* 400) Christ stands on an orb (representing the world) and holds out a scroll with DOMINUS DAT LEGEM (Latin, 'The Lord gives the Law'), words that are sometimes used as the title for this scene.

scythe Associated with the personifications of Time and Death, as symbolic of their power to cut down life. The tradition of showing Time as an old man with the implements for reaping owes its origins to

pagan myths concerning the ancient Greek god Cronos and the Roman god Saturn.

A scythe may also be the emblem of various agricultural patron saints, most of whose cults are very local. In England there are SS Sidwell of Exeter (her name 'scythe-well' may account both for the legend of her beheading by reapers and for her emblems of the scythe and a well) and *Walstan of Norfolk. *See also* sickle.

Sebastian, St (3rd century) Roman martyr. His legend portrays him as a member of the imperial guard of the Roman emperor Diocletian, who secretly supported the persecuted Christians. When the emperor realized that the young soldier was a Christian, he ordered him to be shot to death with arrows. The woman who untied his body from the pillar to which he had been bound realized that Sebastian was still alive and nursed him back to health. Recovered from his injuries, he courageously confronted the tyrant to reproach him; Diocletian thereupon ordered that he should be clubbed to death. The martyrdom of Sebastian was a very popular subject with Renaissance artists; he is shown as a nearly naked youth tied to a pillar or tree, with soldiers shooting at him with bows and arrows.

St Sebastian is the patron saint of soldiers and archers; as one of the *Fourteen Holy Helpers, his assistance was particularly invoked against the plague. Despite the popularity of his cult in most European countries, there are only two ancient English church dedications to him. The similarity of his death to that of St *Edmund, a popular indigenous martyr, may have told against Sebastian's adoption in England.

seraphim The highest-ranking of the nine orders of *angels. They are depicted in art as fiery creatures, usually in human form, with six wings, following Isaiah's vision of God upon his throne (Isaiah 6:1–8).

Christian tradition interpreted the flames as showing that the seraphim were burning with the love of God. Their iconography is often merged with that of the next-ranking *cherubim.

Sergius and Bacchus, SS (died *c.* 303) Officers in the Roman army deprived of their rank and martyred on the orders of the emperor Maximian for refusing to honour the pagan gods. The centre of their cult, and presumed site of their martyrdom, was at Sergiopolis (Rusafa in northeast Syria). Their cult became very widespread in the Eastern Church. They normally appear together, dressed in Byzantine court dress but wearing the torques of Roman officers and sometimes holding lances.

serpent *see* dragon; Satan; snake.

Seven Deadly Sins Traditionally, the principal form in which man's rejection of God's law is expressed. St *Gregory the Great listed seven sins in the 6th century, and that list became more or less standardized in the art and literature of the later Middle Ages. The usual seven are: Accidie (*or* Sloth; Latin: Accidia); Avarice (*or* Covetousness; Latin: Avaritia); Anger (*or* Rage *or* Wrath; Latin: Ira); Envy (Latin: Invidia); Gluttony (Latin: Gula); Lust (Latin: Luxuria); Pride (Latin: Superbia). In art they may be personified either in female shape or as grotesque embodiments of the particular vice; hence Gluttony is a grossly corpulent eater, Anger a bully with fist or weapon raised to strike, etc.

Avarice and Lust are sometimes shown as a pair, being considered the particular vices of men and women respectively. Their punishments are shown on the inner wall of the south porch at Moissac (southern France): Avarice, in the form of a miser, bears a devil on his shoulders, while Lust, in the form of a female cadaver, is devoured by serpents.

Seven Liberal Arts The secular subjects studied in the Middle Ages: Grammar, Logic, Rhetoric, Arithmetic, Astronomy, Geometry, and Music. The word 'liberal' meant originally that these were arts worthy to be studied by free men, as opposed to the more servile mechanical arts.

The Seven Liberal Arts are most frequently personified as women in accordance with a scheme contrived in the first half of the 5th century by the North African grammarian Martianus Capella. His Latin allegorical treatise *The Marriage of Mercury and Philology* was much admired in the early Middle Ages and was influential in the way in which the Seven Liberal Arts, described there as the bridesmaids of Philology, were depicted. They are sometimes presented in art and literature as an intellectual counterpoise to the moral qualities of the *Three Theological Virtues and the *Four Cardinal Virtues. They appear in sets in romanesque and Gothic sculpture and enjoyed a popularity lasting well into the Renaissance, especially in Italian art.

There is some variation in the way in which they are shown, but the attributes by which they can be identified are usually as follows: Grammar with two young students concentrating on their books while she holds a whip to correct them; Logic with a snake or lizard or, later, a pair of scales to weigh the truth; Rhetoric with sword and shield, also a book or scroll; Arithmetic with a writing tablet or abacus; Astronomy with a globe, armillary sphere, quadrant or other astronomical instrument; Geometry with a pair of compasses or set square; Music with a row of bells and, in the late Middle Ages and Renaissance, other musical instruments such as a lute.

Sometimes instead of or in addition to her particular attributes, each of the Seven Liberal Arts is accompanied by a historical figure who is supposed to have been the outstanding exponent of that art. Thus Rhetoric is usually accompanied, or even represented, by Cicero, Logic by Aristotle, Geometry by Euclid, etc.

Seven Sacraments The seven solemn ceremonies of the Roman Catholic and Orthodox Churches, which are considered to bestow a particular grace upon participants. The seven are baptism, the Eucharist (Holy Communion), penance, confirmation, matrimony, holy orders and extreme unction. Protestants emphasize the first two as having Christ's authority in the gospels.

Scenes illustrating all the sacraments are sometimes found in medieval churches, especially on the baptismal fonts, or painted on altarpieces. An alternative way of depicting them, particularly in the Counter-Reformation period, was to show appropriate episodes from the New Testament; for instance, *Mary Magdalene's anointing of Jesus' feet illustrated penance or the *Last Supper represented Holy Communion.

Seven Sleepers of Ephesus Legendary saints who took refuge in a cave at Ephesus during the persecution of Christians under Decius (250). When their pursuers blocked up the cave's mouth they fell into a deep sleep which lasted around one hundred and ninety years (different versions of the legend cite different periods). At last they awoke and emerged to find a Christianized world.

The legend was widely known and popular in both East and West (and in Islam), and the sleepers' supposed tomb at Ephesus was a place of pilgrimage in the early Middle Ages. Despite this, the legend was not often represented in art; the few pictures that are known show seven youths slumbering in a rocky cave.

Seven Sorrows of the Virgin *see under* Sorrows of the Virgin.

Seven Women at the Tomb In the Eastern tradition, the number of women who brought spices and perfumes to Christ's sepulchre. Luke 23:55–6 mentions an unspecified number of women who had followed Jesus from Galilee and who prepared ointments for his body. The Western tradition assigns this role to the *Three Marys.

shamrock An emblem of St *Patrick, and hence also of Ireland.

sheep A very frequent symbol in literature and art for the followers of Christ. In the Old Testament the people of Israel are referred to as 'sheep' in several places (for example, Psalm 79:13 'we thy people and sheep of thy pasture will give thee thanks' and Isaiah 53:6 'we like sheep have gone astray'). The metaphor is taken over into the New Testament where it occurs at several points in the sayings and parables of Jesus, who defines his relationship with his followers in terms of that between a good *shepherd and his flock (for instance, John 10:11–15, the Parable of the Lost Sheep in Luke 15:4–7 and Jesus' injunction to Peter to 'feed my sheep' (John 21:15–17)). The separation of the righteous from the wicked at the *Last Judgement is visualized as a shepherd's division of his flock into sheep and *goats (Matthew 25:32–3).

Ample biblical warrant therefore existed for the portrayal of Christ's adherents as sheep, and it was a common convention in mosaics, wall-paintings and sculptures of the early Christian era. Sometimes the sheep stand for the apostles, as in the two files of six sheep in the apse mosaic of Sant'Apollinare in Classe, Ravenna, but in less formal schemes they are there simply as symbols of the faithful. *See also under* Adoration of the Shepherds.

shell The emblem of St *James (the Great). A scallop shell, worn on the hat or wallet, was used as a badge by pilgrims to his shrine at Compostela in northwest Spain from the 12th century onwards. Hence the shell came to be an identifying mark of St James himself, particularly in sets of the *Twelve Apostles.

The pre-eminence of the Compostela pilgrimage in Western Christendom led to shells being identified with pilgrims in general, and thus other pilgrim saints, such as SS *Roch and *Bona, generally display a shell somewhere on their clothing.

shepherd A metaphor for Christ in relation to his followers: 'Lord Jesus, that great shepherd of the sheep' (Hebrews 13:20). Jesus' own presentation of himself as a shepherd (*see also under* sheep) had Old Testament precedents, as in Psalm 80:1, where God is described as the 'Shepherd of Israel'.

The concept of Christ as shepherd of the Christian flock was most powerfully embodied in the image known as the Good Shepherd (Latin: Bonus Pastor): a youthful shepherd carrying a sheep across his shoulders. In this case the sheep represents the lost soul for whom the shepherd has searched in the wilderness, as in the parable of the Lost Sheep, and 'when he hath found it, he layeth it on his shoulders, rejoicing' (Luke 15:5). The image of the Good Shepherd, with its message of salvation, was very frequent and widespread in the earliest Christian centuries, featuring in catacomb art, in the wall-paintings from Dura Europos (Syria) and on the sides of sarcophagi, where it is generally the central figure. However, after the 5th century it was entirely superseded by other conventions for representing Christ.

Less stylized than the Good Shepherd, the figure of a shepherd, sometimes engaged on a mundane pastoral activity such as milking or simply guarding the sheep, appeared frequently in early Christian art. One of the latest and most powerful exam-

ples of this identification of Christ with shepherd is the mosaic in the mausoleum of Galla Placidia at Ravenna (c. 425), showing Christ seated in a paradisal landscape, with six sheep around him. These images too vanished for many centuries before reappearing in Victorian representations of Christ as shepherd with children as lambs.

In late medieval art, *Nativity scenes began to include the shepherds mentioned in Luke's gospel (2:8–20) and the *Adoration of the Shepherds became a separate topic for artists, sometimes with a tiny scene of the angelic annunciation to the shepherds in the background.

ship An attribute of St *Ursula and of Hope (see under Three Theological Virtues). See also ark, Noah's; boat.

shoes The emblem of SS Crispin and Crispinian, patron saints of shoemakers and leatherworkers. These shadowy martyrs are said to have been Roman missionaries at Soissons in northern France in the 3rd century, who earned their livelihoods by shoemaking. Their alternative emblem is a shoemaker's last. They were also venerated at Faversham in Kent.

An Old Testament subject sometimes seen is Moses removing his shoes or sandals in response to God's command: 'put off thy shoes from off thy feet, for the place whereon thou standest is holy ground' (Exodus 3:5). This injunction also influenced the depiction of the *Transfiguration in icons.

shower see rain.

sibyls Pagan prophetesses whose utterances were believed from the early Christian era onwards to be cryptic prophecies of Christ. So-called sibylline oracles proliferated from various Greek and Jewish sources in the Greco-Roman world between about 100 BC and AD 600, many of them apparently originating in Egypt. The sibyls themselves were known by the names of the places with which they were associated; the ten mentioned by Lactantius (3rd century AD) quoting Varro (1st century BC) are Persian (or Chaldaean), Delphic, Libyan, Cimmerian, Erythraean, Samian, Cumaean, Hellespontine, Phrygian, Tiburtine (or Albunean). The medieval lists of their names are however irregular and confused; for instance, the Erythraean and Cumaean sibyls are sometimes said to be one and the same.

Estimates of the number of sibyls varied from one to ten or twelve; twelve sibyls were sometimes used in decorative programmes to balance the twelve minor prophets of the Old Testament. The credibility of the sibyls was greatly enhanced in Christian eyes by Constantine the Great in 325; in a public oration he accepted some lines of the Sibyl of Erythrae (in western Asia Minor) as a genuine prophecy of Christ and interpreted Virgil's Fourth Eclogue in the same way, with the allusion to 'Cumaean song' (line 4) as meaning that the Sibyl of Cumae had foreseen the birth of Christ.

The sibyls' status as true seers was widely accepted in the Middle Ages; for instance, in the Annunciation play of the Towneley miracle cycle God speaks of the sibyl who comes at the end of the list of Old Testament prophets as 'Sybyll sage, that sayde ay well'. Once enrolled among the prophets, sibyls often featured with them in Christian art, most famously in Michelangelo's paintings on the ceiling of the Sistine Chapel. They are sometimes shown as aged crones (recalling the story that Apollo gave the Erythraean Sibyl the gift of extreme longevity) but also as attractive young women in varieties of oriental dress; in their hands are scrolls or books. A late medieval convention also shows them with individual attributes that allude to a specific aspect of Jesus' life that

128

that particular sibyl is believed to have foretold: thus a *hand for the Tiburtine Sibyl, the *lily of the Annunciation for the Erythraean.

Typical of their appearance in art are the three sibyls in a paintings of the Virgin Mary as Queen of Heaven by Jan Provost (Hermitage, St Petersburg): the Persian Sibyl in the foreground points to a scroll on which is written the words of her prophecy, GREMIUM VIRGINIS ERIT SALUS GENCIUM ('a virgin's womb will be the salvation of mankind'), while the two other sibyls stand behind the kneeling figures of the Roman emperor Augustus and King David. The Tiburtine Sibyl (also known as the Albunean Sibyl) is particularly associated with Augustus because she is said to have revealed to him the coming of Christ. Sets or partial sets of sibyls appear in various media (inlaid marble in the floor of Siena Cathedral, stained glass in the windows of Auch Cathedral, southern France).

sickle An emblem of various agricultural saints, often with only local cults. In Spain a sickle is the emblem of St Isidore (*c.* 1070–1130), a patron saint of Madrid, who worked all his life as a farm labourer. In Bavaria and western Austria a woman with a sickle is likely to be St *Notburga. Reapers with sickles frequently appear in northern European treatments of the subject of the *Flight into Egypt. *See also* scythe.

Silvester, St *see* Sylvester, St.

Simon, St (1st century) Apostle and martyr. To differentiate him from Simon *Peter, he is referred to in the gospels as 'Simon the Canaanite' (Matthew 10:4, Mark 3:18; a mistranslation in the Authorized Version of an Aramaic word) and 'Simon called Zelotes' (Luke 6:15). From the latter it is inferred that he had formerly been a member of the Jewish extremist sect of Zealots; alternatively, it may mean no more than that he was 'full of zeal'.

Simon was one of those gathered in Jerusalem at Pentecost, but after that nothing is definitely known about him. He may have preached in Egypt before joining St *Jude, with whom he is closely associated in legend and the Church calendar and with whom he is said to have suffered martyrdom in Persia. His feast day in the East is 10 May. His emblem may be a *saw, a *falchion or a cross, depending on which account of his martyrdom is followed.

Sitha, St *see* Zita, St.

skeleton The personification of Death or its universally recognized symbol. Death as a crowned skeleton leads the dancers in the favourite medieval and early Renaissance theme of the *Dance of Death. A skeletal cadaver was often placed beneath the effigies on tombs of late medieval dignitaries as a warning of the inevitable end of human pomp and pride. *See also* Three Living and Three Dead.

skin An attribute of St *Bartholomew, who sometimes holds his own skin, along with the knife with which he was flayed alive. For the skin worn by *John the Baptist, *see under* camel.

skull In Orthodox icons of the *Crucifixion a human skull and bones are very often to be seen underneath the Cross of Jesus. The convention also appears, though less regularly and in less stylized form, in Western medieval art. The presence of the skull accords with the biblical interpretation of Golgotha, where the Crucifixion took place, as 'a place of a skull' (Matthew 27:33).

From at least as early as the 3rd century there grew up a tradition that *Adam had been buried at Golgotha (contradicting the Jewish tradition of Adam's grave at Heb-

ron); thus the skull was interpreted as Adam's, and Christ, the second Adam, brought about the salvation of Adam's descendants at the very place where the evidence for the first Adam's mortality was to be seen.

From the Middle Ages onwards a skull has very commonly been used as a *memento mori*, and so was shown as a suitable object of contemplation for those saints such as SS Jerome and Francis who withdrew from or rejected the world in order to pursue the religious life. An aged monk holding a skull and dressed in white robes is the Italian Benedictine reformer St Romuald (*c.* 950–1027), founder of the austere Camaldolese Order.

Sloth (*or* Accidie) One of the *Seven Deadly Sins.

snake The guise assumed by the Devil in which to tempt Eve in the Garden of Eden and so instigate the *Fall of Man. The snake was cursed by God (Genesis 3:14) and thus became a general symbol of evil (*see also under* dragon). A common attribute of St *John the Evangelist is a *cup with a small snake or dragon writhing out of it, and St *Patrick may be shown trampling snakes underfoot.

Despite these negative associations a snake has benign significance when entwined around a cross, being equated in this context with Christ. This idea originated in the episode in which the Israelites complained during their wanderings in the wilderness and were punished by being afflicted with a plague of poisonous snakes which bit and killed many of them; *Moses, following God's instructions, made a serpent of brass and set it up on a pole so that all those who had been bitten by the snakes could gaze upon it and be cured (Numbers 21:4–9). The connection between Jesus and the healing serpent of Moses was made in Jesus' own words: 'And as Moses lifted up the serpent in the

wilderness, even so must the Son of man be lifted up' (John 3:14). For other incidents involving the staff of Moses turning into a snake *see under* rod.

A snake is also the attribute of Prudence (*see under* Four Cardinal Virtues), recalling Jesus' exhortation to his disciples as they were about to set out on their travels to be 'wise as serpents' (Matthew 10:16).

soldier A very considerable number of early martyrs were soldiers in the Roman army who were put to death for refusing to make the requisite sacrifices to the emperor or the pagan gods. Among those who appear armed and in the *armour of Roman or Byzantine soldiers are SS *Adrian, *Demetrius, *George, *Gereon, *Maurice and *Theodore(s). Later, particularly in the West, their armour was updated to present them in the guise of medieval knights. An exception to the general rule of their appearance in armour is on the tier of an iconostasis screen that represents the saints in heaven; here the warrior saints of the Eastern Church abandon the armour of the Church Militant and dress in tunics and cloaks or some other form of civilian dress.

The armoured figure of St *Joan of Arc is familiar from statues all over France, and some other soldier saints too have affinities with particular areas. Thus St Gereon is found only in the vicinity of Cologne, and St Demetrius is ubiquitous in the Orthodox lands but barely known in the West. *See also* centurion.

Sorrows of the Virgin Grievous events in the life of the Virgin Mary commemorated by the Roman Catholic Church as a counterpart to the *Joys of the Virgin. The Sorrows are: the prophecy of Simeon (*see under* Presentation in the Temple); the *Flight into Egypt; the disappearance of the twelve-year-old Jesus when he stayed behind his parents in Jerusalem to dispute with the learned men in the Temple (Luke

2:41–51); meeting Jesus as he was carrying his Cross to Calvary (*see under* Stations of the Cross); keeping watch at the foot of the Cross; the taking down of Jesus' body (*see* Deposition); and his burial (*see* Entombment).

In devotional art these scenes may appear as vignettes around the figure of the grieving Virgin. An alternative convention, favoured in Counter-Reformation Italy and Spain, represents the Sorrows symbolically by seven swords piercing the Virgin's breast, recalling the words of Simeon: 'Yea, a sword shall pierce through thy own soul also' (Luke 2:35).

souls In the earliest Christian art, as represented in the catacombs, the soul was visualized as a young girl, usually shown in an attitude of prayer. The medieval convention was to depict the souls of the dead as children or miniaturized people. A favourite device was to indicate the moment of death by having an angel receive the soul in the form of an infant from the corpse's mouth; for instance, in an English alabaster panel showing the burning of the Alexandrian philosophers after St *Catherine had converted them to Christianity, the onlooker is assured of their salvation by the fact of their tiny souls being collected above the flames by angels. In the case of an evildoer, such as the wicked thief at the Crucifixion, the soul's recipient is a demon. *See also under* dove.

The *Dormition of the Virgin afforded an opportunity for a neat reversal of the usual mother-and-child image of the Virgin with the infant Jesus: Christ cradling in his arms the infant soul of his mother is frequently seen in Orthodox interpretations of this event.

Most conventional scenes involving souls show them in miniature in relation to heavenly beings. Some depictions of God the Father have tiny souls clustered on his lap. In other images souls, indicated as just heads and shoulders, are gathered together in a napkin held by angels. Medieval statues and paintings of the Virgin sometimes have her extending her cloak in protection over the little souls clustered around her, an image known as the Madonna della Misericordia (Mother of Mercy). (St *Ursula's company of virgins can be shown in a similar way.)

A very popular subject for wall-paintings in medieval churches was the weighing of souls by the archangel *Michael at the *Last Judgement.

spade The emblem of the gardener and hermit St *Fiacre.

spear One of the *Instruments of the Passion: 'But one of the soldiers with a spear pierced his side, and forthwith came there out blood and water' (John 19:34). In sets of Instruments of the Passion, the spear or lance is often associated with the cup or chalice in which the blood and water were collected. The soldier who pierced Christ's side was later endowed with the name of *Longinus.

Among the apostles, SS *Matthew and *Thomas may sometimes hold spears, in reference to accounts of their martyrdoms.

spectacles Occasionally worn by St *Matthew.

spider Appearing out of a chalice, the emblem of St *Norbert.

staff A secondary attribute of numerous saints, indicating either that they were travellers (either as missionaries or pilgrims) or as a mark of authority (*see also* crozier; sceptre). Both significances may be present in the staff of the archangel *Raphael or of evangelizers such as the 6th-century missionary bishop St *Samson of Dol. The staff of St *Antony of Egypt is a distinctive T-shape.

The serviceable staff used by pilgrims is universally seen in the case of saints who

are represented in pilgrim dress: St *James the Great, St *Roch, St *Josse, St *Bona. A similar staff is used by St *Christopher to support the Christ Child as he carries him across the ford.

The staff of St Christopher may also be seen set in the ground and sprouting leaves. This is part of a long tradition of miraculously flowering or sprouting staves or rods, starting in the Old Testament with *Aaron and *Moses and continuing through the apocryphal gospel account of the betrothal of St *Joseph to the Virgin Mary. SS *Joseph of Arimathea and *Aldhelm are also credited with flowering or budding staves.

The personification of the Synagogue or Judaism is commonly shown in Christian medieval art as a blindfolded woman with a broken staff to signify the failure of the authority on which she relies.

stag With a crucifix between its horns, the emblem of SS *Eustace and *Hubert. The same story is told of both, how they underwent a conversion while out hunting, when they had a vision of the crucified Christ between the horns of a stag. Confusion with St Eustace may be the reason why other hunting saints, such as Hubert and the Cornish martyr Gwinear, are shown with such a stag. In Italian art the vision of the stag is most likely to relate to St Eustace, while in French and other northern European art the subject is more probably St Hubert.

A stag is the emblem of the 6th-century Cornish abbot St Petroc, who is said to have protected one from the hunters who were pursuing it. A stag may also accompany St *Julian the Hospitaller. For the motif of stags drinking *see under* deer.

star The sign that heralded the birth of Christ and led the *Three Magi from the east to Bethlehem (Matthew 2:1–10). In early art it is often eight-pointed, as the number eight was associated with perfection and with the Resurrection.

The Virgin Mary, as Queen of Heaven, may wear a *crown of stars. With one star the allusion is to her title of *Stella Maris (Latin, 'Star of the Sea'). St *Dominic may have a star over his head and St *Nicholas of Tolentino one on his breast. Twelve stars may stand for the *Twelve Apostles.

Stations of the Cross A sequence of painted or sculpted scenes representing stages in Jesus' progress to Calvary, death and burial. Pilgrims to Jerusalem from an early date followed the Via Dolorosa which led from 'Pilate's house' to the supposed site of Calvary, and in Roman Catholic churches the traditional scenes along this route are arranged around the interior so that the devout can visit them in turn for prayer and meditation. The practice grew up in the late Middle Ages with the particular encouragement of the Franciscans.

The number of the scenes has now settled at fourteen: Jesus condemned to death; receiving his Cross; falling for the first time; meeting the Virgin Mary; the Cross given to Simon of Cyrene; *Veronica wiping his face; falling for the second time; meeting the women of Jerusalem; falling for the third time; being stripped of his robe; being nailed to the Cross; his death; the *Deposition; the *Entombment.

Stella Maris *see under* star.

Stephen, St (died *c.* 35) Deacon and martyr. He was one of the seven deacons appointed to supervise works of charity in the first Christian community at Jerusalem (Acts 6:1–8). Stephen was accused of blasphemy by the Jews and his speech in his own defence (Acts 7:2–53) so enraged them that they dragged him out of the city and stoned him to death.

As the first Christian martyr (Protomartyr), Stephen has been honoured

throughout the Church from the 4th century and perhaps earlier; his feast day is the day after Christmas in the West, 27 December in the East. His supposed burial place was revealed in a vision to a Christian priest called Lucian in 415. As a result his relics were translated to Constantinople and then Rome, where he was buried beside another martyred deacon, St *Laurence. Miracles were reported from the moment of the discovery of the remains (St Augustine of Hippo mentions that he knew of some seventy cures), which encouraged the dismemberment of the relics and further diffusion of the cult. Relics of St Stephen were housed in the French cathedrals dedicated to him at Toulouse, Sens and Bourges. In England, Eton College was among the foundations claiming to possess his relics (inventory of 1425) and forty-six churches were dedicated to him.

In medieval and Renaissance art Stephen is shown as a young man in the vestments of a *deacon, holding the palm of martyrdom or a book on which stones may be displayed. Other artists show the stones attaching to his head and shoulders. The latter convention may be associated with the belief that he had particular power to cure headaches.

stigmata The marks of the five wounds in the hands, feet and side of Christ, which appear on the bodies of certain saints, usually following intense meditation on Christ's physical sufferings. The first and best-known saint to exhibit the stigmata was St *Francis. He is sometimes shown at the moment of receiving them: rays of light stream from the wounds of Christ on an actual or visionary crucifix, piercing the saint's feet, hands and side.

Another popular Italian saint who received the stigmata was St *Catherine of Siena. A painting by Beccafumi (Pinacoteca, Siena) shows her kneeling in front of a crucifix as she receives their imprint;

other artists simply show her with the wounds visible in her hands.

stole A long narrow strip of coloured silk worn by both priests and deacons in the Western Church. It may have an embroidered cross in the middle and at both ends. The former wear it round their necks, with the ends hanging free in front during services other than the Eucharist; for the Eucharist, the ends are crossed over the chest and then tied in place at the waist. Deacons wear the stole over the left shoulder only, with the ends tied under the right arm.

An angel holding a stole may be seen in pictures of the conversion of St *Hubert, in allusion to the legend that the Virgin Mary presented him with a stole to indicate that she approved his ordination.

stone(s) The emblem of St *Stephen. St *Jerome is sometimes shown in the desert, kneeling with a stone in his hand with which to beat his breast.

stream *see* river.

Suffering Servant *see under* Man of Sorrows.

sun Christ himself was identified with the sun from the earliest period of Christianity, following the words of the Old Testament prophet Malachi: 'unto you that fear my name shall the Sun of Righteousness arise with healing in his wings' (Malachi 4:2). Cults of solar gods such as Mithras flourished in the early centuries of Christianity, so there was a danger of Christ in this guise being confused with a pagan deity. Indeed one mosaic (probably early 4th century) of Christ as the sun god Helios, driving a chariot, is known from the mausoleum of the Julii under St Peter's basilica in Rome.

Worn on the breast, the sun is the emblem of St *Thomas Aquinas. The

'woman clothed with the sun, and the moon under her feet' (Revelation 12:1) was interpreted as the Virgin Mary. Hence she is sometimes shown as a radiant figure, standing on a crescent moon, against a backdrop of starry sky.

In Crucifixions from late antiquity to the 15th century, a small sun and moon were depicted above the right and left arm of the Cross respectively. They could be either faces drawn on a red disc and a blue or more fully realized personifications. They were subject to various interpretations, for instance that they stood for the twofold nature of Christ (the sun being his divine nature, the moon the human) or the two parts in the Bible, the Old Testament, (the moon) giving illumination only when reflecting the light of the New (the sun).

sundial The distinguishing attribute of King Hezekiah who asked that the shadow should go back ten degrees in the (sun) dial of Ahaz as a token from God that he would be healed of his illness (2 Kings 20:8–11). In an early 13th-century stained-glass panel in Canterbury Cathedral Hezekiah and his sundial appear as the Old Testament type of the *Ascension, the connection being the Christ as the rising *sun 'with healing in his wings'.

swan Associated with the Virgin Mary on account of its beauty and white plumage (signifying purity). It is the emblem of Bishop *Hugh of Lincoln.

swastika (*or* gammadion) In the art of the catacombs, a cryptic symbol of Christ's power. It comprises four gammas (the third letter of the Greek alphabet) joined together at the foot and so was later interpreted as the *Four Evangelists with Christ as their centre.

Swithun, St (Swithin) (died 862) Bishop of Winchester (852–62). An English tradition of obscure origin (but mentioned by Ben Jonson in 1600) holds that the weather on his feast day (15 July) remains the same, whether wet or fine, for the next forty days. There are fifty-eight solo or shared dedications to St Swithun in England.

sword The weapon used by Roman executioners and thus the instrument of death to many early martyrs. Among the apostles St *Paul almost invariably holds a sword and/or a book, and a sword is an alternative emblem for SS *James (the Great) and *Matthew. Early women saints put to death by the sword may have one as an attribute along with their more individual emblems; these include SS *Agnes, *Faith, *Justina of Padua (depicted, for example by Jacopo Bassano, with the sword plunged into her breast), *Barbara and *Catherine of Alexandria.

Later saints who suffered murder by the sword include the British king Clydog (?6th century), who is shown with a sword and lily, and the virgin Juthwara, killed by her stepbrother on suspicion of unchastity. A scene showing one or more armed men in a church attacking a priest with swords is almost certainly the martyrdom of St *Thomas Becket.

The sword is also the characteristic weapon of the archangel *Michael and all warrior saints. Images of the *Last Judgement may show a sword coming out of the mouth of the glorified Christ: 'out of his mouth went a sharp twoedged sword' (Revelation 1:16). For swords and the Virgin Mary, *see under* Sorrows of the Virgin. *See also* dagger.

Sylvester, St (died 335) (Pope 313–35). Elected pope in the immediate aftermath of Christianity's being accepted as the official faith of the Roman empire, Sylvester was responsible for the building of a number of Roman churches. He is also credited, erroneously, with having baptized the emperor Constantine. For these

reasons, although not a martyr, he was venerated as a saint from very early on. His emblem is a *bull or occasionally a chained dragon.

T

tablets (of stone) The emblem of *Moses.

taxiarchs *see under* archangels.

Temperance *see under* Four Cardinal Virtues.

Temptation in the Wilderness The forty days following Jesus' *Baptism, when he withdrew into the desert alone to prepare himself for his work by fasting and prayer. This period is commemorated in the Church calendar by the fast of Lent.

The two main gospel accounts (Matthew 4:1–11, Luke 4:1–13; Mark 1:12–13 gives a brief mention) agree that Satan tempted Jesus in three ways: to prove to the world that he was the Son of God by turning stones into bread or by leaping down unscathed from the top of the Temple and to worship Satan in return for power over kingdoms of this world. When Jesus had rejected all three, Satan departed and angels appeared to minister to him.

As a subject in art the Temptation in the Wilderness only established itself from the 9th century onwards. It appears in developed form in the mosaics in St Mark's, Venice (early 12th century) and in the exonarthex of the Chora (Karye Djami), Istanbul (early 14th century). The temptation to turn stones into bread is the one most often shown; the ministering angels too sometimes appear as a separate subject. In post-medieval treatments Satan very often appears in the guise of a friar.

Ten Martyrs of Crete Ten saints who were put to death on Crete during the persecution by Decius in the mid-3rd century. Their collective feast day in both Greek and Russian calendars is 23 December, and they appear together as a group of men of various ages in icons (eight young and two old, according to the instructions in Dionysius of Fourna's *Painter's Manual*).

Teresa, St *see* Theresa of Avila, St; Theresa of Lisieux, St.

Thaddeus, St *see* Jude, St.

Thecla, St (1st century) Disciple of St *Paul. Her story is told in the wildly improbable *Acts of Paul and Thecla*, which was known as early as the 3rd century to be apocryphal, but which was nonetheless very popular. Hearing Paul preach at Iconium (modern Konya in central Turkey), Thecla was converted to Christianity. She survived attempts to put her to death by fire and wild beasts and retired to live in a cave where she performed miracles of healing. Eventually she vanished into the rock when some men tried to attack her. Thecla is generally portrayed with the martyr's palm on account of her sufferings and sometimes is accompanied by wild animals.

Theodore, St (early 4th century) Martyr. Almost nothing is known for certain about him; his legend states that he was a soldier who burned down a pagan temple and was tortured and burned to death. His cult spread from Euchaïta (also known as

Theodoropolis) in northeastern Asia Minor to Western Europe.

Confusion is compounded by the fact that there were apparently two military St Theodores: one a recruit (Greek: *teron*), the other a general (Greek: *stratelates*), both sometimes referred to as 'the Great Martyr'. Elements of their biographies and cults have been hopelessly entangled from the time of the rise of the cult of St Theodore Stratelates in the 9th and 10th centuries. St Theodore Teron (*or* Tiro) was venerated from an earlier date. Both are credited with having slain a *dragon (sometimes a crocodile) with a spear; the most famous image of St Theodore in this role is the statue on one of the columns in the Piazzetta in Venice, of which city he was the patron saint before being superseded by St Mark.

Relics of St Theodore were venerated not only in Venice but also at Chartres in northern France. In Western Europe the cult of St Theodore has lost ground relative to that of St George, although he retains a feast day on 9 November. The SS Theodores are still recognized as discrete individuals by the Orthodox Church, with feast days ten days apart in February and a place of honour in the ranks of the warrior saints.

In Orthodox art both St Theodores generally appear in the armour of Byzantine or Roman soldiers, and the differences between them, in both dress and physical appearance, are in practice rather ill-defined (although Dionysius of Fourna clearly differentiates them in his 18th-century *Painter's Manual*). Both have pointed or two-pointed beards; the general's hair and beard colour is usually rather redder and his beard more tightly curled, almost giving the effect of ringlets. Both may appear on horseback. They very often appear side-by-side or as a pair, as in the late 14th-century frescoes in the church of St Athanasios tou Mouzaki, Kastoria (northern Greece), where they have placed their swords and shields on the ground and turned with raised hands towards the tiny figure of Christ above them, who is reaching out towards them with crowns (the reward of martyrs) in his hands.

Theotokos (Greek, literally 'god-bearing') The Virgin Mary as the Mother of God. Debates on the nature of Christ in the early Christian era naturally entailed discussion as to whether the Virgin was the mother of Christ only in so far as he was human, or whether she was the mother of both his divine and human natures. In the end the second view prevailed and was endorsed at the Council of Ephesus (431); hence the veneration of the Virgin in the Orthodox Churches. She is very often designated 'Theotokos' or 'Mother of God' (Greek: *meter theou*, usually represented by the abbreviation MP ΘY) in icons and mosaics, and the title may even appear in romanesque depictions.

Theresa of Avila, St (1515–82) Spanish nun and mystic; founder of the Reformed (*or* Discalced) Carmelites. Theresa became a Carmelite nun at Avila at about the age of twenty. Despite ill-health and other discouragements she persevered in her quest for spiritual maturity through prayer and contemplation, eventually attaining to mystical experience. The advice of the Franciscan ascetic St Peter of Alcantara (1499–1562) was very important to her; he lived just long enough to see the opening of Theresa's own convent of St Joseph at Avila, based on her reformed version of the Carmelite rule. She later founded sixteen other houses following the same austere and simple precepts. Her autobiography and other books have become classics of the spiritual life. She was canonized in 1622 and declared a Doctor of the Church in 1970.

St Theresa is shown in art as a nun with a fiery *arrow or perhaps a *dove hovering above her head.

Theresa of Lisieux, St (1873–97) French nun. She joined the Carmelite house at Lisieux (Normandy) in 1888 and eventually died there of tuberculosis. The story of her outwardly uneventful life is told in her autobiography *Histoire d'une âme* (translated into English as *The Story of a Soul*); an account of mundane tasks undertaken in a humble and loving spirit and of great fortitude in the face of suffering, the book had instant appeal and became an international success. Miracles began to be attributed to her intercession, in 1925 she was canonized and in 1929 the huge basilica at Lisieux was begun as a shrine for pilgrims.

Artists show St Theresa of Lisieux dressed in the Carmelite habit and holding roses, as she had likened the miracles she would perform to 'a shower of roses'.

Thomas, St (1st century) Apostle and martyr. He is often referred to as 'doubting Thomas'. John is the only evangelist to record individual actions and sayings of Thomas, including the famous episode when Thomas refused to believe that the other apostles had seen Jesus after the Resurrection and was convinced only when Jesus reappeared some days later and invited him to touch the wounds in his hands and side (John 20:24–9).

After Pentecost nothing is definitely known about Thomas, but his name is attached to a Gnostic text mainly comprising apocryphal sayings of Christ, to the *Gospel of Thomas*, which contains marvellous stories of Christ's infancy, and to the so-called *Acts of Thomas*. The two latter texts were known in a great many languages, and the *Acts* is the source of the tradition that Thomas went to India and preached the gospel there, eventually dying a martyr.

From the 9th century onwards scenes of the Incredulity of Thomas show him lifting his hand to touch the wound in Jesus' side while the other apostles look on. The scene may also be reduced to just the two

essential figures, as in Verrocchio's dramatic group in Or San Michele, Florence (1467– *c*. 1481).

In some versions of the *Dormition Thomas is seen coming through the doorway; he was the last to arrive for this final gathering of the apostles, the reason being that he had to make the longest journey, all the way from India. A popular tradition, illustrated quite frequently in the late Middle Ages, was that the Virgin, aware of Thomas's sceptical inclinations, threw down her *girdle to him as she was ascending into heaven to convince him of her *Assumption.

In early depictions Thomas is unusual among the apostles in sometimes lacking a beard. Later he is shown holding the spear or lance with which he was killed. A more distinctive emblem is an architect's square (T- or L-shaped), referring to the story that he built a palace for the Indian king; an early example of this is on the east portal of Bamberg Cathedral (12th century), while on the west front of Exeter Cathedral Thomas has both square and lance (*c*. 1400).

Thomas Aquinas, St (*c*. 1225–1274) Italian theologian and philosopher, known as 'the Angelic Doctor'. Despite intense family opposition, Aquinas joined the Dominican Order in 1244. He studied at Paris and Cologne and had two important spells of teaching at Paris (1254–9, 1269–72). In the decade 1259–69 he held office in his order and also had various papal appointments in Italy. His huge books, the *Summa contra Gentiles* and the *Summa Theologica*, were immensely important in bringing the thought of Aristotle to the attention of his contemporaries. Although unfinished, the *Summa Theologica* was a vast compendium of learning and it became a standard text in medieval universities. Aquinas was canonized in 1323 and declared a Doctor of the Church in 1567.

Aquinas is shown in the habit of a

Dominican friar on which a star is displayed. He very often carries a book or books to reflect his pre-eminence as a scholar. Aquinas' bulky body drew gibes from fellow students at Paris, who nicknamed him 'the dumb ox'. His teacher, Albertus Magnus, perceptively commented that the dumb ox's voice would in due course be heard the world over. Thus Aquinas sometimes has an ox as an attribute.

Thomas Becket, St (Thomas of Canterbury) (1118–70) English archbishop and martyr. Becket was an outstandingly able administrator and rose through the service of the Church to the point at which the newly crowned king Henry II offered him the chancellorship of England (1155). In that role too Becket was very successful, enjoying not only the trust but also the personal friendship of the king.

In 1162 Henry ensured Becket's election to the see of Canterbury, but as head of the Church in England, Becket applied himself to spiritual and ecclesiastical matters with the same zeal as he had previously demonstrated in secular ones. His uncompromising stand on behalf of Church interests quickly led to a complete rupture with Henry. Becket was forced into exile in France for six years. An agreement was patched up to allow him to return to England in December 1170, but the festering conflict over Church authority immediately broke out again. On 29 December four knights in Henry's service hacked Becket to death with their swords in front of an altar in Canterbury cathedral.

News of the shocking circumstances of Becket's death reverberated throughout Europe with extraordinary speed. Within a very short time miracles were being reported at his grave, and he was canonized in 1173. King Henry, whose exasperated cry, 'Will no man rid me of this turbulent priest?', was believed to have led directly to the murder, had to perform public penance. Becket's relics were trans-

lated in 1220 from the cathedral crypt to a purpose-built shrine, which became the pre-eminent pilgrimage destination in England and accumulated vast riches before its destruction at the Reformation. In England alone, eighty churches were dedicated to him; across the Channel, four of the seven cathedrals in Normandy contain Becket altars.

The subject of Becket's martyrdom very quickly made its appearance all over Europe in a wide variety of media: wall-paintings (*c.* 1200, church of Sta Maria at Tarrasa, near Barcelona), stained glass (*c.* 1206, Chartres cathedral), stone reliefs (1190–1200, font at Lÿngsjo, Sweden), metalwork (*c.* 1250, reliquary at Heidal, Valdres, Norway), enamel, alabaster, manuscript illumination and embroidery. At least forty-five Becket reliquary caskets were produced in the 13th century at the famous enamel workshops in Limoges, central France, and pilgrim souvenirs from Canterbury (*see* ampulla) have been found in Norway and Sweden. The murder scene is by far the most common Becket motif: four (though sometimes fewer) men in armour attacking a bishop who is kneeling in front of an altar on which a chalice or cross is placed. Often there is an additional figure: the priest Edward Grim, who witnessed the attack and was injured in it, may be seen holding the archbishop's cross and a missal. Other popular Becket subjects were his return to England by ship, his ride back to Canterbury, the saint preaching and the penance of Henry II.

As a single figure Becket is shown in his archbishop's robes with crozier and/or cross-staff. The full-length mosaic portrait of him in bishop's regalia at Monreale, Sicily, dates from the late 12th century. Occasionally he may have a sword embedded in his skull (*compare* Peter Martyr, St) or, as in the statue on the west front of Wells cathedral (13th century), be holding the sliced-off crown of his head.

thorns, crown of *see under* crown; Instruments of the Passion.

Three Children Hananiah, Mishael and Azariah, the three 'children of Judah', companions of *Daniel, who were taken into exile in Babylon by King Nebuchadnezzar (Daniel 1:6–7). They attained important posts in the Babylonian state, but their refusal to worship idols left them vulnerable to accusations by the native Chaldaeans: Daniel 3:8–30 relates how they survived being thrown into a burning fiery furnace. The Song of the Three Children, an apocryphal section of the book of Daniel, contains the song of praise that they offered to God during their ordeal. Verses 35–66 appear in the Book of Common Prayer as the Benedicite: 'O all ye works of the Lord, bless ye the Lord.'

A Russian icon painter's manual from the end of the 16th century shows the appropriate icon for their feast day (17 December): the three youths, wearing the small turban-type head-dress characteristic of Jews in Eastern art, stand in the hexagonal furnace under the care of an angel, while King Nebuchadnezzar looks on and the Chaldaeans reel from the heat beneath the arches of the furnace. For their appearance in late antique art *see under* Daniel.

Three Holy Hierarchs In the Eastern Church, the collective title of SS *John Chrysostom, *Basil (the Great) and *Gregory (the Theologian). Icon painters very frequently show them together, formally posed as three standing figures in black and white liturgical robes. *See also* Four Greek Doctors.

Three Living and Three Dead A *memento mori* motif found in medieval art and morality literature from about the mid-13th century. In art the scene shows a confrontation between three kings or nobles (often out hunting) and three hideous skeletons or cadavers. A scroll or scrolls contain the words spoken by the dead to the living: 'As you are, so once were we; as we are, so must you be', or some variant of this. The scene survives in murals in a number of English churches (for example, St Oswald's, Widford, Oxfordshire; mid-14th century) and also in a secular context (the great chamber of Longthorne Tower. Cambridgeshire; *c.* 1330). It is known also from France, Germany, Italy and the Low Countries.

Three Magi (*or* Three Wise Men) The 'wise men from the east' who saw the star that heralded the birth of Christ and followed it to Bethlehem, where they worshipped him and gave him gifts (Matthew 2:1–12). The Adoration of the Magi, one of the most ancient and universal subjects in Christian art, is celebrated in the Western Church on the feast of the *Epiphany (6 January).

The significance of the Magi as the first gentiles (non-Jews) to recognize Christ ensured their place in Christian tradition. The basic story as given in the gospel has been greatly amplified. Matthew does not even specify how many wise men there were; the traditional number of three was deduced by the 3rd-century scholar Origen on the number of gifts mentioned: gold, frankincense and myrrh (Matthew 2:11). Origen's older contemporary Tertullian advanced the Magi to royal status; the gospel story was then seen as a 'fulfilment' of the 'prophecy' in the Psalms: 'all kings shall fall down before him' (72:11). By the 6th century the Magi had acquired names: Caspar, Melchior and Balthasar. By the early 8th century the Northumbrian monk Bede was describing them in some detail as individuals: Caspar, giver of the frankincense, was a beardless youth; Melchior, who brought gold, was an ancient white-haired man with a long beard; and Balthasar, in the prime of his life, was bearded, with an olive complexion.

After 1164, when the German emperor Frederick Barbarossa removed their supposed bodies from the captured city of Milan, the chief shrine of the Magi was at Cologne and they were honoured throughout Western Christendom as the 'Three Kings of Cologne'. (Some parts of the relics have been returned this century to the church of Sant'Eustorgio in Milan from which they were taken.) A text associated with the Cologne shrine, the *History of the Three Holy Kings* by John of Hildesheim, brought together the various medieval sources for the legend of the Magi. This book was soon translated from Latin into other European languages and became widely known. It added a further fund of detail upon which artists could draw in their depiction of the Magi. For instance, it is the authority for showing Caspar, the youngest of the kings, as a black man and for making Balthasar an old man with a white beard.

As the Three Magi often represent the three ages of man – youth, maturity and old age – so their gifts had symbolic reference to aspects of Christ's life. Gold stood for his kingship; frankincense (i.e. incense) for his priesthood; myrrh (being used for embalming) for his Passion and death.

Three Marys The women who went to tend Christ's body in the tomb. They are sometimes referred to as the *Myrrophoroi* (Greek, 'unguent-bearers'), and may also be included among the mourners in pictures and sculptures of the *Lamentation. The gospel accounts of the visitors to the tomb differ as to their names and number, although *Mary Magdalene is named in all four gospels. All three carry ointment jars (as in a mid-13th-century walrus ivory relief in the Danish National Museum), and Mary Magdalene is not clearly differentiated from the other Marys until the late Middle Ages.

In the Eastern Church the traditional number of the women is seven, but only two or three were shown in art. The scene of the women at the tomb was the usual method of depicting Easter and the *Resurrection in the early centuries of Christianity, until the *Anastasis* (*see* Harrowing of Hell) superseded it. It occurs on the wall-paintings from Dura Europos in Syria (first half of 3rd century) and then in ivories, mosaics and othe media from the 4th and 5th centuries. Usually the angel is shown greeting the women in front of the rock-cut tomb, the door of which is shown ajar or displaced.

Three Theological Virtues Faith, Hope and Charity. They are personified as women and may appear either individually or together. Although they were never anything more than personifications of abstract qualities, an early tradition rationalized them as the three daughters of Sophia (Wisdom) who were beheaded during a persecution in Rome, and as such they were all commemorated as martyrs. This fictitious family is also honoured in the East, where the daughters are given the Greek names of Pistis, Elpis and Agape respectively.

The attributes of Faith (Latin: Fides) are overtly Christian: a cross and a chalice. Like Charity she may have a candle, here indicating the light of faith. In a gesture indicating sincerity she points to her heart. She may assume a quite militant aspect with helmet and breastplate.

Hope (Latin: Spes) always has an anchor, since hope is described in Hebrews 6:19 as 'an anchor of the soul, both sure and steadfast'. Embodying the Christian hope of heaven, Hope often gazes upwards towards a crown that stands for the promised reward. A ship (sometimes even worn on her head) may be present to indicate the notion that voyages are an enterprise to be embarked upon in hopefulness. A gardener's spade, such as the one held by the carving of Hope in Auch Cathedral (south-

ern France), conveys a similar message. Hope is also quite common in secular contexts, for instance personifying the Cape of Good Hope in South Africa and thus featuring on the early stamps issued there.

Renaissance images of Charity (Latin: Caritas) show her with a suckling baby or babies and young children about her, but this convention became common only from the 14th century onwards, perhaps deriving from images of the Virgin suckling the baby Jesus (the *Virgo Lactans*). Earlier, Charity was conceived of as a young woman holding a candle, flame or burning heart since the virtue was interpreted as a burning love of God. A late example of this older convention is in the early 16th-century choir stalls in Auch Cathedral, where Charity holds a burning glass and a heart.

Three Wise Men *see* Three Magi.

throne The seat of the glorified Christ, alluded to many times in Revelation. From it the *Last Judgement will be pronounced: 'he hath prepared his throne for judgement' (Psalm 9:7).

In Byzantine art this throne (Greek: *hetimasia*, literally 'preparation') became the pre-eminent symbol of Christ's second coming. The image evolved from an antique convention by which the royal throne could be taken as standing for the king or emperor himself. It functions in this way in the dome mosaic of the Arian Baptistery in Ravenna where the apostles process towards it as they would towards an actual representation of Christ.

On the throne are displayed a cross and/or some of the *Instruments of the Passion, so that the symbols of suffering and humiliation linked with Christ's first coming are brought together with the symbol of his glory and power. The Arian Baptistery mosaic presents the throne as part throne, part altar, with a purple-draped

cross placed upon it (purple is significant both of imperial power and of Christ's Passion and is the liturgical colour of Advent and Lent); similar thrones appear in the mosaic frieze in the Baptistery of the Orthodox, also at Ravenna.

thrones Spiritual beings ranking third in the nine orders of *angels. When distinguished from the other angels in art they carry the *scales of justice (for instance in a window of St Michael's Spurriergate, York), as thrones were conceived of as divine lawgivers.

tiara The characteristic headgear of a pope. *See under* crown.

tongs As metalworker's tools, emblematic of SS *Dunstan and *Eloi. Holding a tooth, the emblem of St *Apollonia.

tonsure *see under* hair.

tooth Held in a pair of pincers, the emblem of St *Apollonia.

torch For the Dominican dog with a torch in its mouth, *see under* dog.

tower The main emblem of St *Barbara, who was imprisoned in a tower by her father to keep her out of reach of her many suitors. She converted to Christianity and as a token of her allegiance asked for three windows to be put into the tower to signify the Trinity. Artists show her with a model of this tower. (The three windows clearly differentiate it from Mary Magdalene's ointment jar, although the two may appear very similar in shape and size.)

The legend of St Barbara is only one of many stories that tell of a maiden shut up in a tower to preserve her chastity. The association with chastity promoted the title 'Turris David' (Latin, 'tower of David') for the Virgin Mary, whom medieval commentators and hymn writers identified

with the maiden in the Song of Songs. The allusion is to Song of Songs 4:4 ('Thy neck is like the tower of David builded for an armoury').

Tower of Babel The tower built on the plain of Shinar the top of which was intended to reach up to heaven; the presumption of the builders provoked God into throwing human speech, which until that time had been one language, into confusion, making people unable to understand one another (Genesis 11:1–9). The Tower of Babel became a byword for the retribution that follows pride and ambition. Many artists illustrated its construction, but its vast, sinister, ruinous bulk is probably best conveyed by a painting by Pieter Breughel in the Kunsthistorisches Museum, Vienna (1563).

Transfiguration The event, narrated in the first three gospels (Matthew 17:1–9; Mark 9:2–10; Luke 9:28–36), when Jesus took *Peter, *James and *John with him to a mountain to pray, 'and was transfigured before them: and his face did shine as the sun, and his raiment was white as the light' (Matthew 17:2).

The disciples saw two other figures talking to Jesus whom they recognized as *Moses and *Elijah. (The significance of Moses and Elijah is that the former is the representative of the Old Testament law and Elijah of the Old Testament prophets; their presence affirmed Jesus' claim to be the promised Messiah who will fulfil both.) Peter offered to build them 'three tabernacles' in which they could remain, but at that moment a cloud came over the scene from which the voice of God was heard, saying 'This is my beloved Son: hear him.' In terror the disciples fell on their faces, and when they looked up Jesus was alone again on the mountain, telling them not to be afraid.

The traditional scene of the Transfiguration is Mount Tabor in Galilee. Three churches had been built there by the 6th century, the largest dedicated to Christ, the two smaller ones to Moses and Elijah. The Transfiguration is one of the twelve great feasts of the Orthodox Church (celebrated on 6 August) and seems to have established itself in the Eastern calendar before the 8th century. In the West it was not generally observed until the mid-15th century, when the Christian victory over the Ottoman besiegers of Belgrade on 6 August 1456 prompted Pope Calixtus III to decree that the feast should be universally celebrated. However, it has never attained to the same status that it enjoys in the East.

The significance of the Transfiguration in the Orthodox world was greatly enhanced by the Hesychast ('quietist') theologians of Mount Athos in the 14th century. By asceticism and spiritual exercises these monks sought to put themselves in touch with the divine energy, which energy they believed to have been manifested in the light of the Transfiguration.

The history of the feast is reflected in the way in which the Transfiguration was portrayed in art. The earliest major interpretation, the mid-6th-century mosaic in the apse of Sant'Apollinare in Classe, Ravenna, is by symbols: Christ is represented by a jewelled cross, the three disciples by three lambs and only Moses and Elijah appear as half-length figures out of the cloud, from which the hand of God appears at the very top of the scene. The classic formulation of the scene however appears almost contemporaneously in the apse mosaic of the church of St Catherine's, Sinai: here Christ stands in a mandorla of light, his hand raised in blessing, with full-length figures of Moses and Elijah beside him, their hands making the gestures indicative of speech, while below them the three apostles fall to their knees in attitudes of amazement. It is rare for any other figures to be present, but Fra Angelico in a fresco painted 1442–3 (Museo San Marco, Florence) adds the

Virgin Mary and St Dominic as onlookers, and Raphael retains the central group of six figures but includes 'the multitude' and the possessed boy (Matthew 17:14–18) on a lower level in the foreground (1519–20; Vatican).

Hesychast influence is strikingly evident in many post-medieval icons of the Transfiguration, particularly in those from Russia. The mandorla around Jesus becomes a major feature of the composition, the height of the mountain peak on which he stands is emphasized and the disciples seem not just overwhelmed by the vision but physically hurled down by the force emanating from it. Their sandals, left behind as they fall, recall God's injunction to Moses: 'Put off thy shoes from off thy feet, for the place whereon thou standest is holy ground' (Exodus 3:5).

Moses may carry the tablets of the law, but often the two Old Testament figures are barely differentiated. The disciples on the other hand are individualized. Peter, though terrified and dazzled, makes an attempt to speak. The beardless St John (always the central figure of the three in later icons) covers his eyes, while St James twists away.

tree An emblem of St *Zenobius, bishop of Florence. Another bishop who may be shown with a tree is St *Boniface.

The tree of life and the tree of knowledge of good and evil, planted by God in Eden (Genesis 2:9), both play an important part in Christian art and symbolism, the latter as the tree of the *Fall, the former as the tree that brings everlasting life and so equated with the Cross of Christ. Following this contrast of the death-dealing and life-giving trees, the tree from which *Judas Iscariot hanged himself is placed next to the life-giving Cross of Christ in scenes on an early 5th-century ivory casket in the British Museum. *See also* palm tree.

Tree of Jesse The family tree showing Jesus' human descent from Jesse, the father of King David, through the royal house of Judah. The main biblical authority is the genealogy at the beginning of Matthew's gospel (1:1–17), taken together with a prophecy of Isaiah (11:1) about the birth of Christ: 'And there shall come forth a rod out of the stem of Jesse, and a Branch shall grow out of his roots.'

The Tree of Jesse is a not uncommon motif in Western church decoration, usually as a mural, but also making up the tracery of a window (as in Dorchester Abbey, Oxfordshire) or as a relief (12th-century bronze door panel, church of St Zeno, Verona). A particularly splendid example is the carving (second half of 12th century) on the central shaft of the main west archway of the Pórtico de la Gloria of the church at Santiago de Compostela. It seems to have emerged in stained glass in the mid-12th century (windows at St-Denis, Paris, and Chartres Cathedral) but rudimentary forms of it can be found in manuscript illustrations of the late 11th century. In the East it was apparently adopted rather later and is comparatively rare; there are 14th-century examples on the exterior wall of the Panagia Mavriotissa at Kastoria and in the church of the Holy Apostles, Thessaloniki (both in northern Greece).

The motif shows the recumbent Jesse with a tree growing from his side and in its branches David, Solomon and various kings and prophets; at its apex is the Virgin Mary with the infant Jesus. A variant form, seen in a mid-12th-century sculpture in the cloister of San Domingo de Silos, Burgos, includes a *Trinity with God the Father holding the Christ Child and the dove at the apex, with the Virgin seated immediately above the figure of Jesse.

triangle An equilateral triangle signifies

the Trinity. God the Father is occasionally shown with a triangular *halo.

Trinity God the Father, God the Son and God the Holy Spirit. Belief in the one God as three Persons in one substance is central to Christianity but finding an acceptable formulation to state the relationship between the different Persons, and the nature of the divine substance in particular, occasioned furious debate and eventually schism in the early Church. The relationship of the Holy Spirit to the other two Persons was the main theological point at issue in the long doctrinal, political and administrative conflict between the Eastern and Western branches of the Church that led to the schism between them in 1054.

The turbulent early history of the dogma of the Trinity profoundly affects the way in which the three Persons have been portrayed at different times and places. In the early Christian centuries, when pagan idols were still to be seen in the towns and temples, the prohibition in the Ten Commandments against 'any graven image' (Exodus 20:4) meant that God the Father was never directly portrayed. Where it was appropriate to indicate God's presence, a cloud or a hand emerging from the cloud was the usual means adopted (as in the apse mosaic of Sant'Apollinare in Classe, Ravenna).

From the 11th century depictions of the Trinity as three Persons began to appear in romanesque art in the West. Some early forms of this image appear to be influenced by the Byzantine Christ *Pantocrator, showing God the Father as a bearded man in the prime of life and the *alpha and omega on either side. In facial appearance therefore, the Father was very similar to the Son; for instance in the 12th-century mosaic sequence of the Creation at Monreale, Sicily, the context and his plain *halo are the distinguishing clues rather than any difference in age or face. Typical-

ly, however, God the Father came to be shown as a venerable, white-bearded figure, 'the Ancient of Days' (Daniel 7:9), usually richly robed and wearing a crown or the papal tiara. Perhaps the most common kind of Trinity group, especially in sculpture, has God the Father seated upon a throne and holding the smaller figure of Christ on the Cross in front of him, while the Holy Spirit in the form of a dove appears over Christ's head.

A variant on this that appears to be peculiar to England is the so-called Bosom of Abraham Trinity in which the Father and the Son are shown in the same positions but the Father holds a napkin full of tiny souls, as in the 14th-century alabaster carving in the Burrell Collection, Glasgow. The name given to this type of Trinity derives from Luke 16:22–3, in which the beggar Lazarus is described as being in Abraham's bosom in heaven.

A rather awkward composition, for instance in the paintings by the 15th-century Netherlandish artists Robert Campin and Jean Bellegambe, has the Son more nearly the same size as God the Father, not on the Cross but supported on the Father's lap; in these groups he is still in his character as Redeemer, wearing only a loincloth and the crown of thorns and displaying the wounds of the Passion.

Yet another version of the Trinity has God the Father bareheaded on his throne in his character as 'the Ancient of days . . . whose garment was white as snow, and the hair of his head like pure wool' (Daniel 7:9). In this version the Son, as a much smaller figure, clad in a robe, is seated upon his lap and holds before him the Holy Spirit in the form of a dove on a disc. This type was also occasionally accepted into late Byzantine art (late 13th-century painting in the vault of the exonarthex of the Panagia Koubelidiki, Kastoria, northern Greece).

In Greek and Russian art the Trinity may be depicted in symbolic form as the

three angels who visited Abraham at Mamre. They are the subject of one of the most famous of all Russian Orthodox icons, the so-called *Old Testament Trinity* by Andrei Rublyov, painted soon after 1408 for the Trinity Monastery at Zagorsk (now Sergiyev Posad). Western pictures that give equal visual weight to the three Persons are not as common as the other types; those that exist show them as three nearly identical robed and crowned figures on a bench-like throne. This convention died out after it was condemned by the Congregation of Rites in Rome as suspect and likely to result in misunderstandings.

More frequently found is the Trinity group comprising the Father with the Son enthroned at his right hand and the Holy Spirit as a dove between them (as in the Washington National Gallery *Mary, Queen of Heaven* by the Master of the St Lucy Legend). Both Father and Son may hold a book or globe. Aspects of the way in which the Son is presented may recall his Passion: a cross in his hand and only a cloak for a garment (no robe); he may either be bare-headed or may wear a triple crown similar to the Father's but with the lowest circlet replaced by the crown of thorns.

trumpet The instrument sounded by the seven angels at the *Last Judgement (Revelation 8:2). It is particularly associated with the summoning of the dead from their graves to judgement: 'the trumpet shall sound, and the dead shall be raised incorruptible' (1 Corinthians 15:52).

T-square The emblem of St *Thomas the apostle.

Twelve Apostles The twelve chief disciples of Christ, who were with him throughout his earthly ministry, from the time of his Baptism to his Ascension (Acts 1:21–2). Slightly variant names appear in the lists given in Matthew 10:2–4, Mark 3:16–19, Luke 6:13–16 and Acts 1:13.

After Judas Iscariot had forfeited his place and committed suicide, Matthias was chosen by lot to replace him. In the Acts and Epistles, Paul and Barnabas are also referred to as 'apostles', and so there is some variation in the identity of the twelve, with Paul (emblems book and sword) very often displacing Matthias (emblem axe). Sometimes the two evangelists who were not also apostles (Mark and Luke) are intruded into sets of the twelve; in this case they generally ousted the little-known Simon and Jude.

In church art the twelve apostles were frequently depicted together, and from the 13th century they were increasingly individualized by their emblems. Before that, with the exception of Peter (who had his keys from a very early date), they generally just held books as symbols of their role as teachers. Many former sets are dispersed or fragmentary, due to the vulnerability of such large groups to damage and loss. Examples of English apostle sets appear among the stone sculptures on the west fronts of Wells and Exeter Cathedrals (both late 14th century), in the east window of Malvern priory church and the antechapel windows of All Souls College, Oxford (both c. 1440) and on the alabaster tomb of Sir Richard Vernon at Tong, Shropshire.

The *Four Evangelists generally have different emblems from the evangelical beasts when they are portrayed in their character as apostles; thus Matthew may have a sword or halberd, and all four may be shown holding books or scrolls. According to most traditions, all the apostles, with the exception of St John, were martyred, and so are entitled to display the palm frond of martyrdom as well as the instruments of their sufferings. Other apostolic emblems that are common and easy to identify include the knife (Bartholomew), saltire cross (Andrew), spear (Thomas), cup with serpent (John), scallop shell (James the Great), loaves of bread

or cross (Philip), boat or club (Jude), fish, falchion or saw (Simon). It is worth noting that the emblems of the minor apostles tend to be rather variable.

Another ancient tradition relating to the apostles is that they each contributed a clause to the Creed, so that in some cases when they are portrayed together, each holds a scroll with the relevant words upon it. In this type of set Matthias is always present, rather than Paul. Peter always has the opening words, Matthias generally the last, but there is considerable variation in between. An English alabaster altarpiece, formerly at Zamora in Spain and now in the Victoria and Albert Museum, London, and the figures flanking the windows in the nave of Fairford church, Gloucestershire (early 16th century) are examples of this convention. Statues of scroll-holding apostles found in the church porches of Brittany, six on each side, form a kind of guard of honour for those entering the church.

In church festivals and dedications, and therefore in art, three pairs of apostles are often linked together: Peter and Paul, Philip and James (the Less), Simon and Jude. *See also* Communion of the Apostles.

Twenty-four Elders According to the Book of Revelation, those who sit closest to the throne of God and worship him. 'Upon the seats I saw four and twenty elders sitting, clothed in white raiment; and they had on their heads crowns of gold' (Revelation 4:4). They appear as subordinate figures in scenes of the *Last Judgement or of Christ in glory, often holding musical instruments, not necessarily just the 'harps' mentioned in Revelation 5:8. There is a fine set of them, immediately identifiable by their crowns, in the tympanum of the romanesque south portal of the church at Moissac (southern France); they gaze upwards in wonder and adoration at the great figure of Christ above them.

U

unicorn A mythical animal imagined as a small horse-like beast with one straight, sharply pointed horn in the middle of its forehead. No one could capture a unicorn by brute force, but it could be taken by guile, since it became tame and trusting in the presence of a virgin, even to the extent of going to sleep with its head on the virgin's lap. By using a virgin as a decoy, hunters were able to capture the creature.

This fable came to be interpreted as an allegory of the Incarnation; for instance an early 14th-century English 'Hymn to the Virgin' by William of Shoreham equates Christ with the unicorn: 'That unicorn that was so wild . . . Thou hast y-taméd and y-stild With milke of thy breste'. Another respect in which the unicorn could symbolize Christ was that as its horn was believed to be an antidote to poison, so Christ is the antidote to the deadly poison of sin. The unicorn is also sometimes associated with other virgins, in particular the virgin martyrs SS Justina of Antioch and Justina of Padua.

Uriel *see under* archangels.

Ursula, St Virgin martyr of uncertain date and origin. Her legend, which seems to have evolved around the 9th century, describes her as a British princess who fled her native land with eleven companions to escape or postpone an unwelcome marriage to a pagan prince. She made a pilgrimage to Rome, but at Cologne on the return journey she and all her train of virgins were slaughtered by the Huns because she refused to marry their chief.

Ursula herself was killed by an arrow, sometimes seen as one of her attributes.

The medieval Ursula legend seems to have grown out of the discovery of an early 5th-century inscription to some unnamed virgin martyrs discovered at Cologne, and a subsequent misreading of a text about them was probably responsible for the expansion of the number of Ursula's train to 11,000 virgins. The unearthing of a mass of bones from an ancient graveyard at Cologne in the 12th century gave a significant boost to the story. The bones were eagerly seized upon and distributed as relics and so helped spread the cult of St Ursula throughout the adjacent areas of Germany, France and the Low Countries, although the church of St Ursula in Cologne itself, where the numerous reliquaries of Ursula and her virgins are housed, remains the centre of her cult.

The legend of St Ursula was a popular subject in art, and there exist cycles of narrative paintings showing incidents from her journeys and martyrdom. The most famous of these sequences is that painted by Memling in 1489 to adorn the shrine housing her relics in the Hospital of St John, Bruges. As a solitary figure she is usually shown as a princess with crown and sceptre; under her *ermine-lined cloak she may shelter a cluster of her companions (in a manner similar to that of the *Virgin Mary in her character as the Virgin of Mercy). Ursula may also be shown with a boat to signify her travels, as in the painting by Palma Vecchio (Penrhyn Collection), and/or a banner of victory (a red cross on a white ground).

V

vase Containing a *lily or lilies, a vase is often prominent in pictures of the *Annunciation. An empty vase on a tomb is symbolic of the departure of the soul from the body. *See also* jar.

Vedast, St (Vaast, Foster) (died 539) Bishop of Arras in northern France from 499. He prepared the Frankish king Clovis for baptism (496) and as bishop of Arras enjoyed considerable success in Christianizing the surrounding region, where his name is still commemorated. His cult spread in a modest way to eastern England, particularly through Augustinian canons from the Arras area in the 12th century, and three churches (in London, Norwich and at Tathwell, Lincolnshire) were dedicated to him. In art he appears with the bear which he ejected from a derelict church or the wolf from which he rescued a goose on behalf of its owners.

veil A cloth covering the head and shoulders. A nun's veil, which is worn over a close-fitting linen head-dress (wimple), is symbolic of her chastity and her renunciation of the world. The veil (Greek: *maphorion*) of the Virgin was a treasured relic at the Blachernae church in Constantinople. It was deposited there in the mid-5th century and the event was commemorated on 2 July, the day on which the Western Church celebrates the *Visitation.

In Orthodox art the blue, brown or purple *maphorion* worn by the Virgin very often has small gold decorations in the form of a cross or star at the point where it covers her forehead and on each shoulder. The *maphorion* is the standard head covering for holy women. The *maphorion* of Eve is normally red, as is that of SS Marina (*see under* Margaret, St) and *Anne.

The veil was also standard wear for female saints in the Western tradition. St *Agatha was said to have used her veil to divert a flow of lava from Mount Etna away from the town of Catania. The cloth of St *Veronica is sometimes referred to as a veil.

vernicle *see under* Veronica, St.

veronica *see under* Veronica, St.

Veronica, St (1st century) The Jerusalemite woman who pitied Jesus on his way to Calvary and wiped the sweat from his face with her veil (or a cloth), on which the likeness of his features remained imprinted (*see under* acheiropoietos). There is no biblical authority for this story, which appears in a late version of the apocryphal *Gospel of Nicodemus*. The etymology of the name 'Veronica' is a reflection of this legend (Latin: *vera icon*, 'true image'). Jesus' meeting with St Veronica is one of the *Stations of the Cross, and she may be included among the women around the foot of the Cross in paintings of the Crucifixion. One very long-standing tradition identifies her with the woman who had an issue of blood (Matthew 9:20–2), so she is often invoked against gynaecological ills.

The cloth bearing the features of Jesus, very often wearing the crown of thorns, is the invariable attribute of St Veronica,

who holds it up for the viewer, as in Rogier van der Weyden's *Crucifixion* triptych in Vienna (Kunsthistorisches Museum). The original was claimed to exist in Rome from the 8th century, and from the 12th century it was housed in St Peter's. Copies of it, known as 'veronicas' (or sometimes referred to under their medieval English name of 'vernicles'), are popular pilgrim souvenirs.

vesica piscis (Latin, literally, 'fish sac') A pointed oval outline placed upright behind a sacred figure. It is also sometimes called a 'mandorla' (Italian, 'almond'). The light and energy emanating from Jesus in paintings of the *Transfiguration are often manifest as a *vesica piscis*. Paintings showing a vision of the Virgin Mary also commonly employ this device, particularly at the moment of her *Assumption.

vestments The ceremonial garments worn by the clergy to celebrate the various Church rituals. Different kinds of priest have distinctive robes and headgear, often a useful clue to the identity of saints in art if it is known what rank they held in the Church hierarchy. There are also significant differences between Orthodox and Roman Catholic liturgical garments. *See* bishop; cardinal; deacon; pope.

Victor, St (died *c.* 290) Martyr. The core of his legend suggests that he was a Roman soldier who suffered torture and death for his beliefs under the emperor Maximian, along with several others whom he had converted to Christianity. His burial cave in the catacombs under the basilica of St Victor at Marseille became a major pilgrim shrine, and he has been honoured in many places in Western Europe since the early Middle Ages. He is often known as St Victor of Marseille to distinguish him from several other St Victors, most notable of whom was his near-contemporary St Victor Maurus, that is, St Victor the Moor, to whom churches are dedicated in Milan and Cremona. Both are shown in art as Roman army officers.

Vincent of Saragossa, St (died 304) Spanish deacon and martyr; patron saint of Saragossa and Lisbon and of winegrowers. He was imprisoned, tortured and put to death at Valencia in the persecution of the Christians under Diocletian. His remains were thrown into the sea attached to a millstone but were miraculously washed ashore on Cape St Vincent. Two ravens (or crows) guarded his body until it could be transported by ship to Lisbon. Millstone, ship and birds sometimes appear as his attributes.

As the earliest martyr of Christian Spain, St Vincent is widely honoured in that country. He was also venerated in Italy (where he appears in the late 6th-century mosaic procession of martyrs in Sant'Apollinare Nuovo, Ravenna), France (where Paris and Le Mans claimed to possess relics) and England (where Abingdon claimed relics and six ancient churches were dedicated to him). He appears as far afield as Russia, with a feast day on 11 November; his feast day in the West is 22 January.

Vincent appears frequently in Spanish art with the palm of martyrdom, dressed in his robes as a *deacon and holding a book. Confusingly, he may also have a *gridiron on which he is said to have been tortured. (The gridiron is thought to have been appropriated by the writer(s) of the legend of the other martyred deacon, St *Laurence, but to belong more properly to St Vincent.)

Vincent Ferrer, St (*c.* 1350–1419) Spanish Dominican friar. He played a significant role in healing the division in the papacy after 1378 when there were rival popes in Avignon and Rome, and was responsible for the conversion of many Jews in Spain. He was chiefly famous as a

preacher who undertook strenuous missionary tours of France, Spain and Italy drawing vast crowds wherever he spoke. The fiery zeal of his preaching is represented in art by showing him as a Dominican friar, open book in hand, with a sunburst on his breast.

vine A type of Christ, based on his own words to the disciples: 'I am the true vine, and my Father is the husbandman' (John 15:1). A little later he expanded the metaphor to illustrate his relationship with his followers: 'I am the vine, ye are the branches: He that abideth in me, and I in him, the same bringeth forth much fruit' (John 15:5). Christian art has frequently made use of a vine with bunches of grapes to illustrate this relationship. By extension, the vineyard itself can be a metaphor for the Church.

Early Christian reliefs of a man resting beneath a vine illustrate the story of *Jonah (see also gourd).

violet Being low-growing with small flowers, a symbol of humility. It is particularly associated with the Virgin Mary (for instance, strewn on the floor at her feet in Lorenzo Lotto's *Visitation* in the Pinacoteca Civica at Iesi). The violets on the floor in front of the Virgin and Child in Hugo van der Goes' Portinari altarpiece of the Nativity remind the onlooker of Christ's humility in becoming the naked baby in the stable, also of the Virgin's humble acceptance of her role.

Violets are also the emblem of St Fina, a 13th-century Italian girl who died at an early age of paralysis after much suffering; when her body was removed from the wooden board on which she had been lying the wood was found to have blossomed into violets.

Virgin Mary The mother of Jesus, whom Christians have acknowledged since the mid-5th century as the Mother of God (*see*

Theotokos). From the very early centuries it was recognized that she holds a unique position as intercessor with her Son on behalf of sinners. The Orthodox and Roman Catholic Churches both accord her particular honour, over and above that due to the saints.

The rather few facts about her life in the canonical gospels were supplemented early in the Christian era by apocryphal writings, in particular the *Gospel of James (Protevangelium)*. This is the source for her parents' names, the circumstances of her birth (*see under* Anne, St), her upbringing in the Temple at Jerusalem and her betrothal to *Joseph. Luke's gospel (1:26–56, 2:1–51) takes up the story with the Annunciation and subsequent events, supplemented by Matthew 1:18–25 and 2:1–23. Mary appears at the *Marriage at Cana, John (19:25–7) records her presence at the Crucifixion and Acts 1:14 mentions her remaining with the disciples in Jerusalem before Pentecost. After that the apocrypha again become the sole source.

In the calendar of the Orthodox Church no fewer than five of the twelve great feasts honour her: the Birth of the Virgin (8 September), the *Presentation of the Virgin (21 November), the *Annunciation (25 March), the *Presentation in the Temple (*or* Hypapante; 2 February) and the *Dormition (15 August). Of these only the Annunciation and the Presentation in the Temple are based on gospel narrative; the remaining three rely entirely upon the apocryphal material. In the West the feast of the *Immaculate Conception (8 December) is likewise based on the *Gospel of James*.

The Virgin appears in Christian art from the earliest period. Some of the catacomb pictures of her show her as a veiled woman standing with her hands raised in prayer (*see under* orans). Very early mosaics may show the Virgin as a queen, crowned like a Byzantine empress (as in Sta Maria Maggiore, Rome).

In Byzantine art famous icons of her in different poses, usually holding the Christ Child, became models for all subsequent icons on this particular pose; the most famous of all, on account of its pedigree (having been purportedly drawn from life), was the Virgin *Hodegetria but there were numerous other much-copied icon types with a distinguished history. Some names, such as Virgin *Eleousa or Virgin *Platytera, indicate the pose or composition; others denote geographical origin, such as Virgin Pelagonitissa (from the region of ancient Pelagonia northwest of Thessaloniki). Certain older icons of the Virgin are famous for their miracle-working powers, such as the Virgin Tiniotissa (of Tinos), discovered in 1822, to whose island church the sick and crippled from all over Greece throng twice a year to be healed on the feasts of the Annunciation and Dormition.

In Orthodox churches the Virgin is an important and recurring figure in the decorative scheme. She features prominently in scenes from the life of Christ and depictions of the great festivals, and scenes of her own life are also sometimes included as a distinct cycle. It is standard to have a mosaic or painted Virgin and Child on the vault of the main apse, and she also appears as a single figure on the iconostasis screen, balancing St *John the Baptist as part of the central *Deisis group. The conventional placing of the Dormition was as the major scene on the west wall of the nave.

From the 7th century it was customary to show the Virgin with a dark blue mantle and *veil. Blue (the colour of heaven) and white (the colour of purity) are particularly associated with her in both Eastern and Western traditions, not only in the clothes she wears but also in the flowers associated with her. Romanesque and Gothic artists took many features and motifs from the Eastern tradition of depicting the Virgin, but the strong expansion that her cult underwent in the later Middle Ages prompted artists to include other Marian themes in their repertoire, such as the *Visitation. The Coronation of the Virgin as Queen of Heaven (Latin: *Regina Coeli*), following on from her *Assumption, became a frequent subject. Sets of scenes for altarpieces and other devotional sequences were established under the titles of the Five *Joys of the Virgin or the Seven *Sorrows of the Virgin. She was also associated with the devotion of the *rosary (*see also under* Last Judgement). An invention that proved popular mainly in England was St Anne teaching the Virgin to read. Scenes from the life of the Virgin also appeared in new media; at the beginning of the 16th century Dürer made a series of woodcuts on this theme. There were many variations on the theme of the Virgin offering her breast to the Child (Latin: *Virgo Lactans*).

In the Protestant countries the cult of the Virgin suffered very severely at the hands of Reformation iconoclasts; in England, for instance, her major pilgrimage shrine at Walsingham, where there was a replica of the Virgin's house at Nazareth, was destroyed in 1538. In Roman Catholic countries her cult has continued to thrive, together with a number of different conventions for depicting her in art, some taken over from medieval models, others evolved from Counter-Reformation presentations of her. The *Maestà, the Virgin in Glory (standing in the sky surrounded and supported by cherubim) and the Virgin as Queen of Heaven (wearing a *crown of stars and standing on a crescent moon) honour the Virgin's rank in the hierarchy of heaven. Other images focus on her pity for humanity; the Madonna della Misericordia (Virgin of Mercy, Our Lady of Mercy) shows her spreading her cloak wide to draw in under its protection a host of people. As the Mater Dolorosa (Mother of Sorrows) she is shown weeping for her Son.

virtues Spiritual beings ranking below *thrones and above *dominations in the nine orders of *angels. Their function, according to the 13th-century compilation by Jacobus a Voragine, *The Golden Legend*, is to 'do all things difficult which be pertaining to divine mystery . . . [and] to perform miracles'. This may be signified in art by having the virtues hold objects connected with eccelesiastical ritual such as the *pyx and chrismatory (receptacle for the sacred oils).

Virtues, Cardinal *see* Four Cardinal Virtues.

Virtues, Theological *see* Three Theological Virtues.

Visitation The visit of the Virgin Mary to her cousin Elizabeth, mother of *John the Baptist, after the Annunciation (Luke 1:39–56). The baby that Elizabeth had miraculously conceived leapt in his mother's womb in acknowledgement of Mary's unborn son. Mary's words on this occasion are known under their Latin title of Magnificat: 'My soul doth magnify the Lord . . .'

The rarity of Visitation scenes in Orthodox art can be attributed to the fact that the Visitation itself is not observed as a feast in the Orthodox Church; it only appears among scenes of the infancy of Jesus which were produced mainly in the early Byzantine period. However, on 2 July, the day on which the Visitation is celebrated in the West, Luke's narrative of the Visitation was read in the Orthodox liturgy to celebrate the placing of the Virgin's *veil in the Blachernae church in Constantinople. The Visitation only entered the Western calendar in the 13th century and was not definitively established until the late 16th century, but the scene nonetheless gained currency in the late medieval period and Renaissance.

The usual manner of illustrating the event is to show the two women, one young, the other elderly, embracing, with their attendants looking on, and perhaps Zacharias emerging from the house behind Elizabeth, as in Dürer's early 16th-century woodcut in his Life of the Virgin series.

Vitus, St Martyr of doubtful date but probably south Italian origin. His legend, which is a late concoction of negligible historical value, suggests that he was tortured in various ways, including being thrown into a cauldron, and executed under Diocletian in Sicily. His tutor Modestus and nurse Crescentia, who had instructed him in the Christian faith, suffered with him.

The cult of St Vitus is very ancient. A 4th-century church was dedicated to him and Modestus in Rome, and his relics were taken in the 8th century to France (St-Denis, Paris) and from there in the 9th century to Germany (Corvey Abbey, Saxony); he is included in German lists of the *Fourteen Holy Helpers, and his supposed body was translated in 1355 from Pavia to Prague, where the cathedral is dedicated to him. His aid is sought by those suffering from epilepsy, convulsions, hydrophobia and various nervous disorders, including chorea, which is commonly known under the name of St Vitus' Dance. His emblem of a cock is believed to have been taken over from a pagan deity.

W

Walburga, St (died 779) English-born abbess of Heidenheim, southern Germany. Like her brothers SS Wynnibald (died 761) and Willibald (died 786), Walburga left England as part of the missionary movement of St *Boniface. She assumed control of Heidenheim after Wynnibald's death, and in 870 her remains were entombed beside his at Eichstätt, where Willibald was bishop. Eichstätt became an important pilgrimage centre on account of the miraculous oil that flowed from the rocky niche where Walburga was buried. The cures worked by this oil became so famous that her relics were divided and taken to the Rhineland, France and the Low Countries, thus spreading her cult.

St Walburga's day was 1 May and her legend attracted pagan material associated with the pre-Christian grain goddess venerated by the northern European peasants on that date. The revels of witches in the Harz mountain area were said to take place on the eve of 1 May (Walpurgisnacht). A story told of Walburga has echoes of the grain miracle on the *Flight into Egypt: a peasant carting sheaves of corn encountered Walburga fleeing from an enemy and hid her among the sheaves on his cart until her enemy had passed by; next day he discovered that all his sheaves had turned into gold. St Walburga was therefore particularly linked with good harvests and was a protector of the peasants. In art she is seen as a nun carrying a stalk or stalks of grain or a phial of her miraculous oil. She is sometimes shown crowned and in royal robes, following the unhistorical belief that she was the daughter of a certain 'King Richard of England'.

wallet *see* purse.

Walstan, St Anglo-Saxon saint of uncertain date. According to his legend he was of royal birth but sought employment as a humble farm labourer. His shrine at Bawburgh in Norfolk was the centre of a popular local cult in the Middle Ages, with farmers and labourers gathering there on 30 May to seek his blessing on themselves and their beasts. In paintings of Walstan a sceptre and crown suggest his royal origins, while a scythe and a *calf allude to his chosen way of life; at Sparham in Norfolk he is depicted with all these attributes.

warrior *see* soldier.

Washing of the Feet Traditionally an act of humility, performed by Jesus for his disciples (John 13:5–15) at the *Last Supper. The scene is set in the room where the Last Supper was to take place and is focused on the moment when Jesus is washing the feet of St *Peter, who, astonished and uneasy, gestures towards his head, in a dramatization of his words: 'Lord, not my feet only, but also my hands and my head' (13:9). The other disciples look on, some tying or untying their sandals.

The title of this scene in Greek Orthodox art is *Nipter* (Greek, 'a basin for washing'). The Washing of the Feet regularly appears in Byzantine art as part of the Passion cycle, sometimes at that

place in the church where a bishop or abbot washed the feet of members of the lower clergy or monks on Holy Thursday. The equivalent ceremony in the Roman Catholic Church was called the Pedilavium; the Maundy Thursday ceremony in which the English sovereign takes part is a truncated survival of this ritual.

water *see* fountain; river; well.

weighing of souls *see* scales.

well The watering of animals at a well is mentioned in several Old Testament passages. Abraham's servant Eliezar, who had been sent to seek for a wife for Isaac among Abraham's own kindred, met Rebecca at a well where she gave him water and his camels also (Genesis 24:10–28). This scene, shown for example in a 12th-century mosaic at Monreale, Sicily, was considered to prefigure the *Annunciation, which an apocryphal account sets by a well to which the Virgin had come to draw water. The wellside Annunciation is shown by a number of Byzantine artists.

Another popular wellside scene in art is the first meeting of Jacob and Rachel (Genesis 29:2–12). Moses too won his wife Zipporah by assisting her and her sisters against the shepherds who drove them away from the watering troughs (Exodus 2:15–21). St Sidwell, a saint local to southern England, has the attributes of a well and a *scythe. *See also* Samarian Woman at the Well.

whale The 'great fish' that swallowed and then regurgitated the prophet *Jonah (Jonah 1:17–2:10). In art it is sometimes recognizably a whale but more commonly appears as an imaginary monster, part fish, part sea serpent (*see also* leviathan).

The three days that Jonah spent in the belly of the whale were referred to by Jesus as a parallel to the period between his own death and Resurrection: 'For as Jonas was

three days and three nights in the whale's belly; so shall the Son of man be three days and three nights in the heart of the earth' (Matthew 12:40). For this reason the story of Jonah and the whale was interpreted from the earliest times as being an allegory of resurrection, and so was considered a highly suitable subject for sarcophagus reliefs and catacomb murals.

wheat *see under* corn.

wheel The universal emblem of St *Catherine of Alexandria. It can be shown either whole or broken in pieces, usually with spikes on the outer edge of the rim. Borrowed from the St Catherine legend, it is an element in the legend of St *Christina.

Wheels occasionally appear under the feet of the winged *cherubim or *seraphim, for instance in the 12th-century mosaics on the vault of a side chapel at Monreale, Sicily. These are the wheels seen in the vision of Ezekiel beneath the throne of God (Ezekiel 1:15–21).

wheelbarrow The attribute of the early 8th-century English hermit St Cuthman who used one to transport his crippled mother. His cult centre was at Steyning (West Sussex), where he had built a church, but after the Norman conquest his relics were transferred to Fécamp in Normandy.

Wheel of Fortune A symbol of the transitoriness of earthly power and happiness, very frequently encountered in the religious and secular art of the Middle Ages and Renaissance, as well as in the morality literature of the period. Fortune is depicted as a woman turning a wheel on the top of which sits a prince at the height of his career. As the wheel turns, so the fortunate man tumbles from his pride of place and, at the lowest point of the wheel, is shown a hapless wretch grovelling on the ground.

To complete the cycle, eager aspirants to power clamber up the ascending curve of the wheel.

whip *see* scourge.

whirlwind In the Old Testament, a manifestation of divine power. A whirlwind swept *Elijah up to heaven in a chariot with horses of fire (2 Kings 2:11), and it recurs at the beginning of the vision of Ezekiel: 'behold, a whirlwind came out of the north, a great cloud, and a fire infolding itself' (Ezekiel 1:4).

wild man *see* woodhouse.

Wilgefortis, St Fictitious Portuguese virgin martyr. Wilgefortis, daughter of a pagan king of Portugal, converted to Christianity and took a vow of virginity. When her father attempted to marry her off to the king of Sicily, another pagan, Wilgefortis prayed that she might become physically unattractive to him and was thereupon granted a miraculous growth of luxuriant beard. Her father ordered her to be crucified.

Wilegefortis was popular in several European countries as a saint who could be invoked by women to rid ('uncumber') them of unwanted husbands, and in England is actually known as St Uncumber. Her cult may have originated in the 14th century in Flanders and was strongest in the Low Countries, where she was also known as St Helper; other names are Liberata (in Spain and Italy), Débarras (France) and Kummernis (in Germany).

She appears in art as a young, bearded woman. If shown crucified she may be fastened to the cross by her long beard. The origin of her somewhat bizarre cult may be in a misunderstanding of an image of Christ on the Cross wearing a long robe, as occurs in romanesque treatments of the subject. Medical literature, however, does attest abnormal hair growth in adolescent females, linked with the disorder of anorexia nervosa.

William of Norwich, St *see under* boy.

windlass The emblem of St *Erasmus.

windmill An occasional attribute of St *Victor.

wine *see under* grapes; Marriage at Cana.

wings The distinguishing characteristic of *angels, *archangels and other supernatural beings. (The presence of wings is the obvious factor distinguishing the archangel Michael from St George when both are depicted as young men in armour crushing a dragon beneath their feet.)

The wings of heavenly inhabitants are usually depicted as feathered and birdlike, while the wings of demons and evil spirits are bat-like. Angels and archangels have only two wings, but the *cherubim have four (following Ezekiel 10:21) and the *seraphim six (Isaiah 6:2). The vision of Ezekiel also provides artistic justification for showing angelic wings as 'full of eyes'.

wodehouse *see* woodhouse.

wolf In England, a wolf holding a crowned head in his jaws is an allusion to the story that God set a wolf to guard the head of the martyred East Anglian king *Edmund until his retainers were able to find it for burial.

In Breton art a wolf turned guide dog accompanies the blind abbot St Hervé (6th century). Elsewhere in France, but particularly in England, the wolf that may accompany St *Vedast is less benignly disposed, sometimes having a goose in its jaws.

woodhouse (*or* woodwose) A wild man who lived in the woods or other desolate

places, sometimes identified in the Middle Ages with the satyr of classical mythology. Clad in skins and often carrying a club, the wodehouse was a popular medieval decorative motif, appearing in domestic, ecclesiastical and heraldic art. In medieval churches it can very often be found carved on misericords. *Compare* Green Man.

wound Displayed by several saints who, like *Thomas Becket, died violent deaths. The friar St *Peter Martyr exhibits wounds in both head and shoulder, often with the murder weapon still lodged in them. A wound or sore on a leg is the mark of St *Roch. *See also* stigmata.

Wrath (*or* Anger) One of the *Seven Deadly Sins.

wreath The emblem of St *Cecilia. In the medieval period, before musical instruments became her normal emblem, she was usually shown holding a wreath of flowers. Wreaths of flowers also crown the heads of angels and the blessed souls in heaven.

writer A standard way of depicting the *Four Evangelists, in both Byzantine and romanesque art. It appears particularly in medieval manuscripts.

Y

youth *see* boy.

Z

Zenobius, St (late 4th century) Bishop; patron saint of Florence. Zenobius is credited with many miracles, the most famous of which was the bringing back to life of a child who had been run over and killed by an ox cart. Cycles of his miracles were a favourite topic of Florentine painters. His coffin, knocking against a dead tree as it was taken for burial, caused the tree to break into flower; he is therefore sometimes shown with a flowering tree as his emblem.

Zita, St (1218–72) Italian domestic servant; patron of servant girls. Her entire life from the age of twelve was spent in the service of the family of a weaver at Lucca. Her employers at first objected to and derided her piety, but she gradually obtained their respect, and in the outwardly uneventful context of her life miraculous happenings began to occur. Her cult, centred on her tomb in the church of San Frediano, Lucca, spread across Western Europe in the later Middle Ages but was only tardily accepted as official by the Roman Catholic establishment. Her feast day is 27 April.

In England she is known at St Sitha, Sithes or Citha. Her most usual emblem is a key or bunch of keys and a purse, symbolic of her role as housekeeper; an English alabaster carving from the second half of the 15th century (Castle Museum, Nottingham) shows her with keys and purse but also with a book and rosary (to denote her piety) and a posy of flowers as well. The posy alludes to the occasion when a loaf of bread she was holding was transformed into flowers in her hand.

SELECT BIBLIOGRAPHY

Attwater, Donald *The Penguin Dictionary of Saints*, 2nd edn, Harmondsworth, 1983

Babic, Gordana *Icons* (tr. M. Tomasevic), London, 1988

Baggley, John *Doors of Perception: icons and their spiritual significance*, London & Oxford, 1987

Bandera Viani-Venezia, Maria Christina *Museo delle Icone Bizantine e post Bizantine e Chiesa di San Giorgio dei Greci*, Bologna, 1988

Basford, Kathleen *The Green Man*, Ipswich, 1978

Baxandall, M. *Limewood Sculptors of Renaissance Germany*, New Haven, Conn., 1980

Baxandall, M. *Giotto and the Orators: humanist observers of painting in Italy and the discovery of pictorial composition*, Oxford, 1971

Bentley, James *Restless Bones: the story of relics*, London, 1985

Berger, Pamela *The Goddess Obscured: transformation of the grain protectress from goddess to saint*, London, 1988

Bond, Francis *Dedications and Patron Saints of English Churches*, Oxford, 1914

Borenius, Tancred *St Thomas Becket in Art*, London, 1932

Bridge, A. C. *Images of God: an essay on the life and death of symbols*, London, 1960

Byzantine and Post-Byzantine Art, catalogue of exhibition, Athens Old University, 26 July 1985–6 January 1986, Athens, 1985

Chatzidakis, Manolis *Byzantine Art in Greece: Kastoria* (tr. H. Zigada), Athens, 1985

Cheetham, Francis W. *Medieval English Alabaster Carvings in the Castle Museum Nottingham*, revised edn, Nottingham, 1973

David-Danel, M.-L. *Iconographie des Saints médecins Come et Damien*, Lille, 1958

Demus, Otto *Byzantine Mosaic Decoration: aspects of monumental art in Byzantium*, London, 1948

Demus, Otto *The Mosaics of Norman Sicily*, London, 1950

Demus, Otto *Romanesque Mural Painting*, London, 1970

Dionysius of Fourna *Painter's Manual* (tr. P. Hetherington), London, 1974 [written c. 1730–4]

Every, George, *Christian Mythology*, revised edn, London, 1987

Farmer, David Hugh *The Oxford Dictionary of Saints*, 2nd edn, Oxford, 1987

Fournée, J. *Le Culte populaire et l'iconographie des saints en Normandie*, Paris, 1973

Henken, Elissa R. *Traditions of the Welsh Saints*, Cambridge, 1987

Huyghebaert, L. *Sint Hubertus*, Antwerp, 1949

James, M. R. *The Apocryphal New Testament*, Oxford, 1924

Jameson, Anna *Sacred and Legendary Art*, 2 vols, London, 1848

Kartsonis, Anna D. *Anastasis: the making of an image*, Princeton, NJ, 1986

Kelley, Fr Christopher P. (tr.) *An Iconographer's Patternbook: the Stroganov tradition*, Torrance, Calif., 1992

Kitzinger, Ernst *Byzantine Art in the Making: main lines of stylistic development in Mediterranean art 3rd–7th century*, London, 1977

Lane, Barbara G. *The Altar and the Altarpiece: sacramental themes in early Netherlandish painting*, New York, 1984

Lawson, John Cuthbert *Modern Greek Folklore and Ancient Greek Religion: a study in survivals*, Cambridge, 1910

Mancinelli, Fabrizio *Catacombs and Basilicas: the early Christians in Rome*, Florence, 1984

Meer, F. van der & Mohrmann, Christine *Atlas of the Early Christian World* (tr. & ed. Mary F. Hedlund & H. H. Rowley), 2nd edn, London, 1966

Meinardus, Otto F. A. *Monks and Monasteries of the Egyptian Deserts*, revised edn, Cairo, 1989

Ortenberg, Veronica *The English Church and the Continent in the Tenth and Eleventh Centuries: cultural, spiritual, and artistic exchanges*, Oxford, 1992

Ouspensky, Leonid & Lossky, Vladimir *The Meaning of Icons*, Crestwood, NY, 1989

Rendel Harris, J. *The Dioscuri in the Christian Legends*, Cambridge, 1903

Rushforth, G. McN. *Medieval Christian Imagery*, Oxford 1936

Schapiro, Meyer *The Sculpture of Moissac*, New York, 1985

Scott Fox, David *Saint George: the saint with three faces*, Windsor Forest, 1983

Sparrow, W. Shaw *The Gospels in Art*, London, 1904

Talbot Rice, D. *The Appreciation of Byzantine Art*, London, 1972

Tolkowsky, S. *Hesperides*, London, 1938

Watson, Arthur *The Early Iconography of the Tree of Jesse*, London, 1934

Weisz, Jean S. *Pittura e Misericordia: the Oratory of S. Giovanni Decollato, Rome*, Ann Arbor, Mich., 1984

Woodforde, C. *Stained Glass in Somerset 1250–1830*, Oxford, 1946

SOME SAINTS' NAMES

Only significant variations in form between some of the major European languages are noted.

ADRIAN *Lat:* Hadrianus
AGNES *Sp:* Inez
ALEXIS *Lat*: Aletius *It:* Alessio *Ger:* Alexius
AMBROSE *It:* Ambrogio
ANDREW *It:* Andrea *Fr:* André
AUGUSTINE, AUSTIN *It:* Agostino
BARBARA *Fr:* Barbe
BARTHOLOMEW *It:* Bartolomeo *Fr:* Barthélémy
BENEDICT *It:* Benedetto *Fr:* Benoît
BLAISE *Lat:* Blasius *It:* Biagio
BRIDGET, BRIDE *Fr:* Brigitte
CATHERINE *It:* Caterina *Ger:* Katharina *Sp:* Catalina
CECILIA *Fr:* Cécile
CHARLES *Lat:* Carolus *It:* Carlo *Sp:* Carlos
CHRISTOPHER *It:* Cristoforo
CLA(I)RE *Lat:* Clara *It:* Chiara
COSMAS *Lat:* Cosmus *It:* Cosimo *Fr:* Côme
CRISPIN *Fr:* Crépin
CYRIL *It:* Cirillo
DENNIS *Lat:* Dionysius *It:* Dionysio/ Dionigi *Fr:* Denis
DOMINIC *It:* Domenico *Fr:* Dominique *Sp:* Domingo
DOROTHY *It:* Dorotea *Fr:* Dorothée
ELIJAH *Fr:* Elie *Gk*: Elias
ELOI/Y *Lat:* Eligius *It:* Eligio/Alo *Fr:* Eloi
ERASMUS *It:* Elmo/Erasmo *Fr:* Elme *Sp:* Ermo
EUSTACE *Lat:* Eustatius *It:* Eustachio *Fr:* Eustache
FRANCIS *It:* Francesco *Fr:* François *Sp:* Francisco
GEORGE *It:* Giorgio *Sp:* Jorge
GILES *Lat:* Aegidius *Fr:* Gilles
HUGH *Fr:* Hugues
IGNATIUS *It:* Ignazio *Fr:* Ignace *Ger:* Ignaz *Sp:* Ignacio
JAMES *Lat:* Jacobus *It:* Giacomo *Fr:* Jacques *Sp:* Jaime/Jago
JANUARIUS *It:* Gennaro *Fr:* Janvier
JEROME *Lat:* Hieronymus *It:* Geronimo/Gerolamo
JOHN *Lat:* Johannes *It:* Giovanni *Fr:* Jean *Sp:* Juan
JOSEPH *It:* Giuseppe *Sp:* José

JUDOC *Fr:* Josse *Du:* Joost
JULIAN *It:* Giuliano
LAURENCE *It:* Lorenzo *Fr:* Laurent *Ger:* Lorenz
LOUIS *Lat:* Ludovicus *It:* Lodovico *Sp:* Luis
LUKE *It:* Luca *Fr:* Luc
MARGARET *Fr:* Marguerite *Gk:* Marina
MARK *It:* Marco
MARTIN *Du:* Maarten
MATTHEW *It:* Matteo *Fr:* Matthieu *Ger:* Matthäus
MATTHIAS *It:* Mattia
MICHAEL *It:* Michele *Fr:* Michel *Sp:* Miguel
NICHOLAS *It:* Nicola *Fr:* Nicolas *Ger:* Nicolaus
PAUL *It:* Paolo *Sp:* Pablo
PETER *Lat:* Petrus *It:* Pietro *Fr:* Pierre *Sp:* Pedro
PHILIP *It:* Filippo *Sp:* Felipe
ROCH(E), ROCK *It:* Rocco *Fr:* Roch/Roque *Sp:* Roque
SEBASTIAN *It:* Sebastiano/Bastiano
SYLVESTER *It:* Silvestro *Fr:* Silvestre
STEPHEN *It:* Stefano *Fr:* Etienne *Ger:* Stefan *Sp:* Esteban
THEODORE *It:* Teodoro
THOMAS *It:* Tomaso *Sp:* Tomé
TIMOTHY *It:* Timoteo *Fr:* Timothée
URSULA *It:* Orsola
VEDAST *Fr:* Vaast
VITUS *It:* Vito *Fr:* Vit *Ger:* Veit
VINCENT *It:* Vincenzo
WALBURGA *Fr:* Vaubourg
WILLIAM *Lat:* Gulielmus *It:* Guglielmo *Fr:* Guillaume

VISUAL INDEX

THINGS ON OR ABOUT THE PERSON

Blindfold

Coif

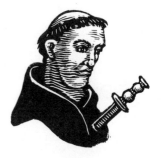

Dagger

Halo

Halo

Knife

Purse

Shell

Stones

THINGS HELD

Balls

Building

Banner

Censer

Chalice/Cup

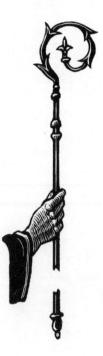

Crozier

Comb

Club

THINGS HELD

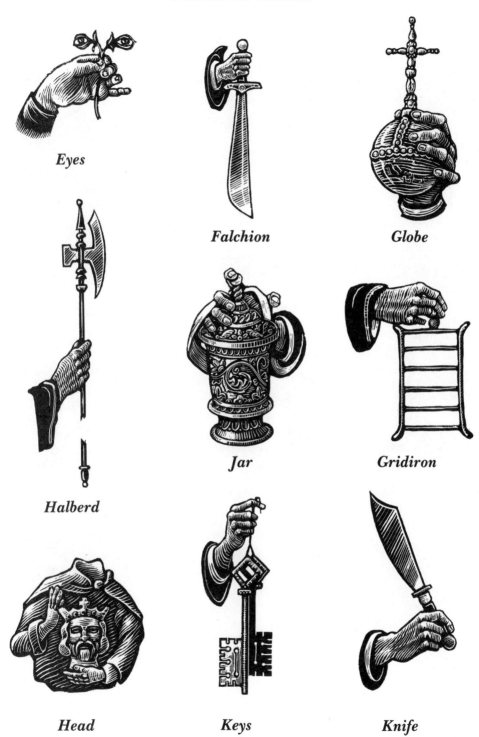

Eyes

Falchion

Globe

Halberd

Jar

Gridiron

Head

Keys

Knife

THINGS HELD

Purse

Monstrance

Organ

Palm Frond

Pyx

Ring

Saw

Rod/Staff

THINGS HELD

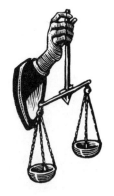

Scales

Scroll

Skin

Tablets (of stone)

Tongs

Tower

Veil

Wheel

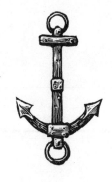

Anchor

Anvil

Jar

Throne

Tower

Vase

Vine

Wheel

GESTURES AND CROSSES

Blessing – Eastern

Blessing – Western

Attracting attention

Protection/Warning off

Orans

Greek cross

Latin cross (crux immissa)

Tau cross (crux commissa)

X-cross (crux decussata)

Papal cross

Patriarchal cross

Russian cross

Swastika

VESTMENTS AND LETTERS/MONOGRAMS

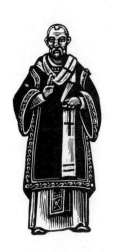

Bishop (Eastern)

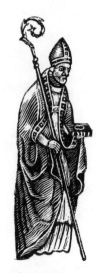

Bishop (Western)

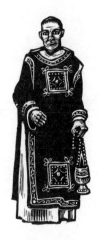

Deacon

Tiara (Papal)

Hat (Cardinal's)

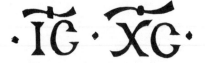

Pantocrator

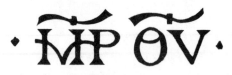

Theotokos

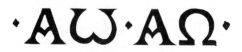

Alpha & Omega

Globe

Chi-ro

Western cathedral church (Latin cross) plan

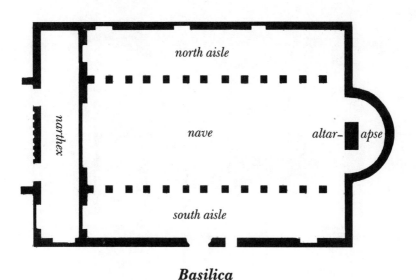

Basilica

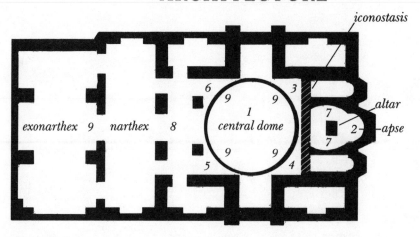

Orthodox (cross-in-square) plan with typical decorative programme

1 Pantocrator	3 Annunciation	7 Archangels
1* Pantocrator or saint/event to which the church is dedicated	4 Nativity	8 Dormition
	5 Crucifixion	9 Four Evangelists
2 Virgin (and Child)	6 Resurrection	10 Other saints

Iconostasis with typical decorative programme

TWELVE APOSTLES (WESTERN)

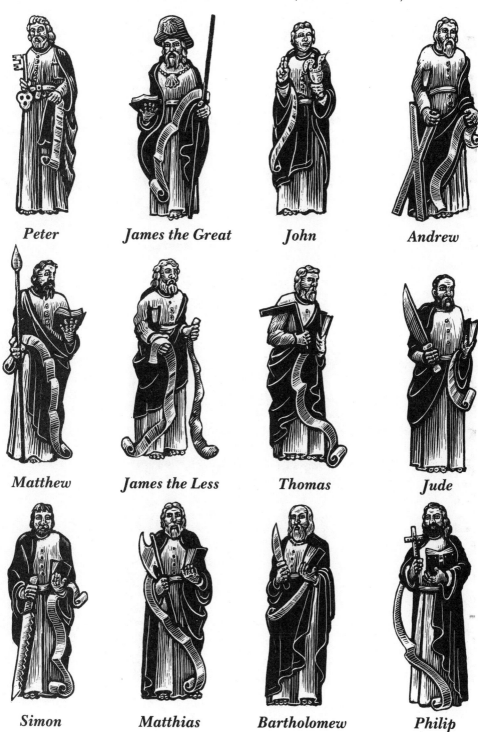

Peter James the Great John Andrew

Matthew James the Less Thomas Jude

Simon Matthias Bartholomew Philip

TWELVE APOSTLES (EASTERN)

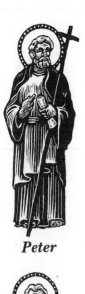

Peter

James the Great

John

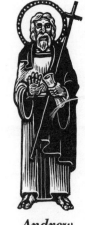

Andrew

Matthew

James the Less

Thomas

Jude

Simon

Paul

Bartholomew

Philip